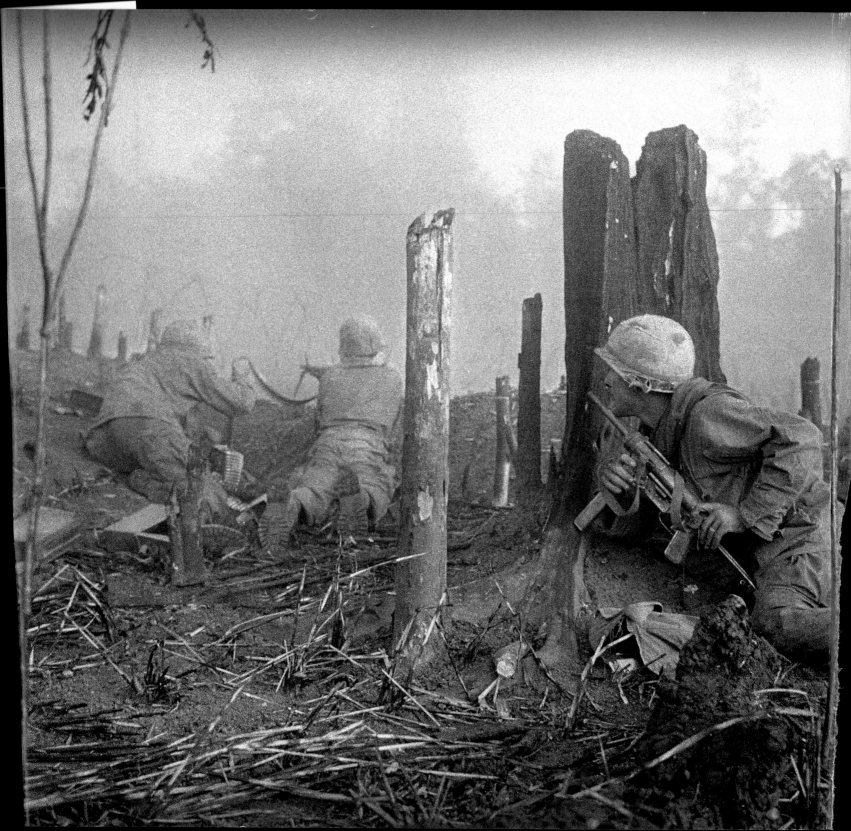

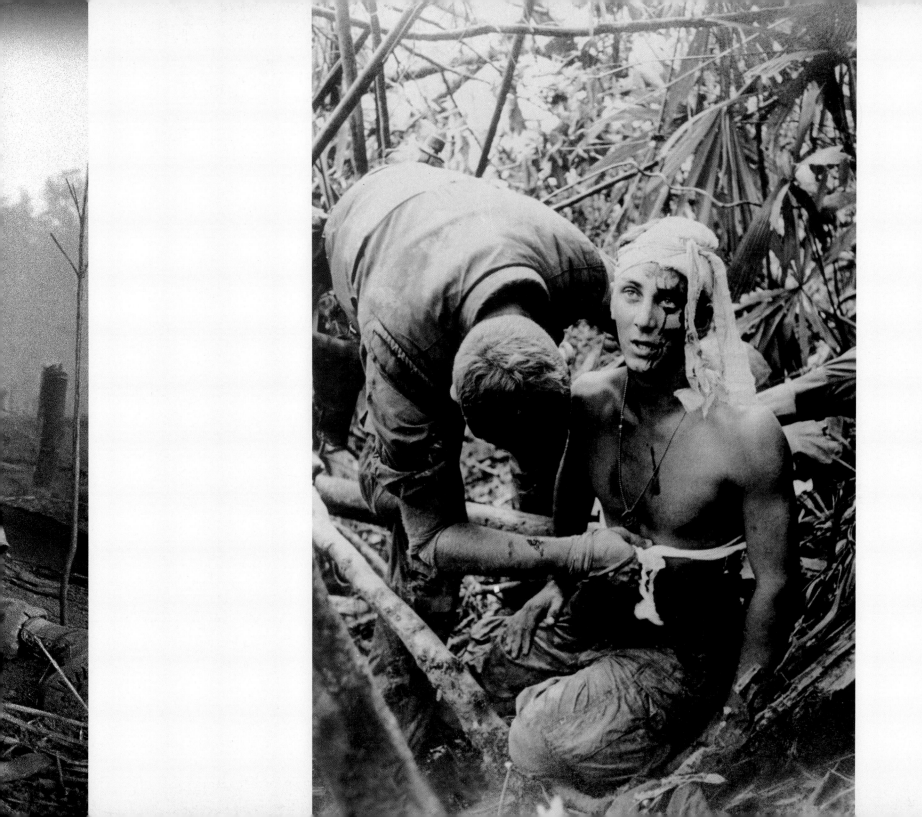

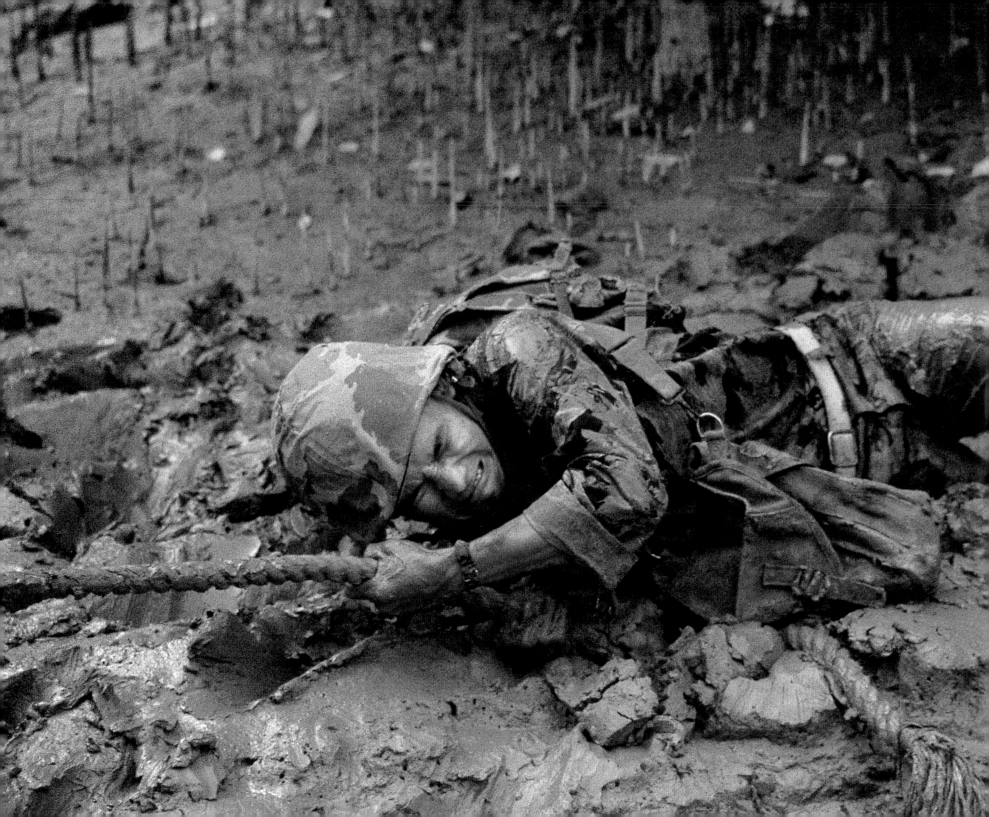

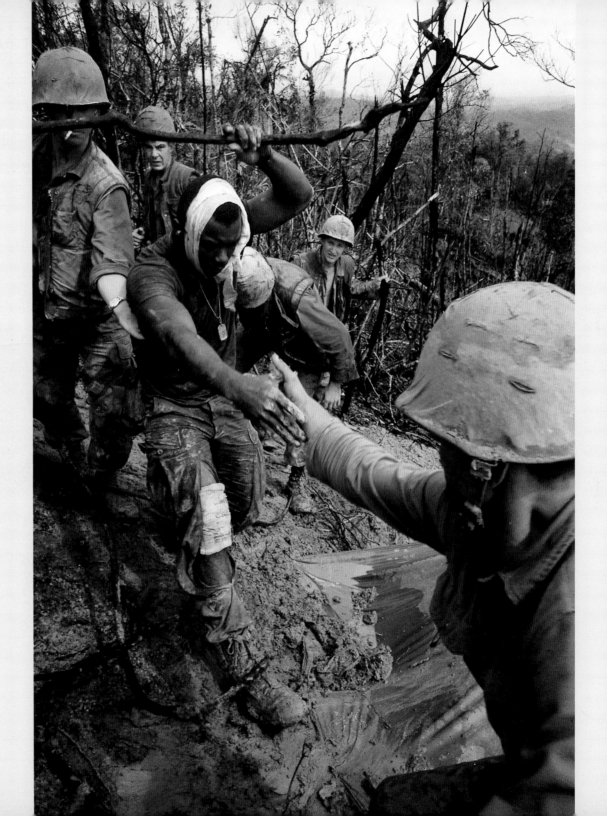

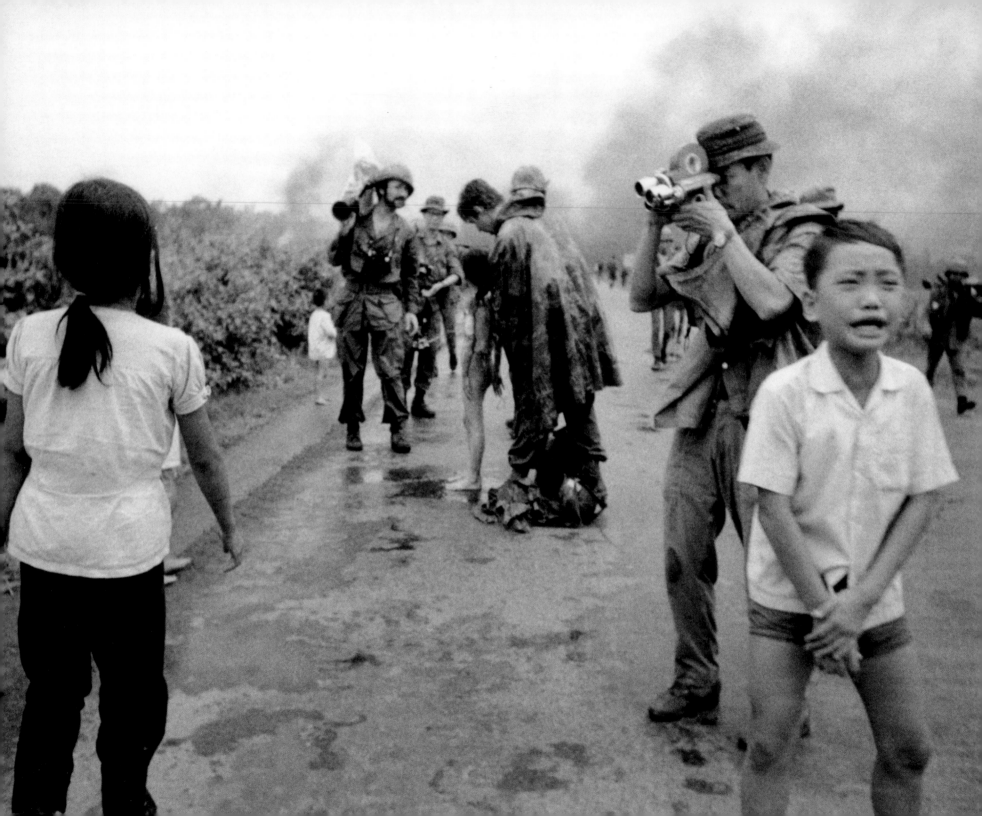

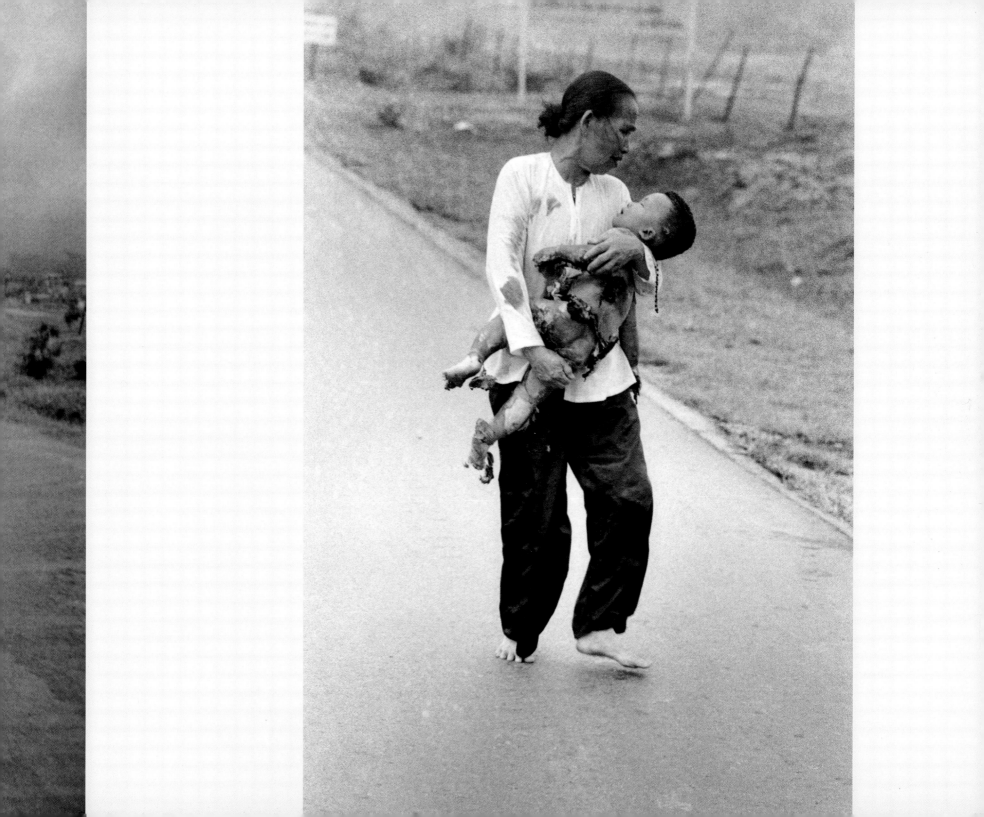

Edited and compiled by **CATHERINE LEROY**

Foreword by **SENATOR JOHN McCAIN**

 RANDOM HOUSE | NEW YORK

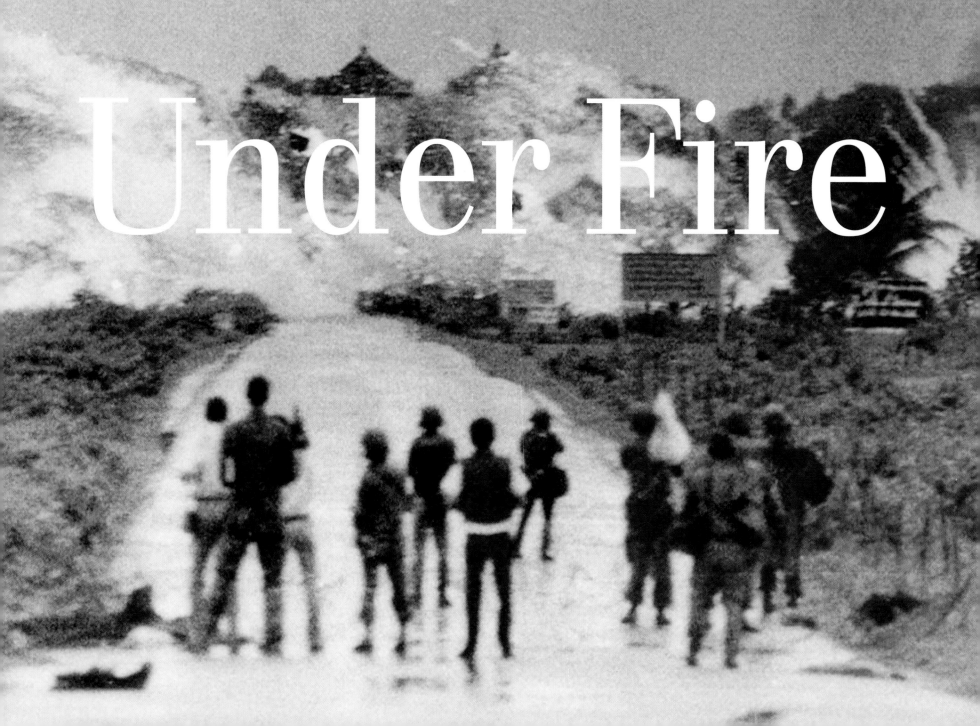

GREAT PHOTOGRAPHERS AND WRITERS IN VIETNAM

Under Fire

All rights reserved. Published in the United States by Random House, an imprint of

The Random House Publishing Group, a division of Random House, Inc., New York.

RANDOM HOUSE and colophon are registered trademarks of Random House, Inc.

ISBN 1-4000-6358-2

Printed in Italy on acid-free paper

Random House website address: www.atrandom.com

9 8 7 6 5 4 3 2 1

FIRST EDITION

BOOK DESIGN BY BARBARA M. BACHMAN

To Gloria Emerson and Jack Smith

with loving memories

JE SUIS LA PLAIE ET LE COUTEAU . . .
ET LA VICTIME ET LE BOURREAU!

—Charles Baudelaire, *Les Fleurs du mal*

I AM THE WOUND AND THE KNIFE . . .
AND THE VICTIM AND THE EXECUTIONER!

—Charles Baudelaire, *The Flowers of Evil*

In some their eyes are hidden in shadows cast by their helmets. Others look into a middle distance, provoking our thoughts about what they see there, or what they remember seeing in another moment, perhaps in some other field, jungle, or paddy. Some stare right at us, some vacantly, some piercingly. Pictures of soldiers in the field, wretched, relieved, determined, desperate, busy, purposeless, haunted, hoping, fierce, and humane, all one face of war, one face with many characters.

It is a surpassing irony of war that for all its horror, it provides the combatant with every conceivable human experience—love and hate, loss and redemption, joy and hopelessness, courage and cowardice, suffering and release, remorse and gratitude. Anyone who loses a loved one knows what great sorrow feels like. Anyone who gives life to a child knows what great joy feels like. The combat veteran knows what joy and loss feel like when they occur in the same moment, the same experience. It's impossible to forget. It transforms us. Some are better for it. Some worse. Some struggle all their lives to recover the balance that war has upset. For others who come back whole in spirit if not in body, the hard uses of life will never again threaten their equanimity.

What does war look like? Everything ugly and beautiful, everything cruel and loving, everything good and bad. For me, in the beginning, it was all just landscapes and seascapes, and carrier decks, and flying telephone poles, and thick black clouds, and thrilling moments. And then it was sandstone and cement walls, a naked light bulb, discomfort, and a sadistic man with an eye clouded by cataracts. And it was also a graceful, lovely young woman, the sight of whom made me happy until she destroyed me with a look of contempt. Most of all, it was inexplicably cheerful men, unwashed, dressed in dirty gray, malnourished, many stooped or hobbling, and brave and honorable—very, very honorable.

War is a hell of a big thing. It takes real strength not only to fight in it, but just to live in it, and see it for all it is, and not be destroyed spiritually by it, but somehow be made better. It takes courage to suffer its miseries—hard held, impossibly enduring, selfless, true in all its bloodstained, filthy, aching grandeur. But during all of it, always, come unexpected moments of beauty and compassion. And they get you through, and make you stronger.

What did these perceptive photographers and graceful writers see in their war? All of the above. All the good. All the bad. What do they want us to see in this moving, splendid book? Maybe, no matter how necessary we judge a call to arms, to remember to shed a tear for all that is lost when war claims its wages from us. Or maybe to remember that no calamity, no nightmare, can vanquish forever the human spirit. They are trying to bring the war to those who have no experience of it. And it's here for you to see, if you look hard enough, and truly. With the power of these pictures and words, maybe you will get an idea about the pain and destruction but still won't fully imagine the stink of war, the noise, the sudden, terrifying quiet, the long stretches of boredom, and the moments of stark terror and ferocious activity. Maybe you won't fully conjure the love and compassion of combatants and victims. But it is all looking at you, beckoning you, not mocking you but certainly challenging your understanding of this most fearsome endeavor. You think you know it? No, you don't. Everything abides in it, and it's hard to see so much in one thing. But keep looking. You're obliged to.

When you open this book you look at war, and war looks at you.

The unparalleled access to the war in Vietnam made it possible for a generation of photojournalists to live with a unique sense of urgency. With cameras they made a difference, giving war a face even when it dragged on and no one seemed to pay attention anymore. We are left with photography even more powerful today than when it captured the fractured moments of chaos. Now it's history.

Living on the edge was the *ordre du jour*, and we were getting closer with each terrifying helicopter assault. There were walks to nowhere in the suffocating heat, and fearful nights spent shivering in muddy foxholes. The exhausting stretches of total boredom and fatigue were interlaced with sudden, intense firefights. We were never sure we would survive, or be able to translate it all into photographs that would have meaning. Yet there was no other place in the world we wanted to be. It mattered as if our lives depended on it. It did.

Some of the texts reproduced in this book were first published as a series in *The VVA Veteran,* a publication of the Vietnam Veterans of America. Philip Caputo was the first to respond when I solicited essays. "The Marines have landed," he wrote me by e-mail; a week later, his beautiful piece accompanying the portrait by Don McCullin of a Marine became the first of many such pairings—one photograph and a writer's reaction.

Several Vietnam veterans, as I had hoped, identified with the images I assigned to them. Jack Smith, inspired by a photograph by Henri Huet, relived his experience in the Ia Drang Valley, in 1965, when his platoon suffered 93 percent casualties while a North Vietnamese soldier used Smith's body as a sandbag for his machine gun. David Halberstam, Neil Sheehan, and Joseph L. Galloway, who started their careers as the Young Turks of the press corps in Vietnam and became celebrated journalists and bestselling authors, rose to the challenge.

Larry Burrows, Gilles Caron, Robert Ellison, Henri Huet, Kyoichi Sawada, Dana Stone, and many others paid with their lives for caring. Their spirits soar in the humanity and compassion of the work they left us, and we must remain forever grateful for their legacy.

Now the brave new world of virtual reality is upon us. TV networks want us to believe that war is like a giant video game designed to entertain us, blurring the lines between reality and infotainment, creating a new mythology: a super war hero, a robotic terminator crafted by Hollywood. Simulating victory in simulated wars suppresses the reality of war: the carnage of death, the organized murder.

The young Americans fighting and dying in Iraq today, and those who will in the years to come, already know that the mythology is another lie.

Under Fire

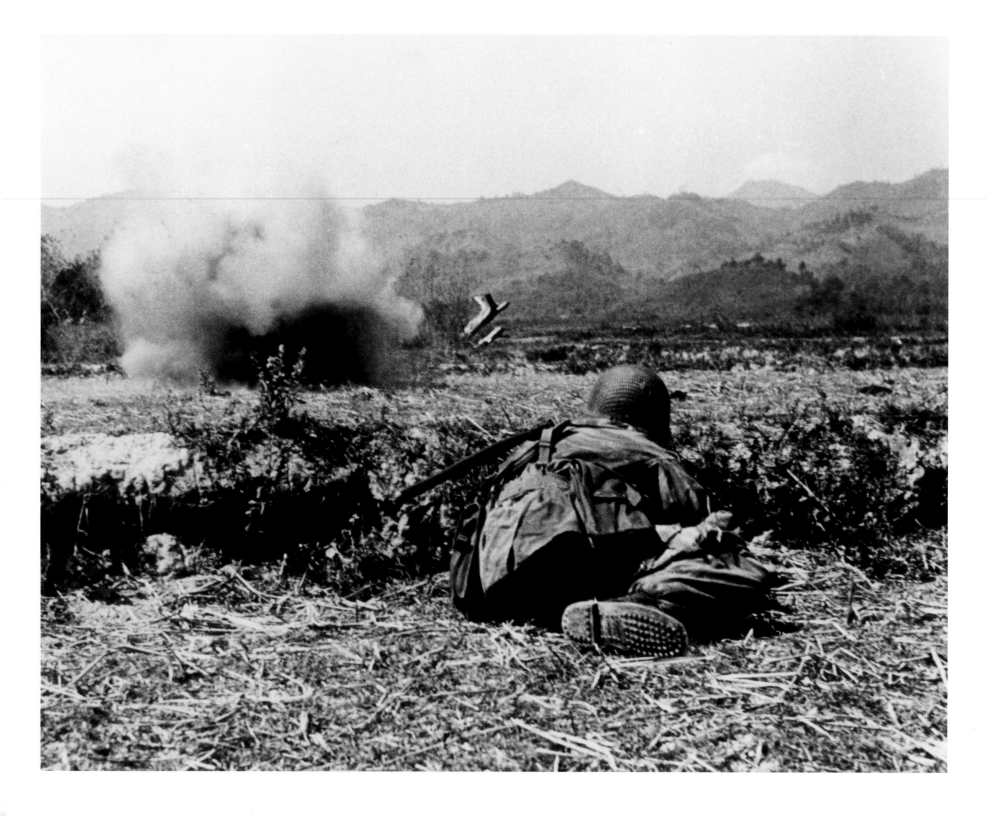

Daniel Camus *photographer* / Jean Lacouture *writer*

IMAGE MAKER

After half a century of tragic expeditions and dozens of journeys between the China border and the Gulf of Siam, I cannot close my eyes without being overwhelmed by a green wave. All the blood spilled since, the villages destroyed, and the massive defoliation can't erase from my memory the color of the rice paddies, the forests, the trails hedged by palm groves, or the fresh papayas on my table.

Opening my eyes on this photograph by Daniel Camus, what expels the green here from "my Vietnam" is the war. This image couldn't be farther away from those embedded in my own consciousness.

During the time of Dien Bien Phu, before it occurred to General Curtis LeMay to bomb Vietnam back to the Stone Age, men had transformed Vietnam from vegetal to mineral. Not only the country. Men, too. The garden became a glaze. The combatants became statues.

Print journalists discovered this truth little by little. Our visual comrades—the image conquerors—understood it long before we did, or better than we did.

The interpretation of war is more tolerable for us "word makers." "Image makers" directly expose themselves to risk, to better exhibit its extreme horror; its obscene, carnal embrace. They are not hindered by all the words that we drag behind us, our elegant prose purposely inserted between death and the reader. We interpret, they show; we plead, they give evidence.

A Daniel Camus, like a Robert Capa, can only do his job by putting his life in danger, and being as close to it as possible. From this comes the poignant force of their contribution to truth. From this comes the admiration that I have had for them ever since I saw them working at the end of 1945 in the Mekong Delta . . . when it was still green.

DANIEL CAMUS was born in Reims, France, in 1929. He studied engineering, but his love for action led him to photojournalism. At twenty-five, he was an airborne sergeant with the French Expeditionary Corps in French Indochina. Cameras in tow, he accompanied fighting units from the Mekong Delta to Dien Bien Phu. In 1954, his photographs of the besieged French fortress were published all over the world. He joined the staff of *Paris Match* in 1956. As a newlywed, he was in Cuba with his wife just in time for Castro's takeover of Havana. Said Castro, "I can't offer you a wedding present, but look, I am offering you a revolution." Camus's career at *Paris Match* spanned thirty years and saw him in all the hot spots in the world. He died in 1995.

Born in France in 1921, JEAN LACOUTURE traveled extensively in Indochina for thirty years. In 1945, he became a press attaché to General Leclerc. In 1951, he joined the daily *Le Monde*. A prolific author and biographer, Lacouture wrote fifty books, including six on Indochina. His bestsellers translated into English include *Ho Chi Minh: A Political Biography, De Gaulle: The Rebel,* and *Jesuits: A Multibiography.*

DANIEL CAMUS

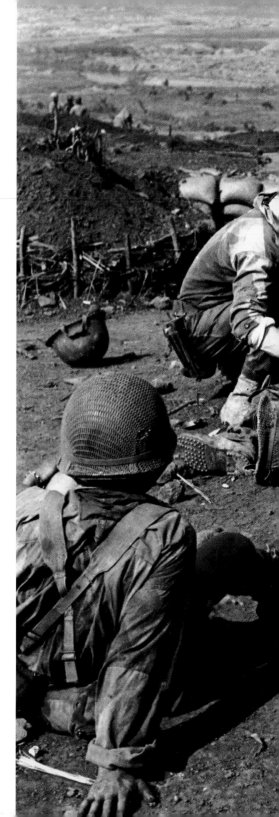

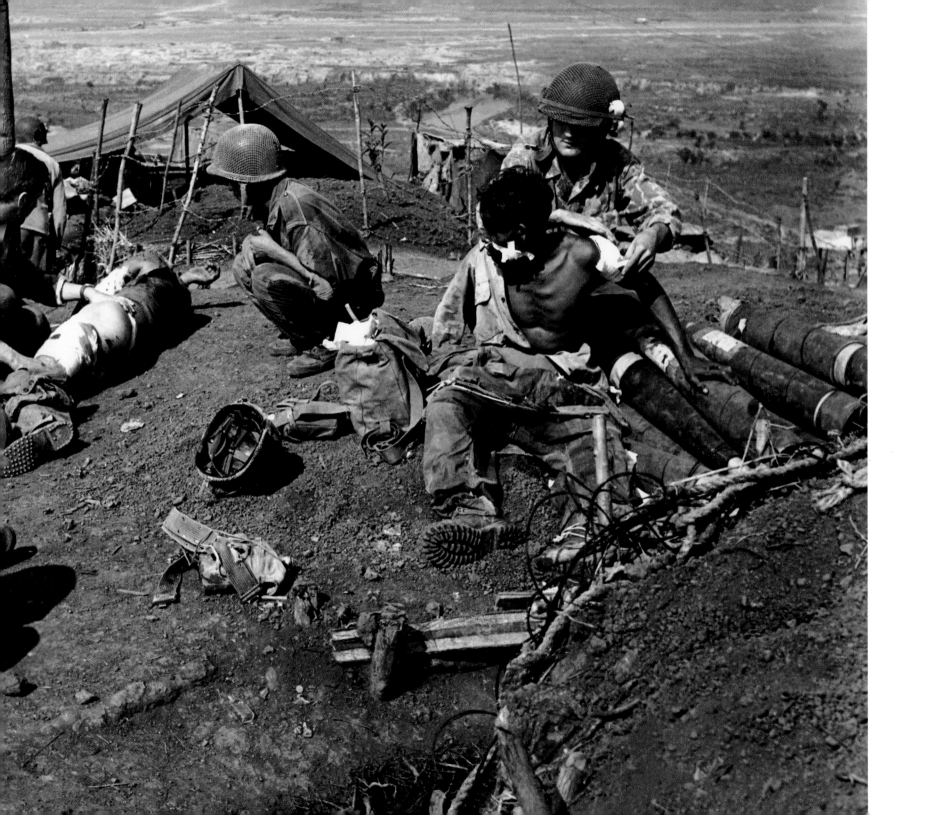

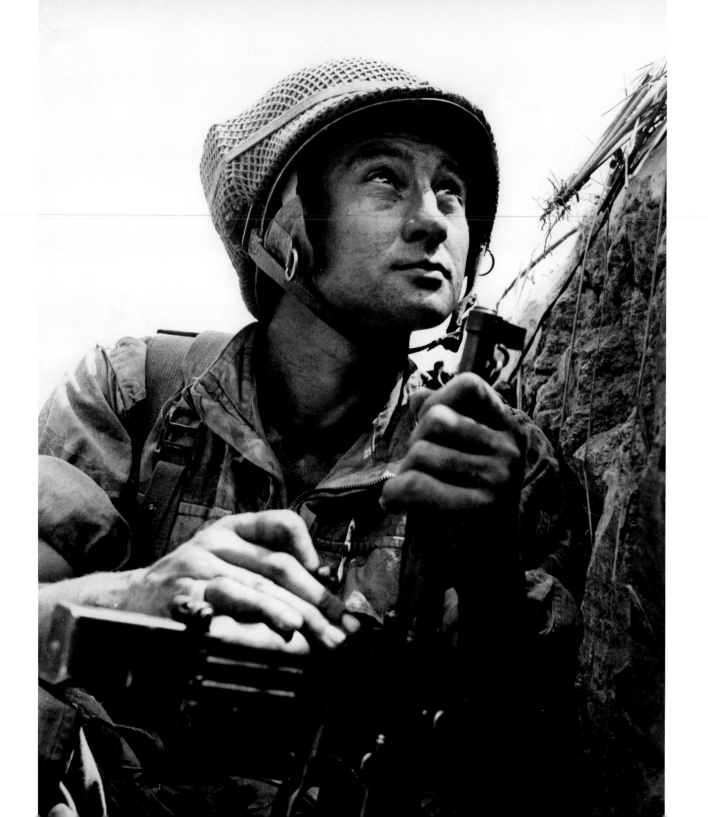

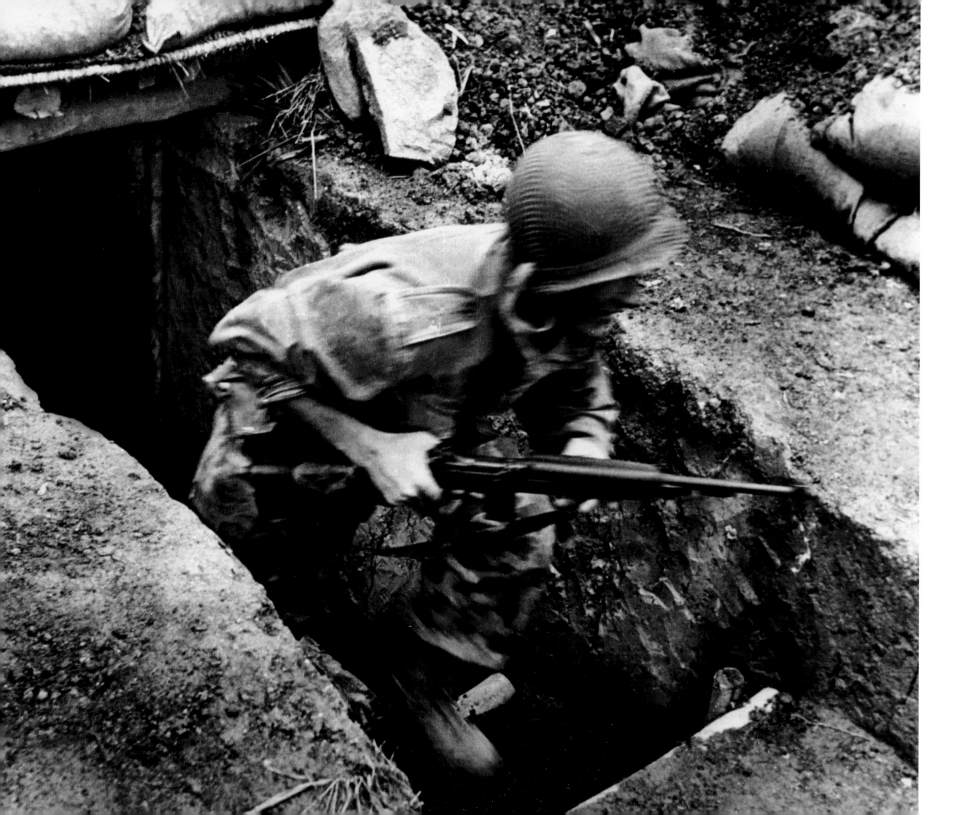

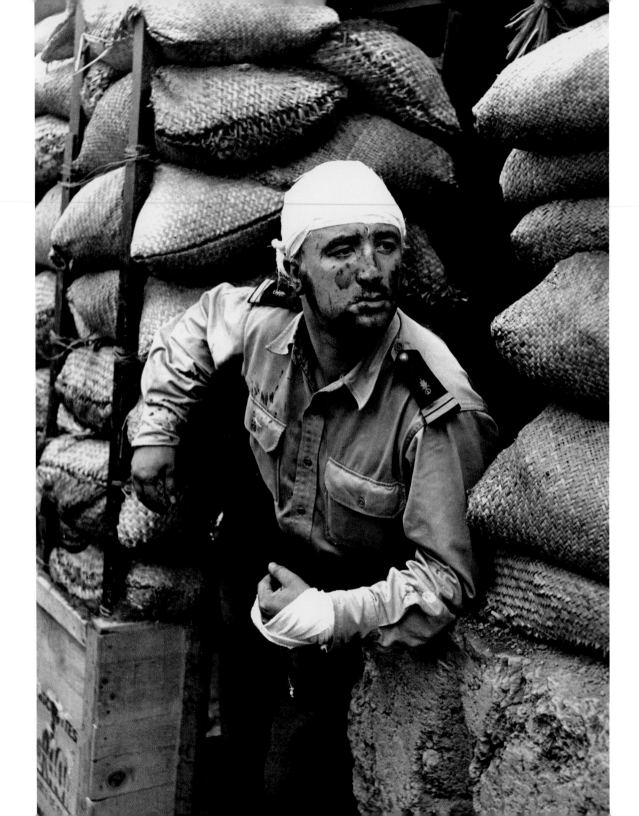

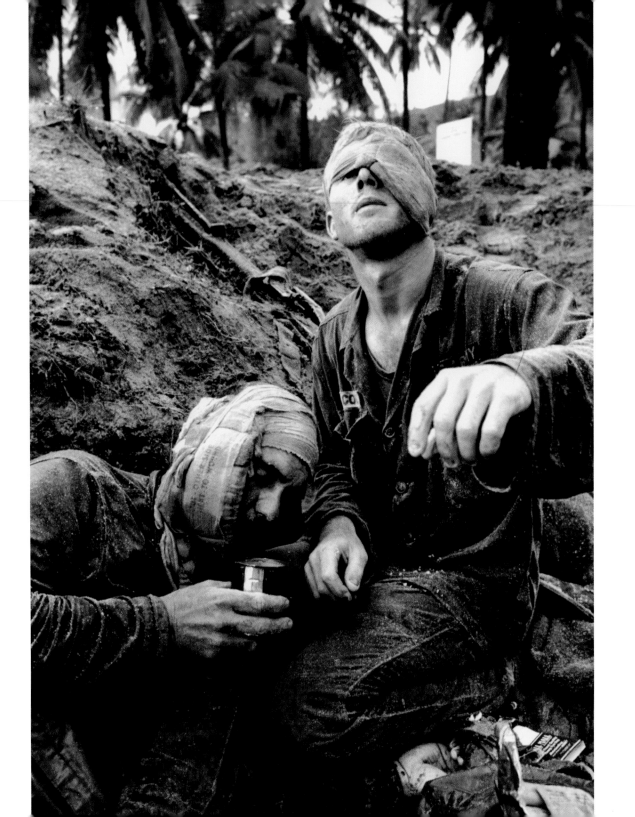

Henri Huet *photographer* / Jack Smith *writer*

SANDBAG FOR A MACHINE GUN

On the fourteenth of November, 1965, in the Ia Drang Valley a few miles from the Cambodian border, the 1st Battalion, 7th Cavalry Regiment landed on top of a North Vietnamese Army basin. A ferocious battle ensued that lasted three days.

I arrived on the last day of the battle. The NVA bodies were piled so thick around the foxholes you could walk on them for a hundred feet in some places. The next day, as my battalion, the 2/7, slipped through the jungle, we were jumped by a North Vietnamese formation—like us, about five hundred strong and mostly boys eighteen or nineteen years old. But they had been in-country for a year, and were much more skilled at fighting and killing. Hearing us coming, they quietly tied themselves up into the trees, and snuck close in the chest-high razor grass.

We were overwhelmed. Men rolled in the grass and stabbed at each other, gouged and punched, or blazed away at enemy soldiers a few feet away. I lay so close to a North Vietnamese machine gunner that I simply stuck out my rifle and blew off his head.

At one point in that awful afternoon, as my battalion was cut to pieces, a small group of enemy came upon me and, thinking I had been killed because I was covered in other people's blood, proceeded to use me as a sandbag for their machine gun. I pretended to be dead while a teenage enemy gunner with bony knees pressed against my sides. He didn't discover I was alive because he was trembling more than I was.

The gunner fired into the remnants of my company. My buddies fired back. I remember thinking, "Oh, my God. If I stand up, the North Vietnamese will kill me; if I stay lying down, my buddies will get me."

Before I went completely mad, a volley of grenades exploded on top of me, killing the enemy boy and injuring me. In the course of thirty hours I was wounded twice and thought myself dead. My company suffered 93 percent casualties. I watched all the friends I had in the world die. The battlefield was covered with blood, littered with body parts; it reeked of gunpowder and vomit.

For years, I had nightmares. I was sour on life—by turns angry, cynical, and alienated. Then one day I looked afresh at my scars, marveling not at the frailty of human flesh, but at the indomitable strength of the human spirit. I began to put the personal hurt behind me.

Ten years ago, with ten other Ia Drang veterans, I traveled back to the jungle in the Central Highlands, and for several days walked the battlefield. What struck me was the overwhelming peacefulness of the place, even in the clearing where I fought. I broke down several times. I wanted to bring back some shell casings—some physical evidence of the battle—to lay at the foot of The Wall in Washington. The forces of nature had erased all remnants of the carnage. Where grass had once been slippery with blood, now flowers bloomed. So I pressed some and brought them back.

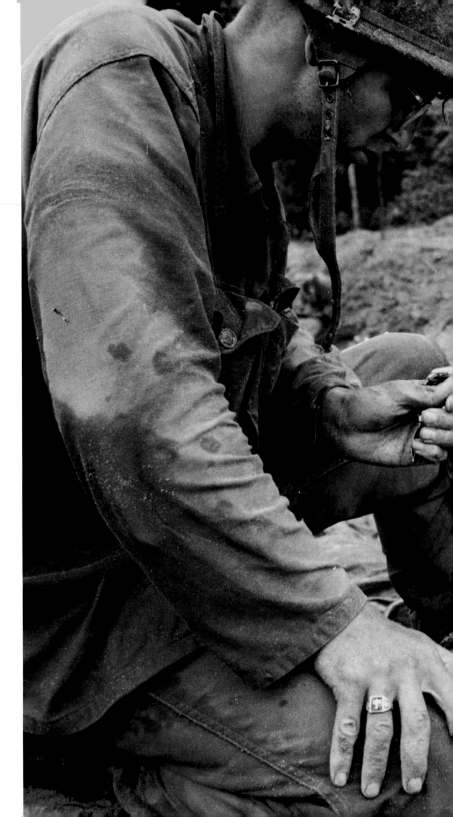

HENRI HUET was born of a French father and a Vietnamese mother in April 1927 in Da Lat, Vietnam. When he was a child, his family moved to France, but he returned to Vietnam from 1949 to 1952, during the first Indochina conflict, as a combat photographer with the French navy. He worked as a photographer for a U.S. government agency, and briefly for UPI in Saigon, before joining AP. In September 1967, Huet was awarded the Overseas Press Club's Robert Capa Award. Just over three years later, he was killed along with three other combat photographers when their helicopter was shot down over Laos. He was forty-three.

JACK SMITH was born in 1946 in Paris, France. During his twenty-six years with ABC, he won two Emmys, a Peabody, and numerous other awards. He was the host for TLC's award-winning series on the Vietnam War. A highly decorated Vietnam veteran, Smith was awarded both the Bronze Star with "V" for valor and the Purple Heart. In 1993 Jack Smith returned to the Vietnam battlefield where he was nearly killed in 1965 for a very memorable ABC News report. He died on April 7, 2004.

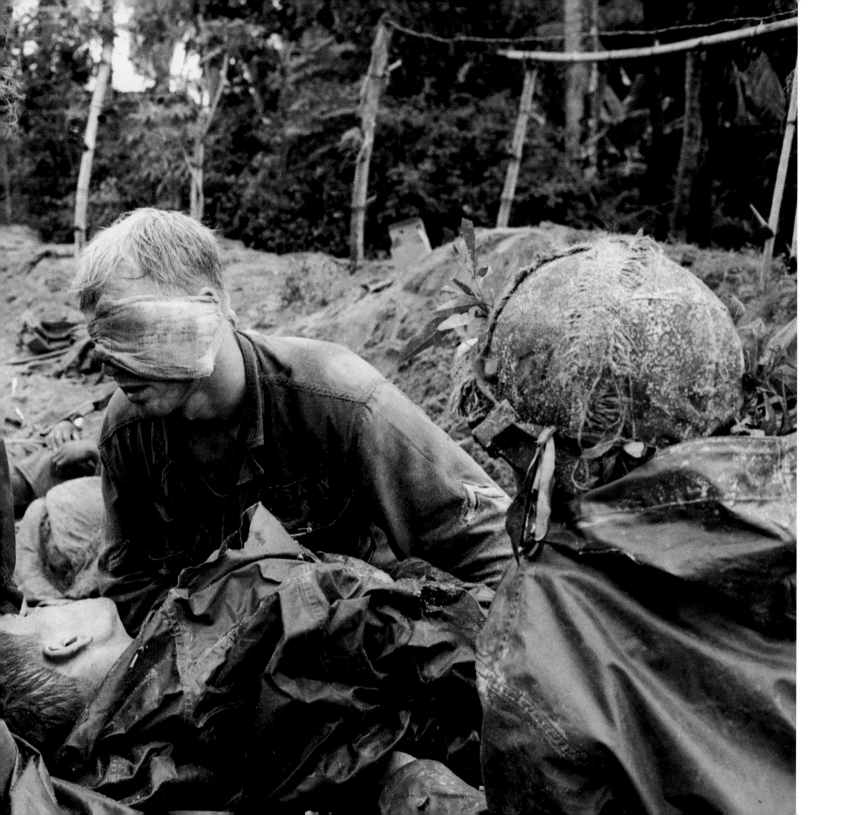

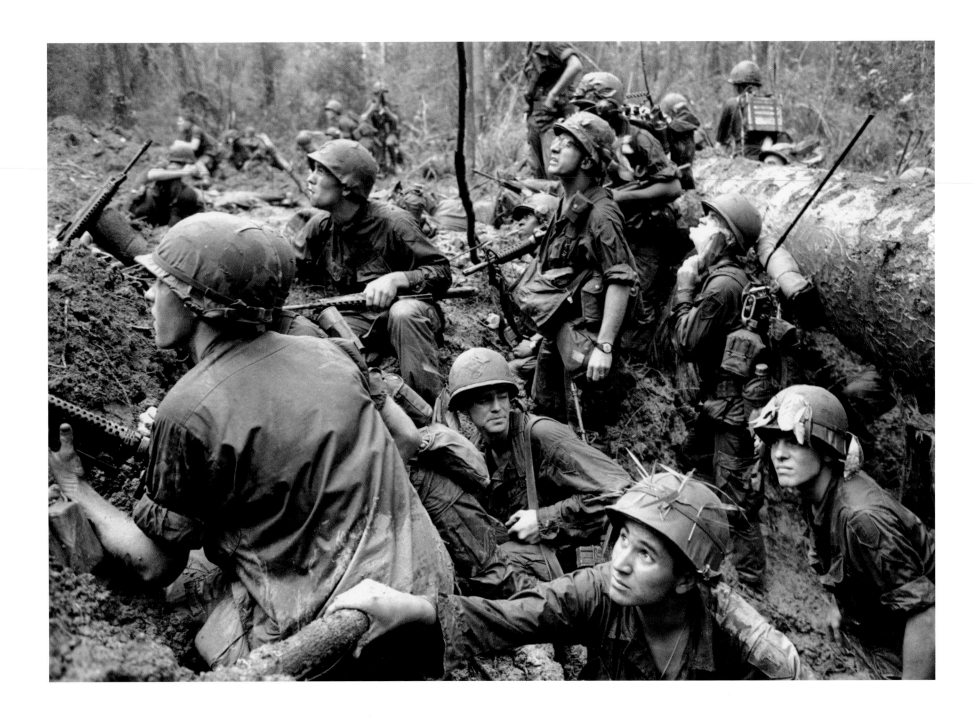

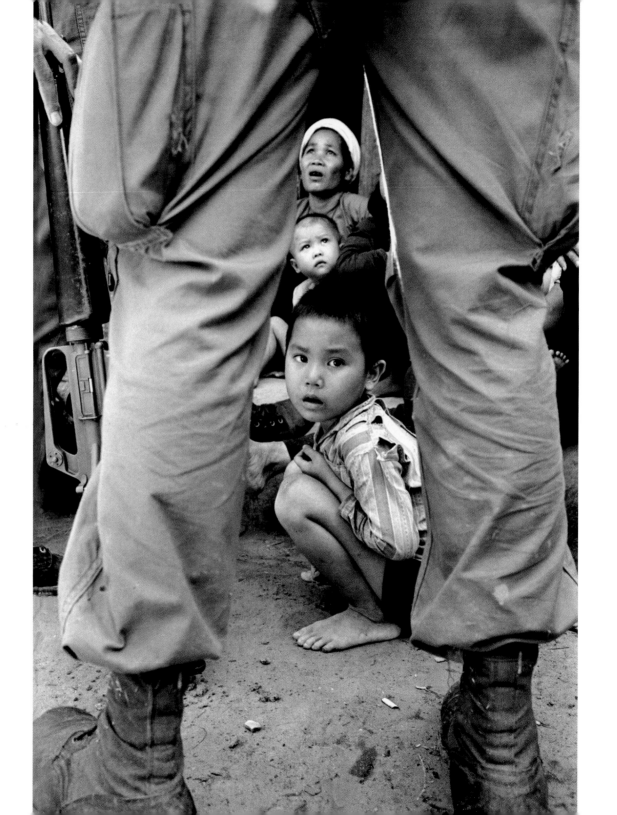

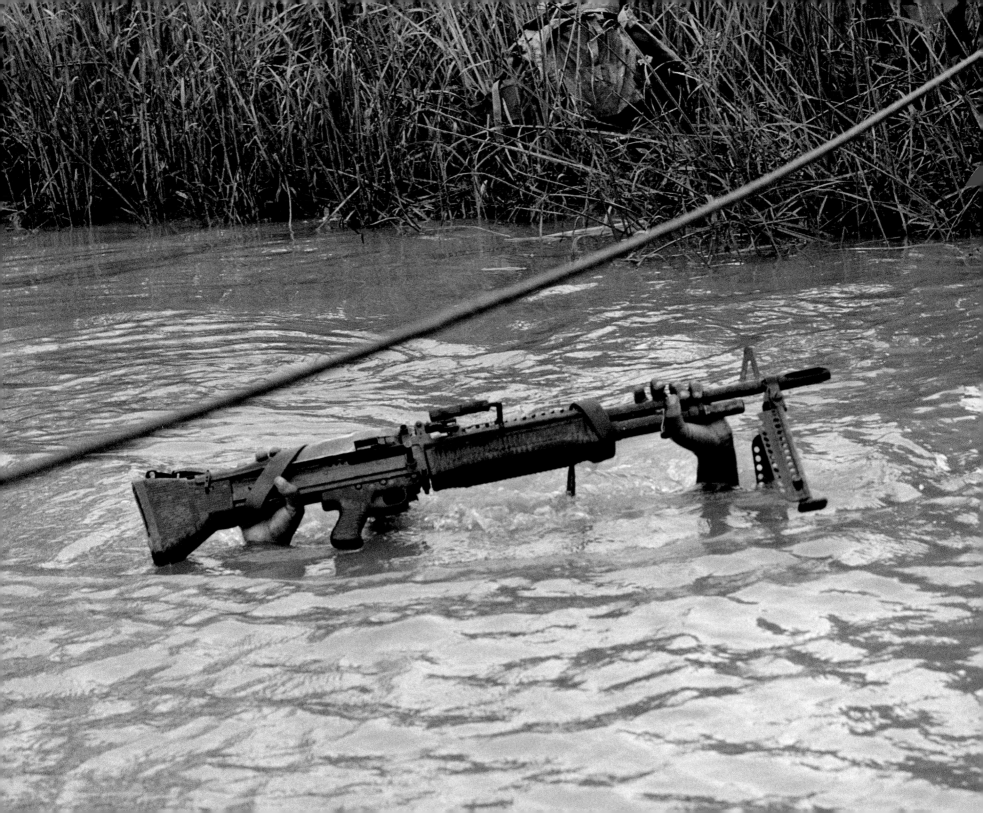

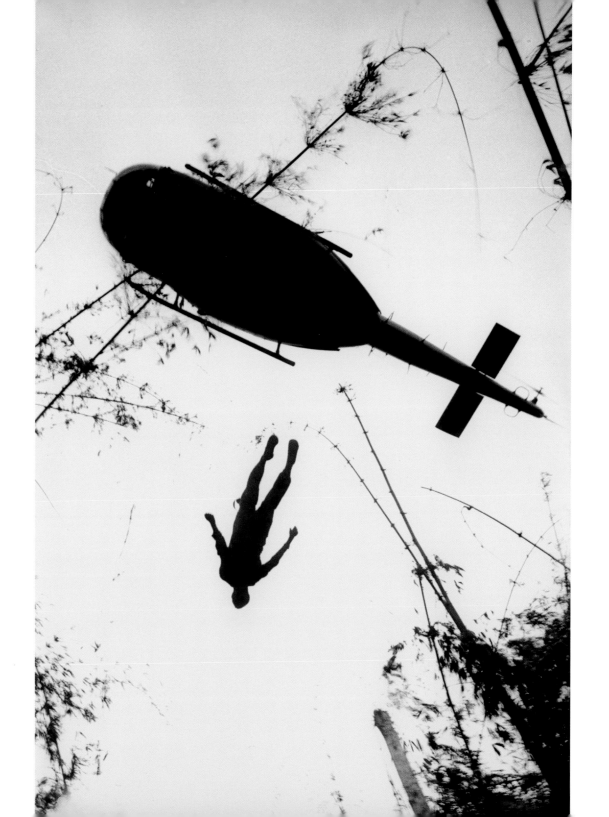

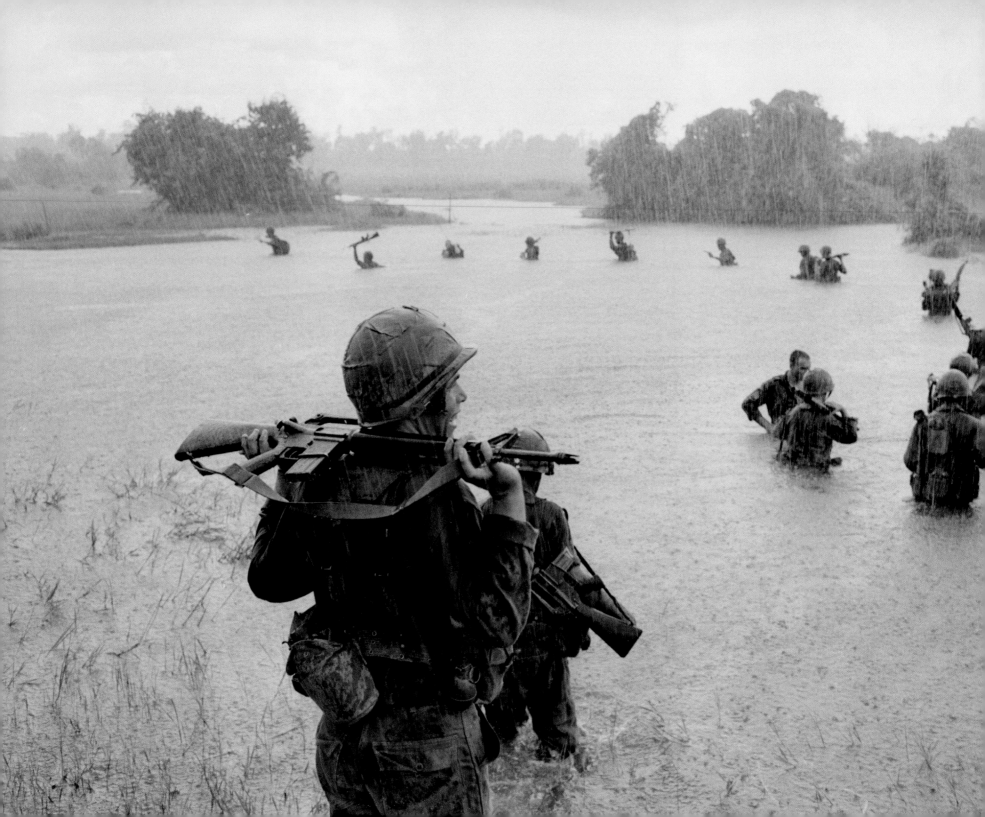

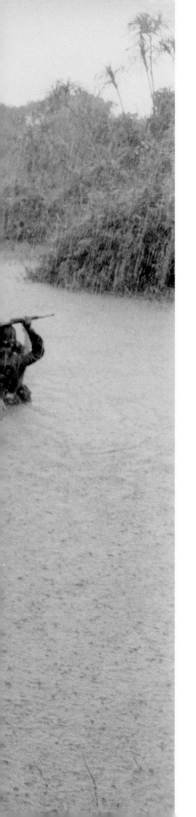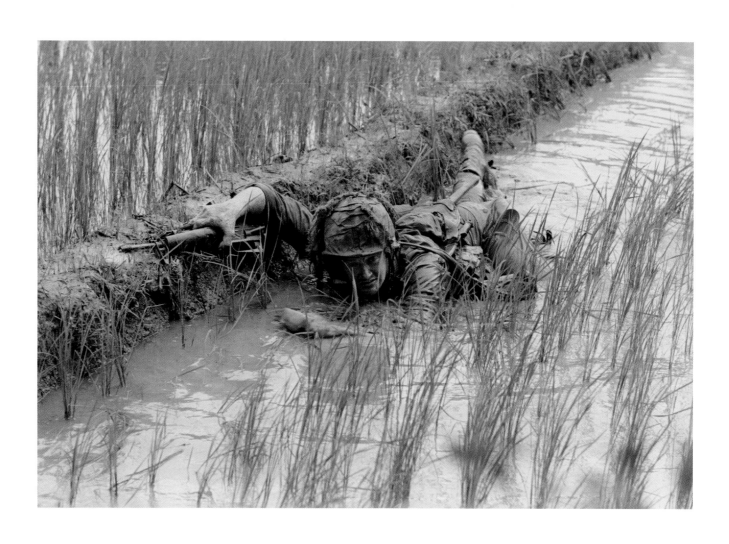

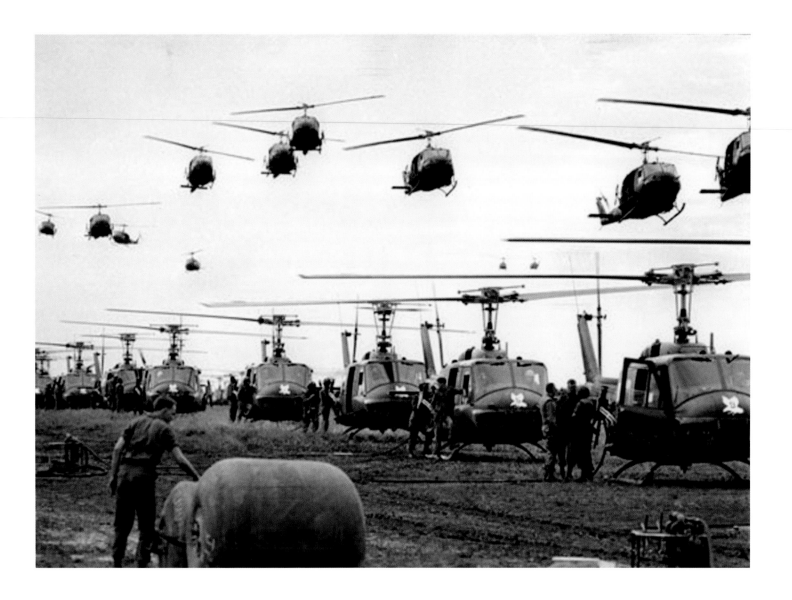

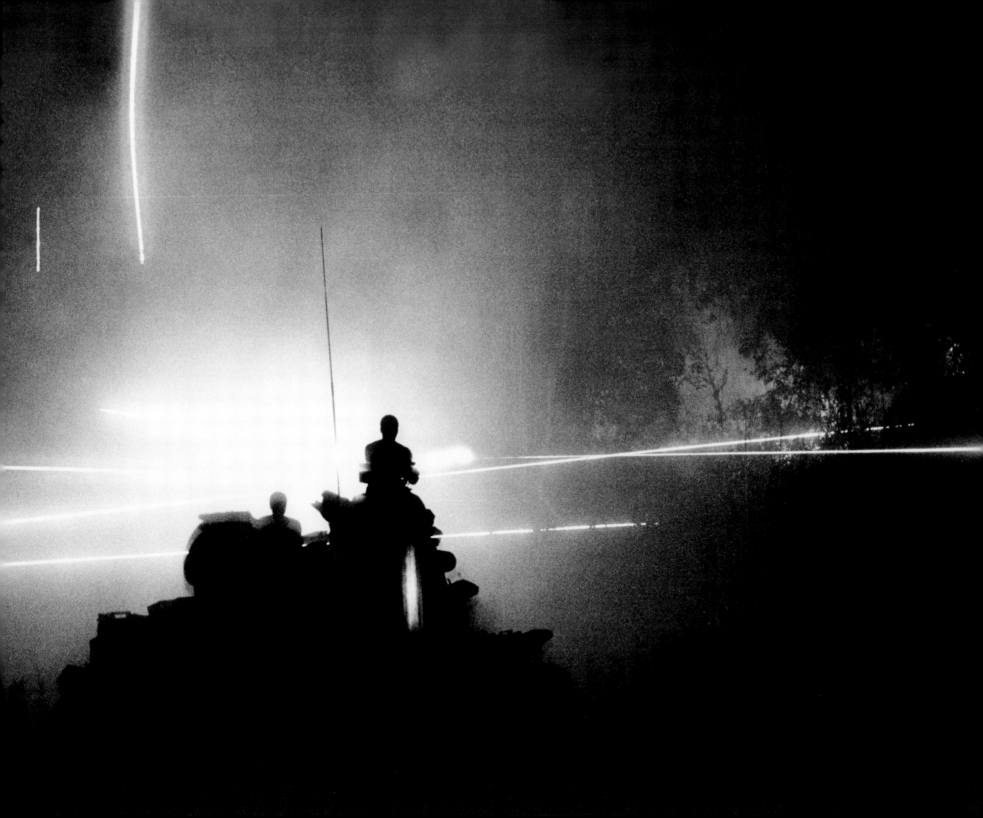

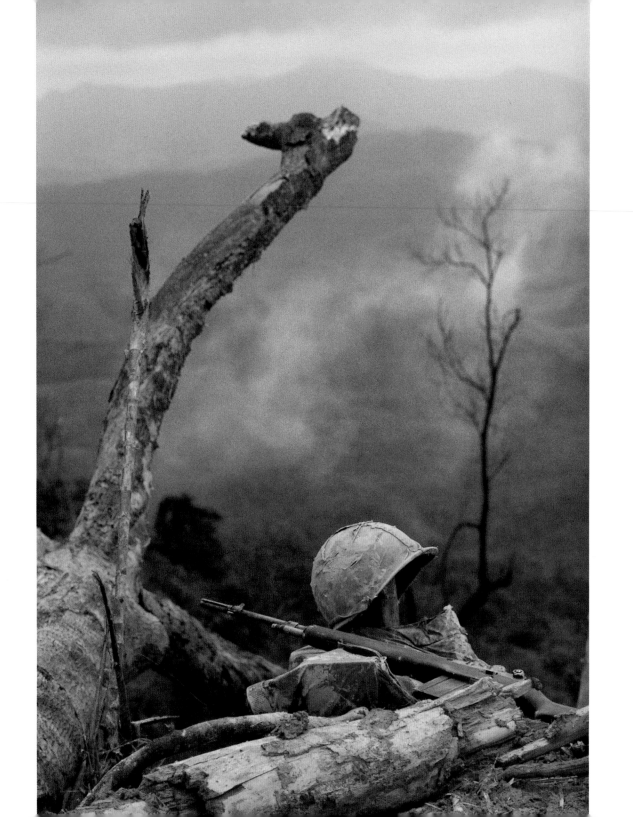

Larry Burrows *photographer* / David Halberstam *writer*

STILLNESS IN THE HIGHLANDS

The war has come, and then it has gone away; it will favor some other place tomorrow, designation still to be determined, a collision created by maps in two separate but adversarial headquarters, so that men who know nothing about each other will stumble into each other's paths in the most lethal way imaginable. But it is over now right here. The sudden explosion of noise, the violent chaos that comes when some tiny sliver of land becomes for a limited time the most contested and the most dangerous piece of real estate in the world, all that is finished. All the young men have already gone or are going. All those who can leave, that is. For some, it is the final destination.

What we are left with is a helmet and a rifle and the formidable backdrop of the highlands. Isn't the blue of the sky beautiful? How can you get a sky so blue on a day so harsh and cruel? Shouldn't the sky be darker? For sure, Larry—that is, Larry Burrows who took the photo—saw and understood how powerful the blue of the sky was at this moment, how important it was to complement the grim image in front of us. He saw it and understood it because he was as much artist as photographer.

What we are left with seems like the ultimate memorial to war; a huge military cemetery with row on row of crosses could not tell the story more eloquently. No wonder a great photographer like Larry took this photo. He had such a wonderful eye, and he was always framing things, taking images that seemed ordinary to others, and turning them into the extraordinary. He knew from the start what the war was and he knew what he was looking for every time he went out in the field, and then, when the image in front of him was right, he caught it. Because of his talents, he gave the transitory a certain permanence.

The moment thus could and would endure. The humanity of the photo is transcending, and yet it is important to remember when we look at it that there is no human being in this photo, no wounded soldier, no dead body sprawled in front of us. The humanity—it is really quite stunning—is in what is not there. The war has come and now the war is going away. No one will be here tomorrow. We are left with a helmet and a rifle and what looks like an instant marker for a grave. It will be silent here tomorrow. The war will have gone somewhere else. It will be someone else's turn.

LARRY BURROWS was born May 29, 1926, in London. His career as a photographer began in 1945. For *Life* magazine, he photographed Ernest Hemingway and Winston Churchill, as well as other celebrities and politicians. He also photographed the paintings that illustrated *Life*'s series on great art. He didn't like to be called a "war photographer," but spent much of his life on the battlefields of the Congo, the Middle East, and Vietnam. Three-time winner of the Overseas Press Club's Robert Capa Award, he was named Photographer of the Year by the Missouri School of Journalism. On February 10, 1971, Burrows and Kent Potter of UPI, Keizaburo Shimamoto of *Newsweek,* and Henri Huet of AP were on board a helicopter headed into Laos. The pilot, lost in inclement weather, flew over an enemy position and they were shot down.

Born April 10, 1934, in New York, DAVID HALBERSTAM is one of America's most distinguished journalists and historians, a man whose writing has helped define the era in which we live. After graduating in 1955 from Harvard, he took his first job on the smallest daily in Mississippi, then he covered the early civil rights struggle for *The Tennessean*. He joined *The New York Times* in 1960, going overseas almost immediately, first to the Congo and then to Vietnam. His early pessimistic dispatches from Vietnam won him the Pulitzer Prize in 1964 at the age of thirty. His last twelve books have all been national bestsellers, including *The Best and the Brightest, The Powers That Be, The Reckoning, The Fifties,* and *War in a Time of Peace.* He is a member of the elective Society of American Historians.

LARRY BURROWS

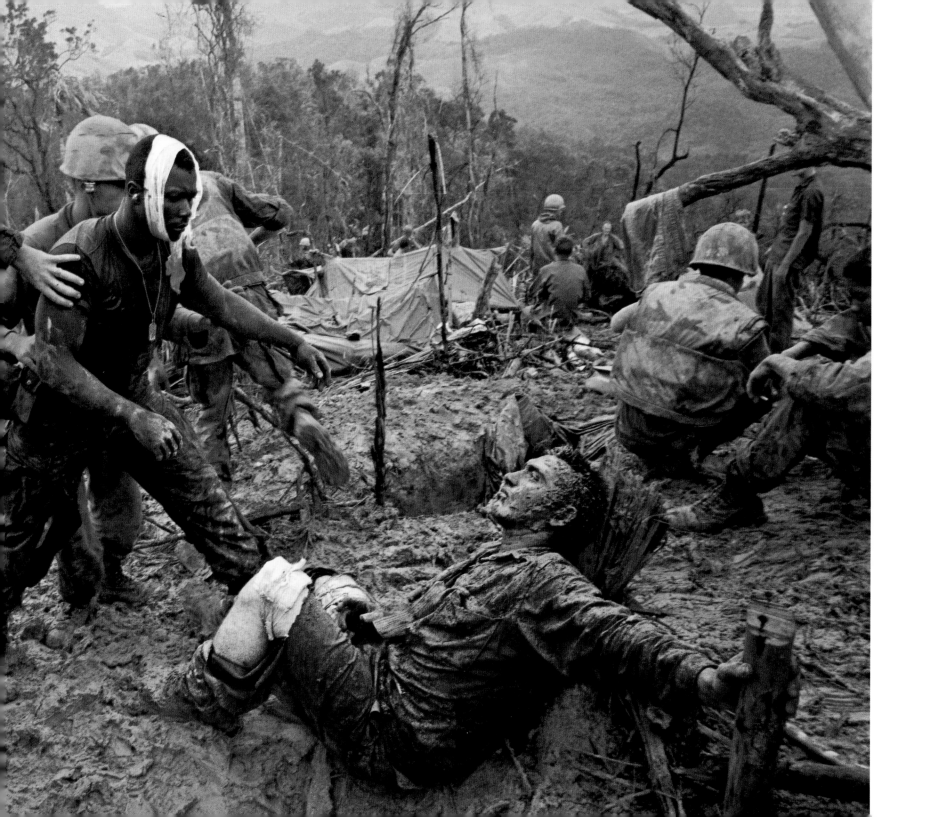

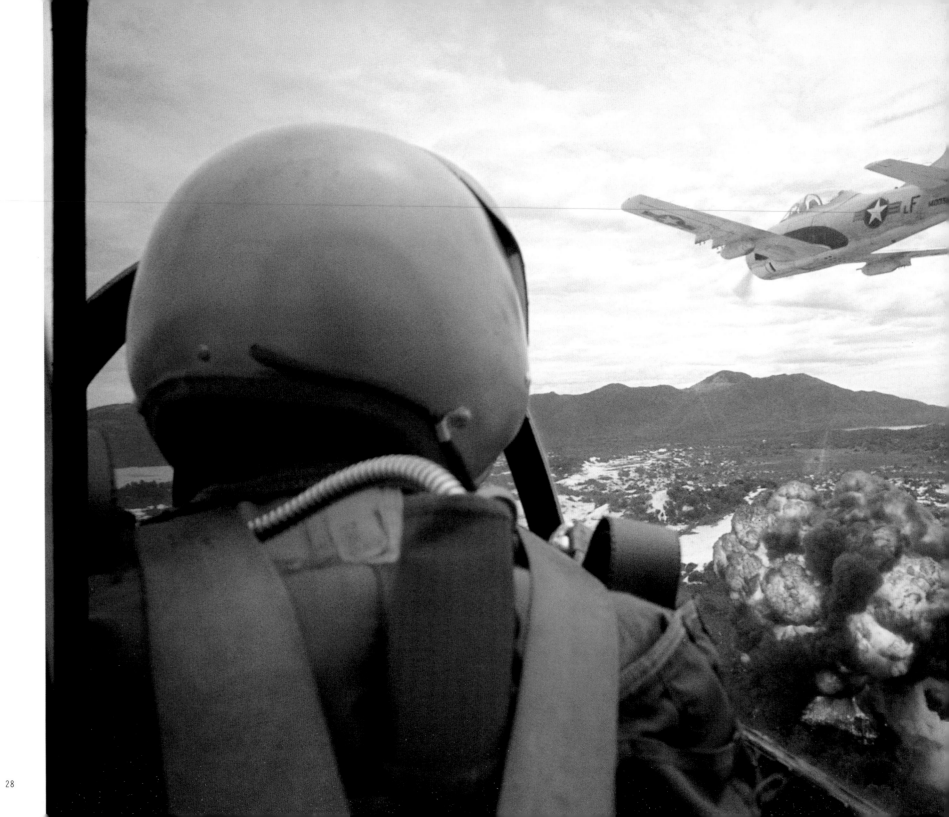

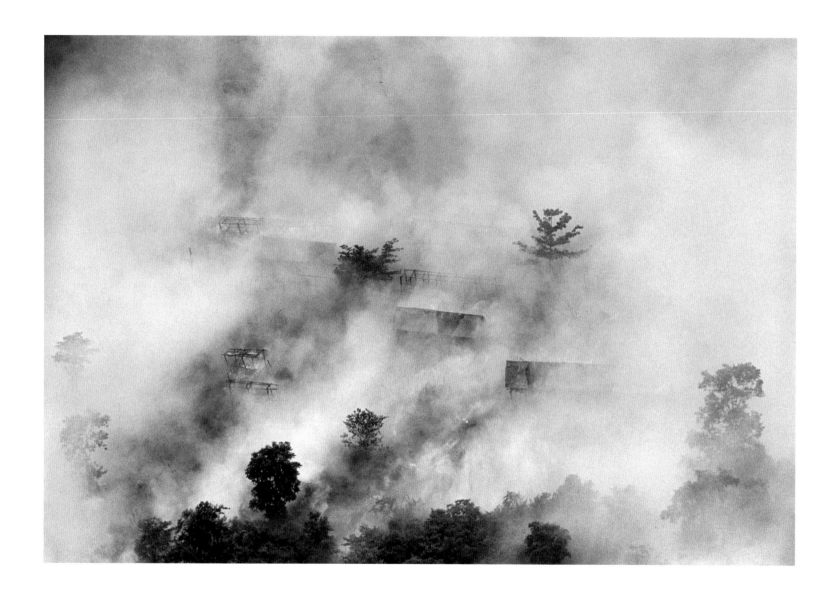

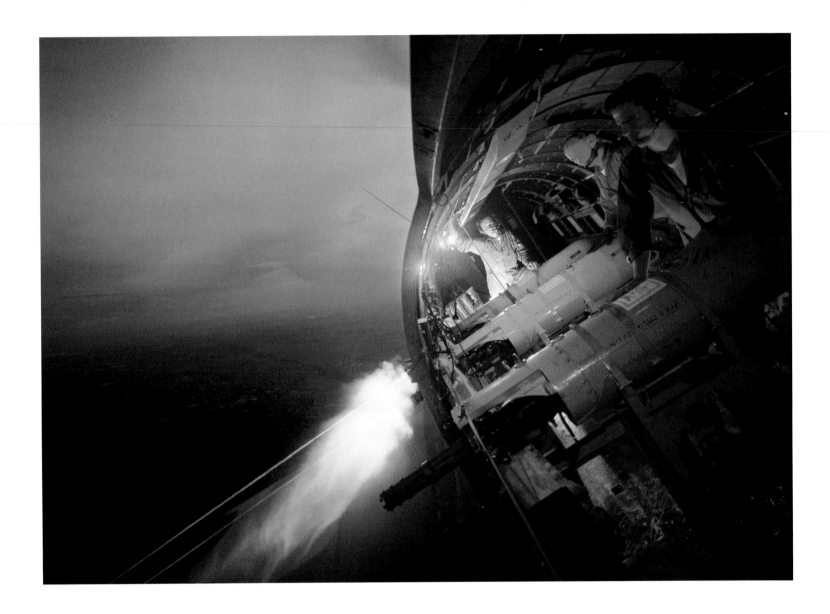

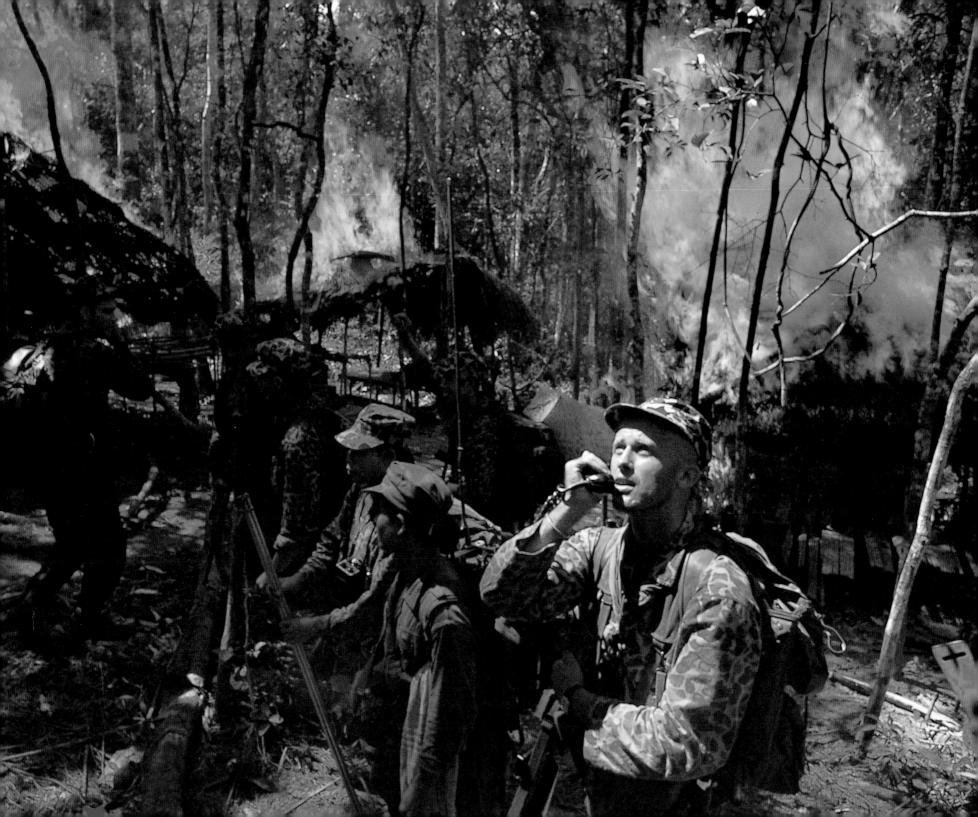

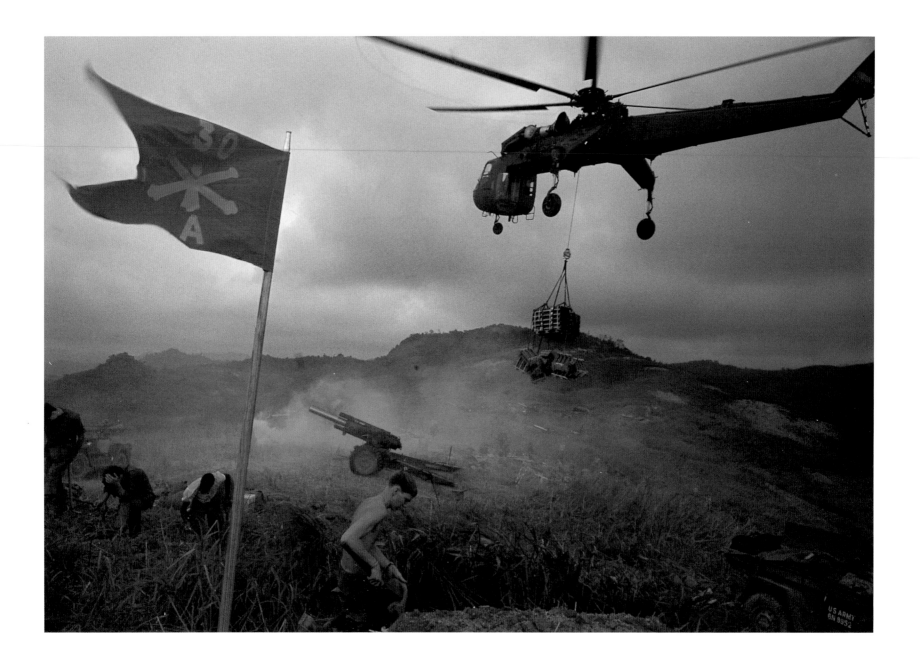

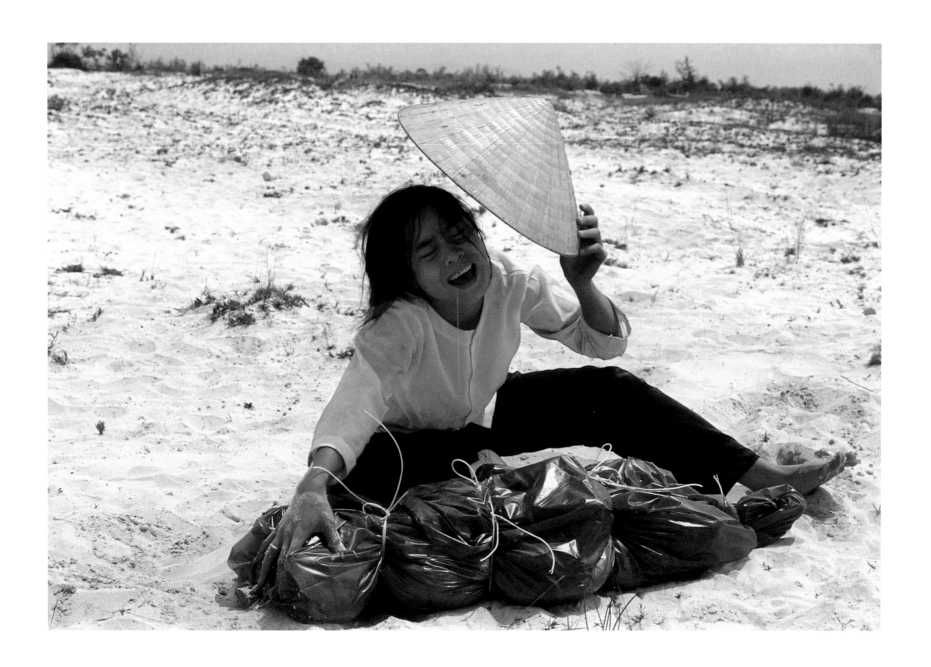

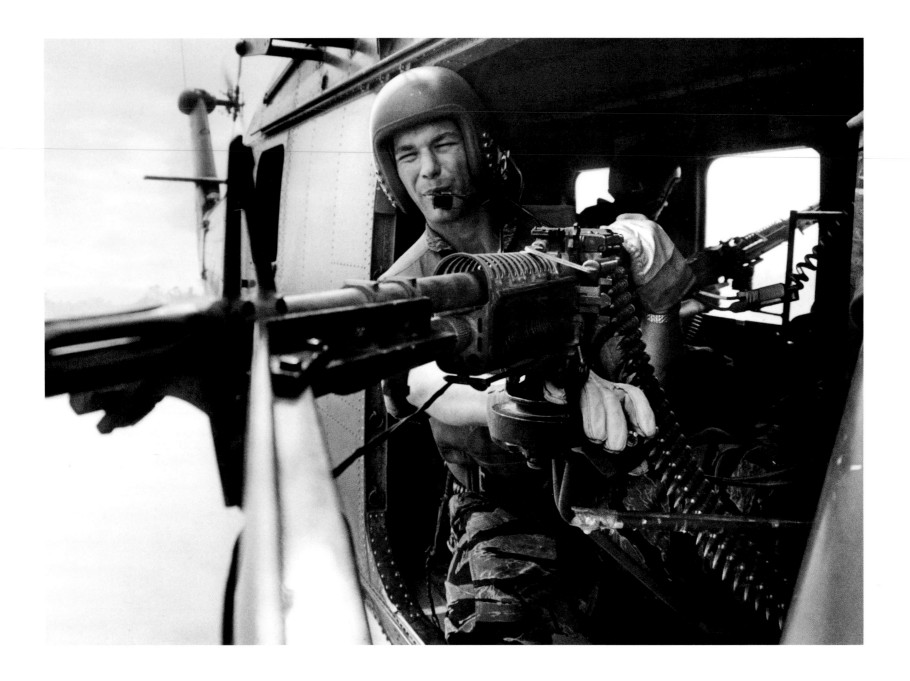

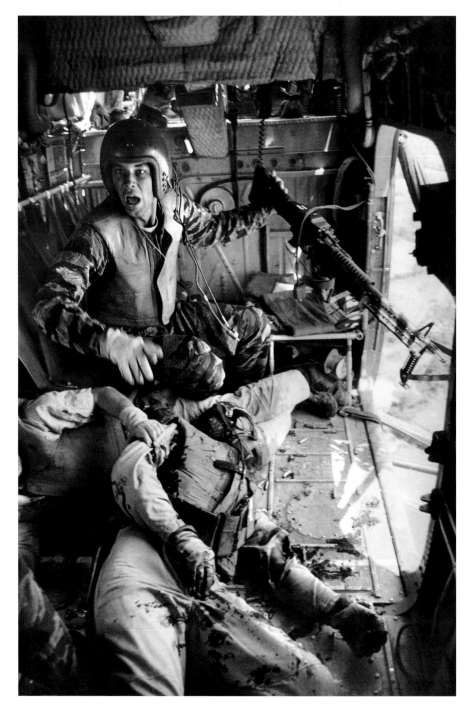

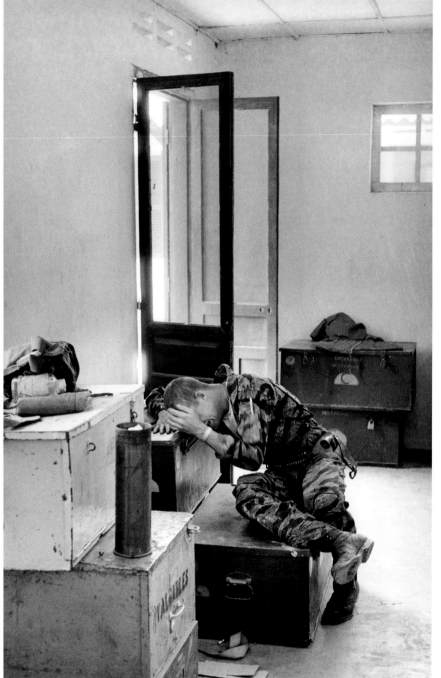

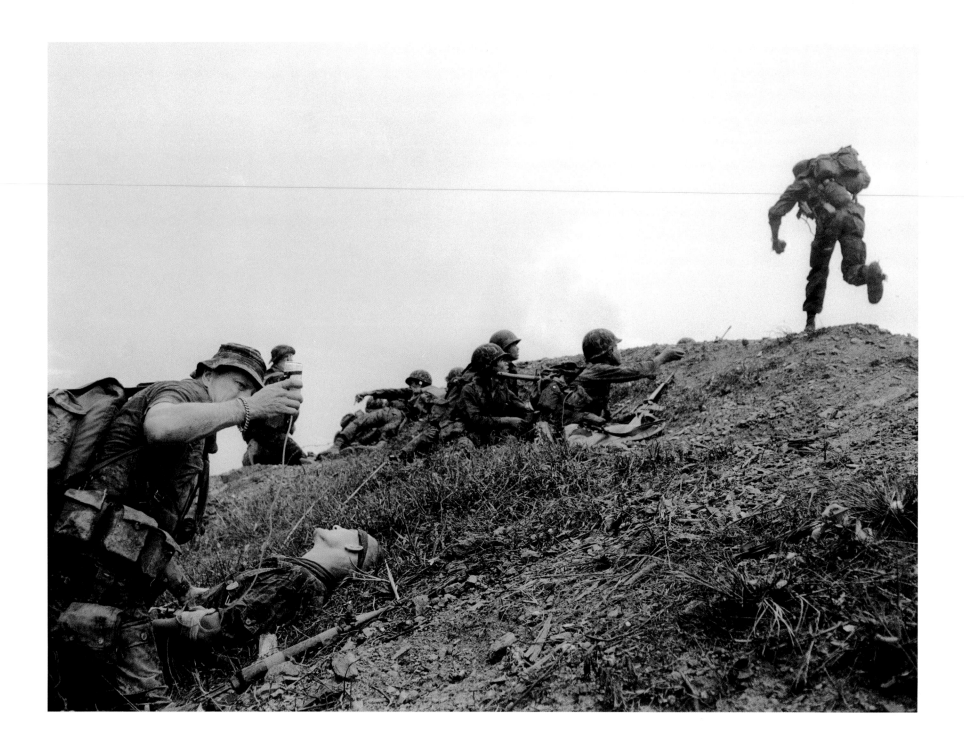

Dana Stone *photographer* / Jack Fuller *writer*

ONE MAN IS DOWN

One man is down. Another is up. One man wounded, clenched with pain. The other man's hand clenched around a grenade as he heads for the crest of a hill.

Something on the other side of that hill has pinned the unit down. The man with the grenade runs toward it, silhouetted against a perfectly blank sky. What the camera does not see is what snaps invisibly through that emptiness. But the men on their bellies know. The photographer knows. A brave man, he is on his belly, too, because he knows. The air is alive with death. Dana Stone's photograph reminds me of some of Robert Capa's great work. One moment in a war: stark, pure, uncomposed. The plainness of the dark, scattered earth. The empty abyss of the sky. The utter randomness: One man is down. Another is up. Their places could have been reversed. They could have been anyone. They could have been you or me. But you were not there, and I wasn't there.

We did not know how it felt that day to have only the fragile slope of the hill protecting us from what was on the other side. We did not hear the bullets cracking through the empty air or wonder when one of the enemy soldiers on the other side of the hill would rise up and lob a grenade into our midst. But if we had been there, we would have hoped beyond reckoning that someone among us would stand up, clench a grenade, run to the crest with it. Maybe the one who stood up would have been you. This is something that can only be known in the moment, then never forgotten by those who survived.

Yet for all the rest of us, this overwhelming moment might have been just one more terrible event in a multitude of such events that made up one long and agonizing but relatively small-scale war. For us, it would have been as if the thing had never happened, preserved if at all by a few names etched into a dark wall. Yes, of course, men stood. Men fell. Men survived. Men died. And life goes on.

Had Dana Stone not been on that hillside, the moment would have been lost. One man was down. One was up. And the third, he bore witness so that in some small, inadequate way we might know the moment, too.

DANA STONE was born on April 18, 1939, in North Pomfret, Vermont. Buying his own ticket to Vietnam in 1966, he worked there as a stringer for AP. Two years later, Stone and his wife left Saigon for Europe, returning to Vietnam in 1971 for UPI and CBS. While working as a cameraman for CBS, he vanished on April 6, 1970, on Route 1 in Cambodia—a day after Gilles Caron's disappearance. His work is displayed in the award-winning book *Requiem*.

Born on October 12, 1946, in Chicago, Illinois, JACK FULLER started as a copyboy at the *Chicago Tribune* when he was sixteen. In 1969 and 1970, he was enlisted in the United States Army, where he served a stint as a Vietnam correspondent for *Pacific Stars and Stripes*. He returned to the *Tribune,* where, as editor of the newspaper's editorial page, he won the Pulitzer Prize in 1986. He became president of Tribune Publishing in May 1997 and joined the board of directors in 2001. Fuller holds a bachelor's degree in journalism from Northwestern University. He is the author of *News Values: Ideas for an Information Age* and six novels: *Convergence, Fragments, Mass, Our Father's Shadows, Legends' End,* and *The Best of Jackson Payne.*

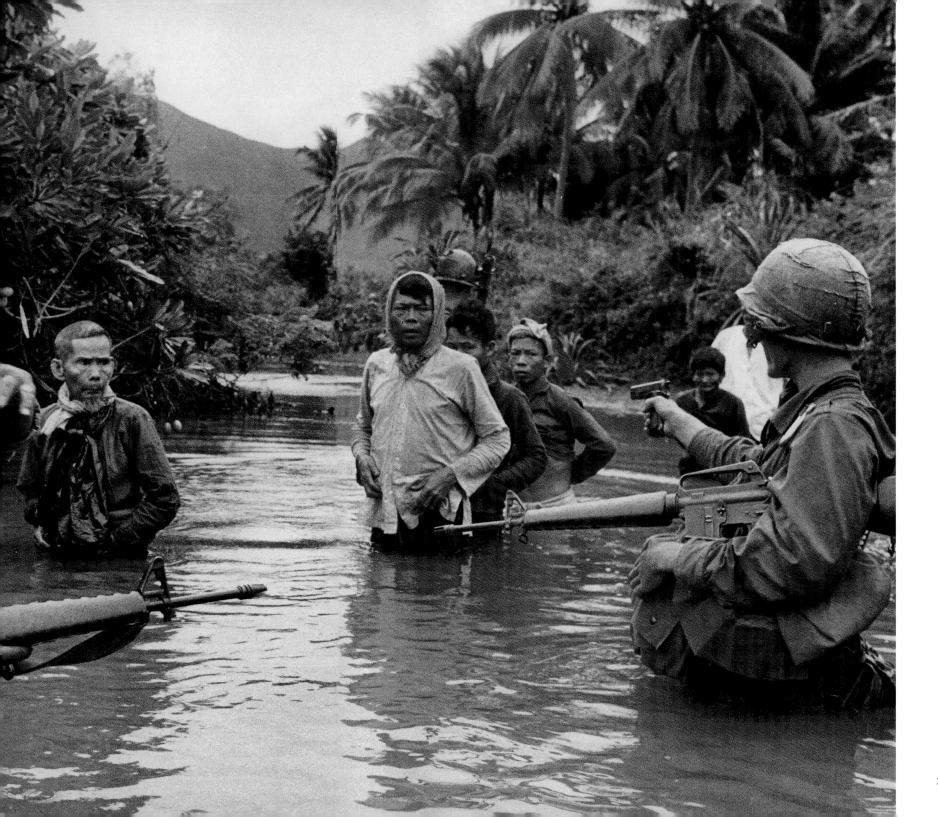

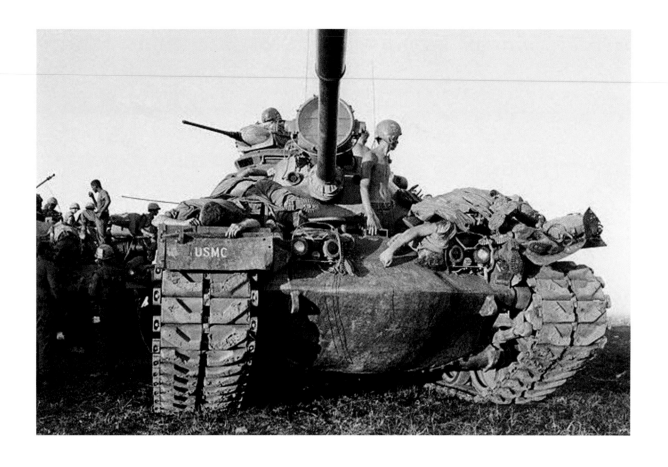

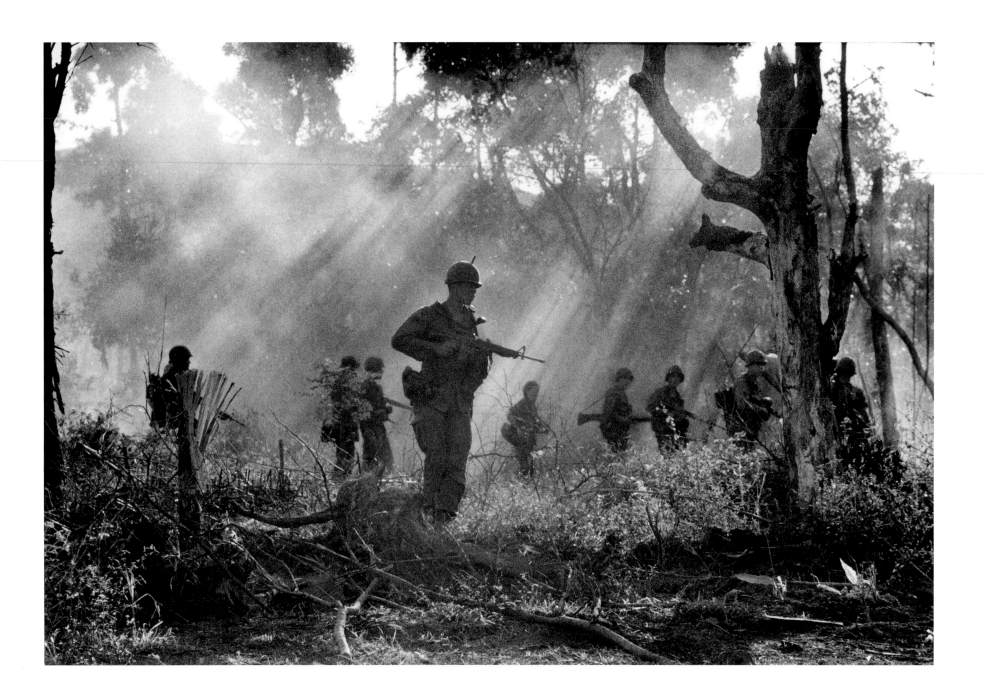

Gilles Caron *photographer* / Jean-Claude Guillebaud *writer*

BEYOND THE EDGE

How could we communicate that? Up against this light and shade in the jungle photographed by Gilles Caron, the soldiers' shadows seem petrified by the rays of light. From this angle, we catch a glimpse of what connects us to Vietnam.

And by this, I refer not to the war itself, but to beauty.

We never look at these photographs without thinking about it. In compositions of black and white, and in the sensitivity of the framing, we see, as did these soldiers of the 173d Airborne, some of the moving Vietnamese "thread." It starts just behind the trees, we are sure.

A thread? Oh, yes! The infinity of the rice paddies framed by cumulus-spotted mountains, their meticulous division into bee cells which, inch by inch, disciplined earth and water as far as the horizon. This grid of clay embankments where women toddle along, shoulders bent under the weight of balancing poles. Gestures, rhythms. The irrigation buckets held by two men facing each other, swinging in cadence at the extremity of a rope. The splashing made by harnessed water buffalo immersed in water.

Other water buffalo—monstrous clay statues shelled with dry mud—follow children leading them by the nostrils. Or they squat on their backbones like Hindu *mahout*. A flotilla of ducks sails surely over rivers and ponds by the thousands.

In Vietnam, whether on the road or in the jungle, soldiers sometimes came so close to houses that they stumbled onto the intimacy of family life: mud walls, straw huts under the watch of a barefoot grandmother, small yards with dozing oxen under the shade of latania palms.

Women raised up, a hand on the hip, throwing back their conical hats on the nape of the neck. The gesture, beautiful. This archaic and peaceful universe repeats itself for miles without beginning or ending. There is only the passage from day to night, scintillant intervals or, as in this photograph, the interplay between light and shadow. The indestructible Vietnamese identity endures; the substance escaping the storm, the reserve for the tomorrows of history.

GILLES CARON was born in 1939 of a half-Scottish mother and a French father in Neuilly, France. In 1967, he co-founded the Gamma photo agency. Dubbed "the French Robert Capa" by Henri Cartier-Bresson, Caron covered conflicts in Israel, Vietnam, and Biafra, as well as the May 1968 student demonstrations in Paris, riots in Northern Ireland, anti-Soviet upheaval in Prague, and the 1970 Toubou rebellion against the central government in Chad. On April 4 of that year, Caron disappeared in a Khmer Rouge–controlled area of Cambodia near Phnom Penh, never to be seen again. His wife, Marianne, and his two daughters live in France.

Born in France in 1944, JEAN-CLAUDE GUILLEBAUD is an author, editor, and essayist. For three decades, he has been a foreign correspondent for *Le Monde,* and has covered the Vietnam War, the Iranian and Ethiopian revolutions, the Yom Kippur War, the Lebanese civil war, and the wars of the former Yugoslavia. He has traveled extensively in Southeast Asia, Africa, the Middle East, and the former Soviet republics. Among his thirty published books are seven travel books. His work *The Hill of Angels: Return to Vietnam,* with photographer Raymond Depardon, was translated into English in 1994.

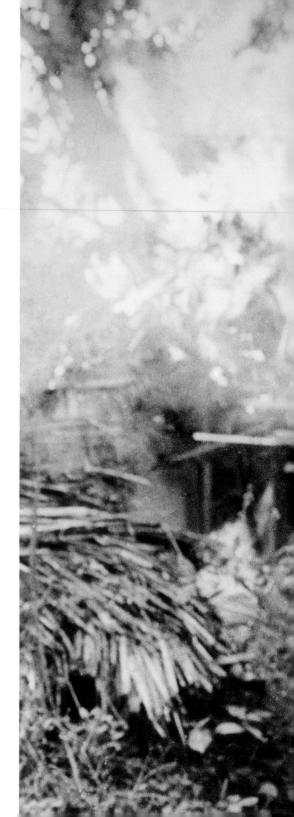

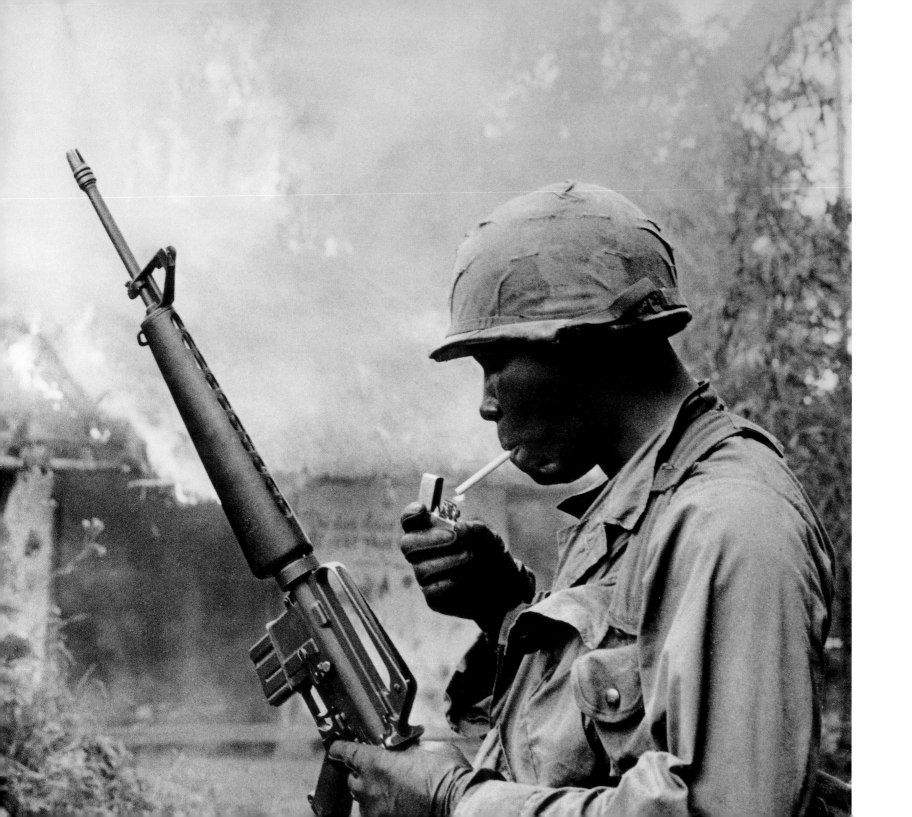

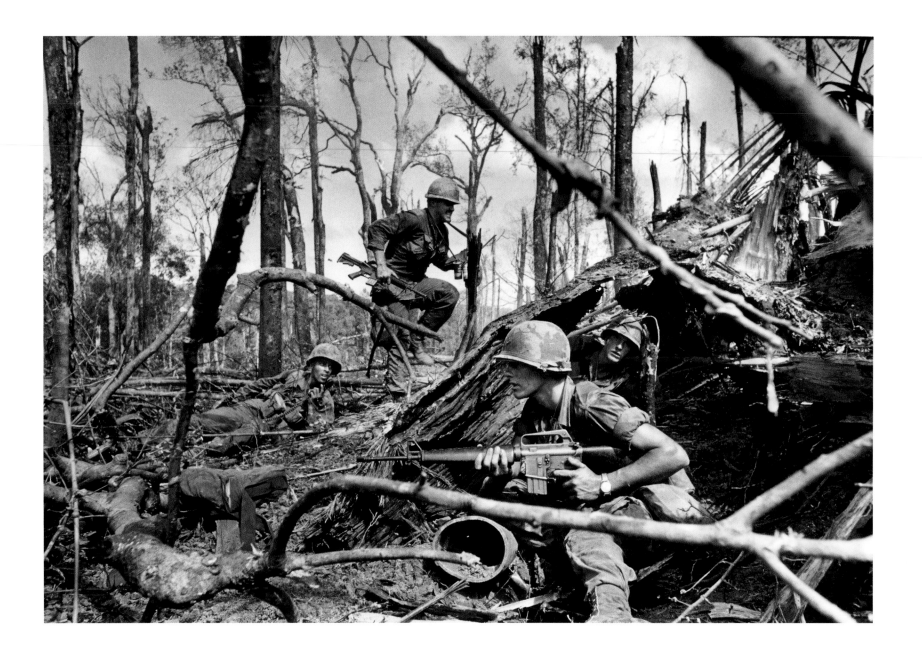

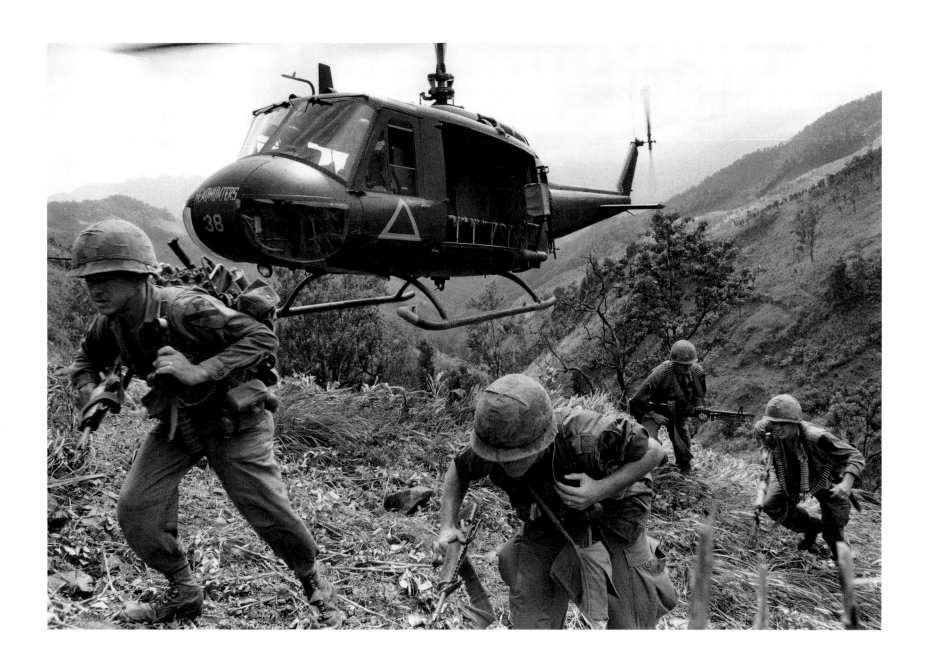

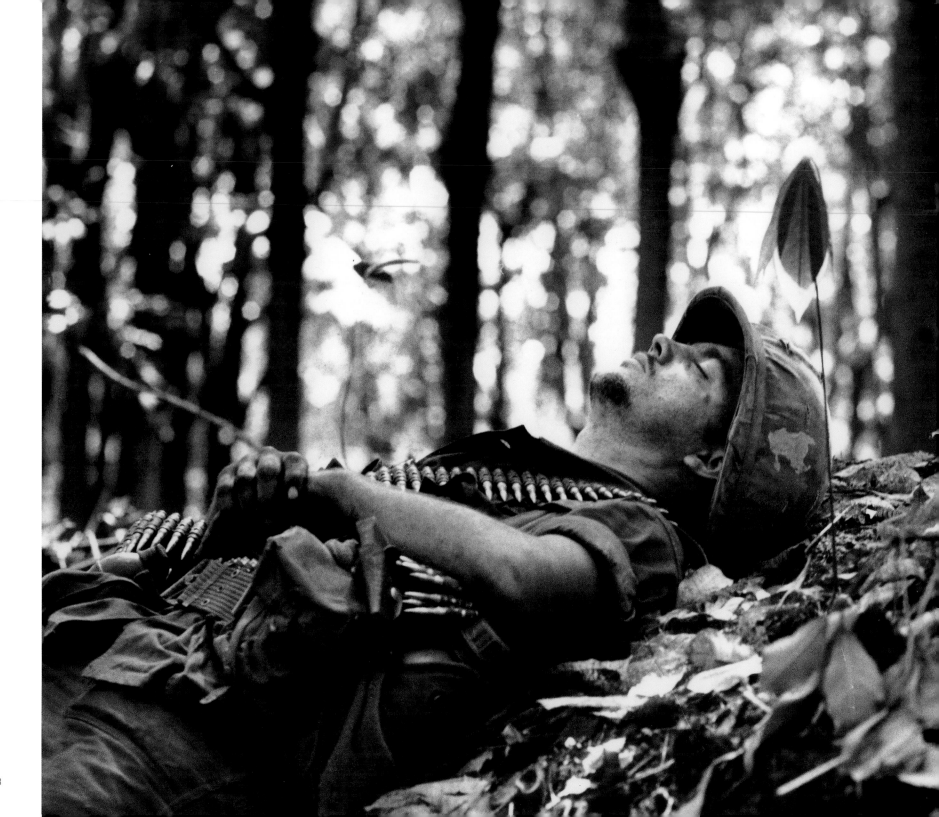

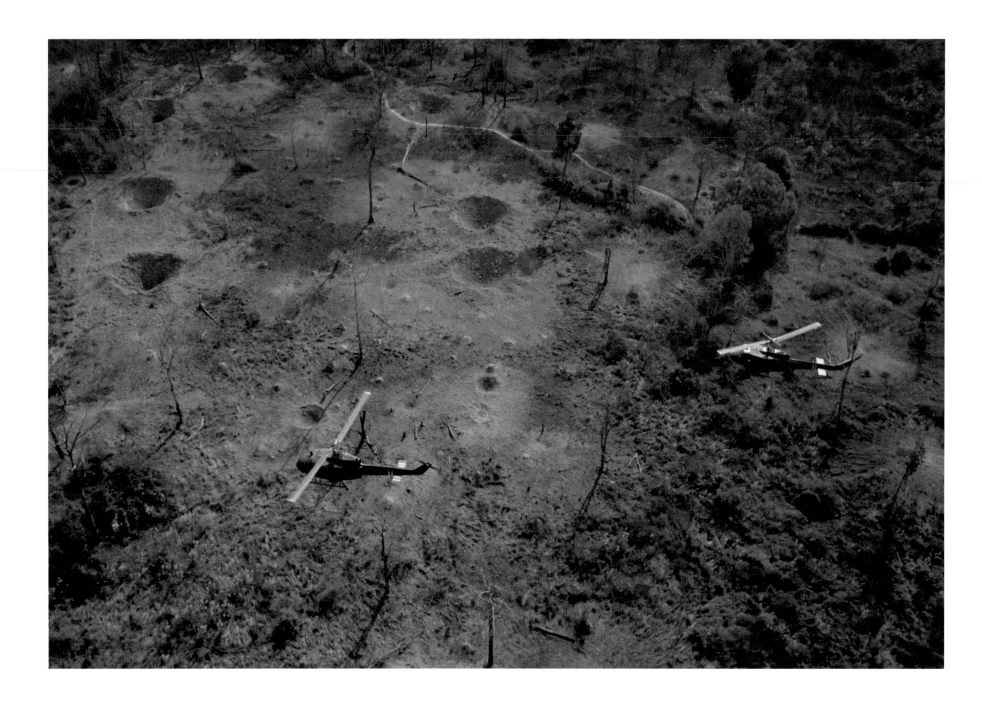

Dick Swanson *photographer* / George Evans *writer*

LANDSCAPE WITH FIGURES

A giant passed this way, its footsteps leaving craters where children will swim during rain season and lovers bathe in secret when the jungle grows back.

There is Vietnam the war and Viet Nam the country. One word and two. Different things. This image contains both. What was done to this land in the name of abstractions was felt by its people as pain.

Always when people are told they are to be saved, they shiver, their skin crawls, they bury their possessions and fear for their children, wondering where to hide them until the giant passes, and weep anxiously in their beds. They know days are coming when some will have only the weeping of graves. They have religions, and some have always prepared for death, but none want it, no one voluntarily wants that silence.

We will save you from yourselves, the giants say. So the people prepare to die. They may all rise up to defend themselves from being saved, but still they prepare to die.

A dirt road threads from the upper right out of dense brush, weaving through a burst of trees across the landscape in a scar above the ruins. Just before it curves upward and disappears into jungle, there's a T formed by a trail dropping to a tree shadow or log or trench, and at the top of it, to the right, a lone figure stands looking down at the shadow or log or trench, then out at the jungle flesh peeled and blown and burned from the skull of earth, then up at the metal hummingbirds, territorial like their avian models. He is holding a weapon smaller than noise, smaller than his dreams, and his hand is frozen on the trigger. He is frozen in time, in a moment that won't come again but will not stop being, however much he wants to be transported to another time, a time when he walked that thread with joss sticks to visit ancestors, a boy who believed in everything.

Born in 1934 in Monmouth, Illinois, DICK SWANSON went to Vietnam in 1966. He stayed five years on contract for *Life,* then moved to Washington, D.C., where he was their White House photographer. He has filed over 500 stories for Time-Life and has worked for *Time, People, Money,* and *Fortune.* In addition, during the 1980s Swanson freelanced for *National Geographic.* His photographs have won awards from the World Press, National Press Photographers Association, and the White House Press Photographers' Association. He also received the prestigious Page One Award. The Center for American History at the University of Texas at Austin currently holds Swanson's archive, spanning thirty-five years in forty countries and including some 100,000 photographs.

GEORGE EVANS was born on June 21, 1948, in Pittsburgh, Pennsylvania. He enlisted in Vietnam as a medical corpsman in the U.S. Air Force hospital at Cam Ranh Bay. A graduate of Johns Hopkins University, Evans has authored five books of poetry published in the United States and England, including *The New World* and *Sudden Dreams.* He has received writing fellowships from the National Endowment for the Arts, the California Arts Council, and the Lannan Foundation, and a Monbusho fellowship from the Japanese government for the study of Japanese poetry. He is the founder and editor of the *Streetfare Journal,* which displays contemporary world poetry and photography on buses in cities throughout the United States.

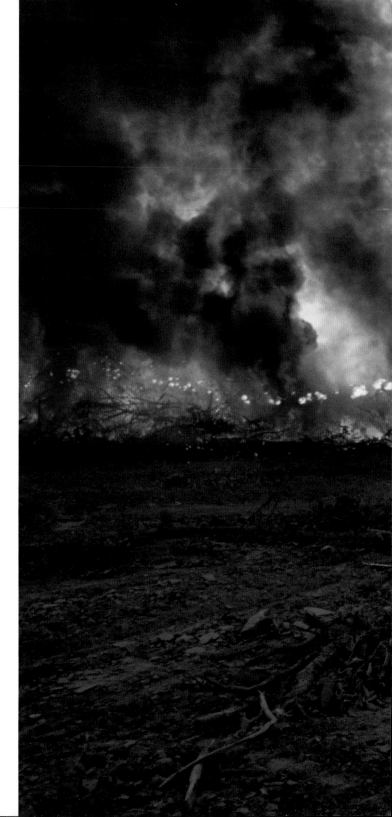

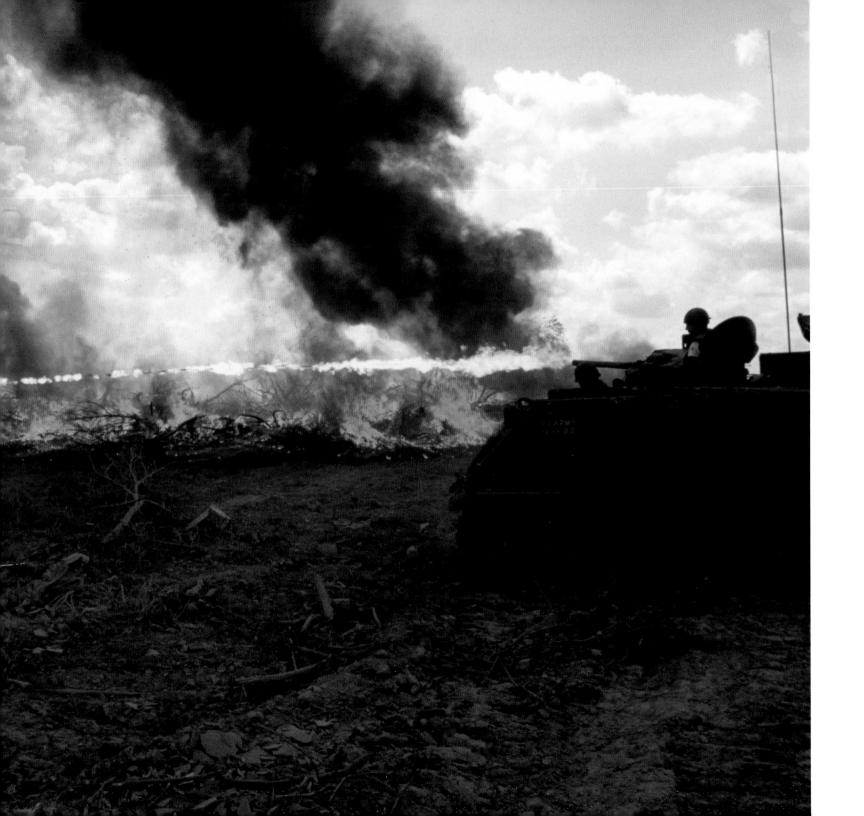

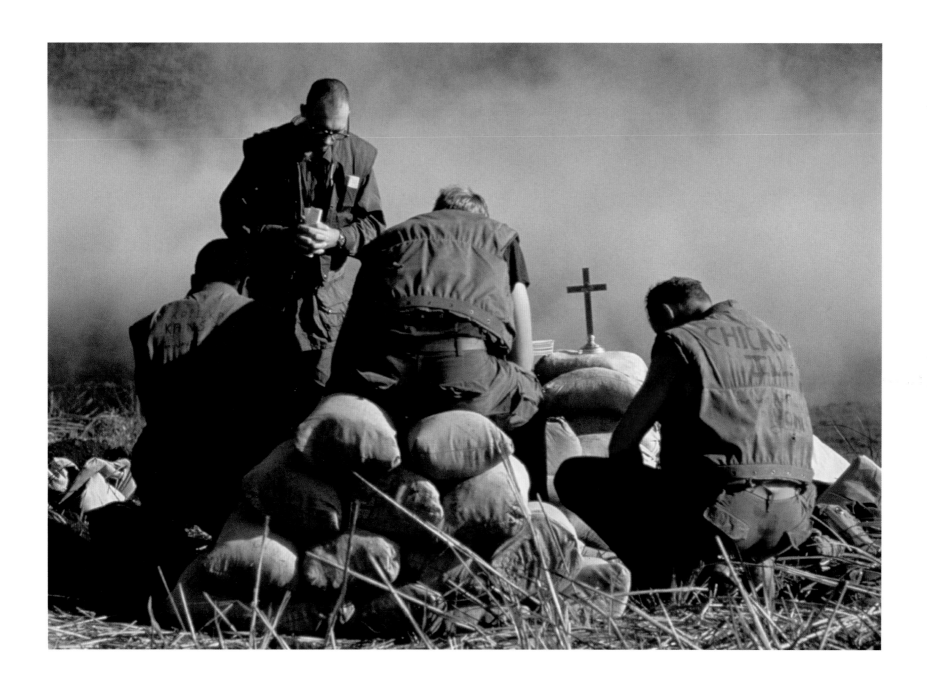

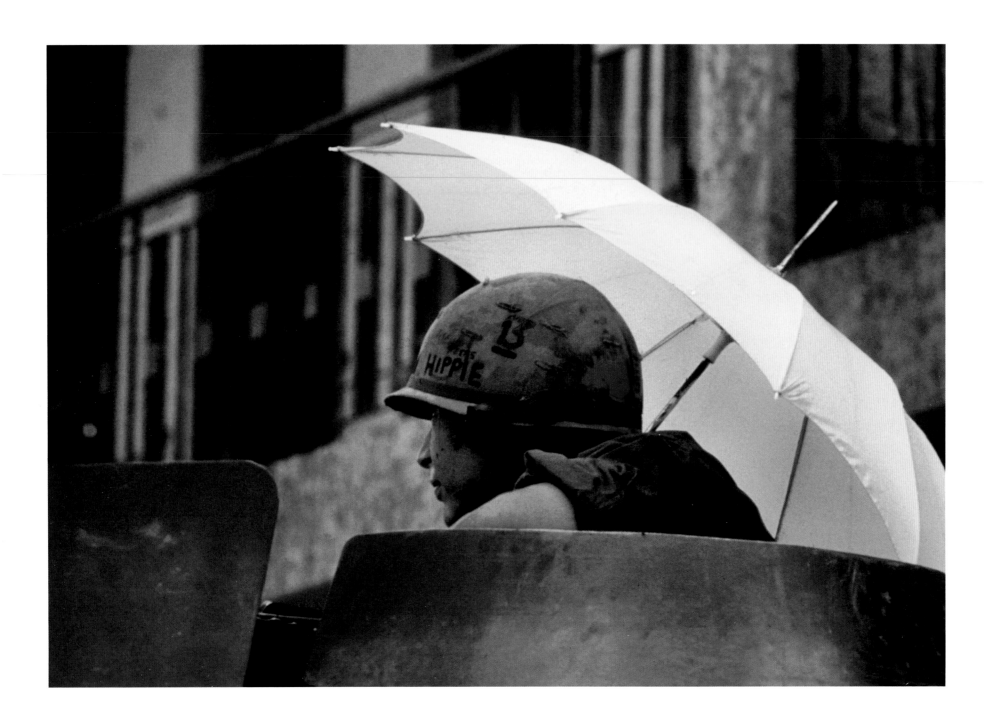

Tim Page *photographer* / Larry Heinemann *writer*

IRON EYES

Well, we were always watching something. And a pink parasol? Well, shade's shade. Somebody's got to sit there in the iron "tub" of the APC, armored personnel carrier—tracks, we called them—trying to keep an eye on everything at once. Bored out of his fucking skull, meanwhile.

It might as well be you. Morning, noon, and night; day in and day out; rain or shine; on and on and on, until you didn't know yonder from hither.

Every once in a long while you actually did see something coming straight at you and your breath caught in your throat. *Hut!* Jesus H. fucking Christ, and your anus clenched tighter than a bolt. That dead lug corkscrew of dread fear tingled up the spine and tickled you to the very ears.

The rancid touch of bile bubbled in your throat, as if a boil as big as a nickel had burst in your mouth. And you with not enough spit left to get rid of it, so it just sat on your tongue. Then the killing began, and sometimes you were at it all fucking day, all night.

I have heard the Vietnamese folk legend of the warrior hero of ages long past who was given an iron horse, a great iron whip, and a suit of iron clothes. And the instant he threw a leg over the horse's back, snap, the animal came alive and began to breathe fire, and the man's heart turned to iron. Of all the accoutrements in a soldier's kit, an iron heart serves best just then. The work of soldiers is, finally, just too mean and ugly for anything less. Iron was once thought to be magic, something so hard that it does not give to the touch, made with fire, fashioned with showers of sparks, and tempered with a wet hiss. Magicians' work, indeed.

Keep at the soldier's work long enough and you acquire the keenest gaze. Called with precise understatement the thousand-meter stare, this is pointed and blunt, perfect concentration, astonishing in its all-pervasive, unambiguous vacancy. The severe focus of imagination without the touch of warmth or light, not so much diminished as condensed. And it was irresistible, you understand. By and by, you gave yourself up to it; we even said it out loud, "I just don't fucking care."

It is old human wisdom that when the slaughterhouse offal is sluiced away and the meat of the kill is dressed and hung, if no prayers are shouted aloft to accompany the spirit of the thing killed, the grief of your murders is not assuaged. Your heart of iron turns black and the patina of grief poisons all the senses.

So, when a man looks at you with iron eyes that do not shine, my advice is to finish your beer, pay up, and leave.

TIM PAGE was born on May 25, 1944,
in Great Britain. At the age of eighteen, his
photographic career began when he covered
the civil war in Laos for AP, UPI, and *Paris
Match.* He moved to Saigon, where he soon
earned a reputation as a high-spirited and
buccaneering photojournalist. Wounded
several times during the war, once almost
fatally, Page has been the subject of
several books and films. He is said to be the
model for the photographer in the film
Apocalypse Now. His own books include
*Tim Page's Nam, Ten Years After, Page After
Page,* and *The Mindful Moment.* With Horst
Faas, he coedited the award-winning book
Requiem, which featured the work of photo-
journalists killed during the Indochinese
wars between 1945 and 1975.

Born in 1944 in Chicago, Illinois, LARRY
HEINEMANN was drafted to serve in
Vietnam with the 25th Division in Dau Tieng.
He later received a B.A. from Columbia
University. His award-winning first novel,
Close Quarters, has been called the seminal
work to come out of the Vietnam War. *Paco's
Story* won the National Book Award and the
Carl Sandburg Literary Award for fiction,
among other distinctions. Heinemann is also
the author of *Cooler by the Lake.* He has
received literature fellowships from the
Guggenheim Foundation, the National
Endowment for the Arts, and the Illinois Arts
Council. He is currently working on a book
about train travel and contemporary life
in Vietnam.

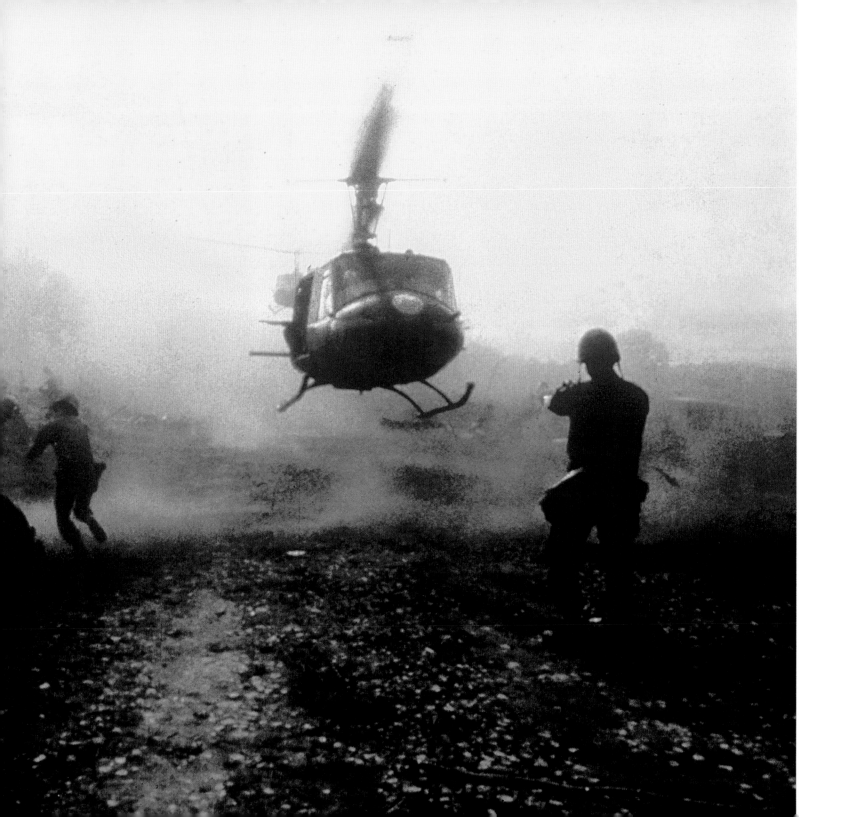

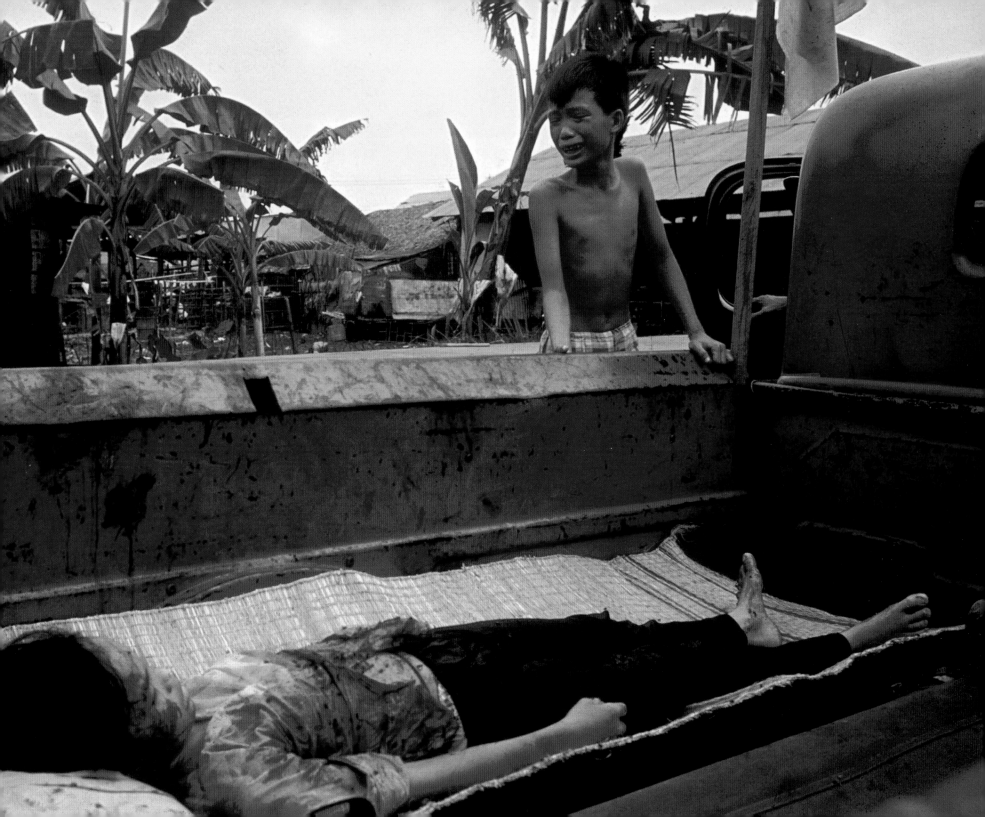

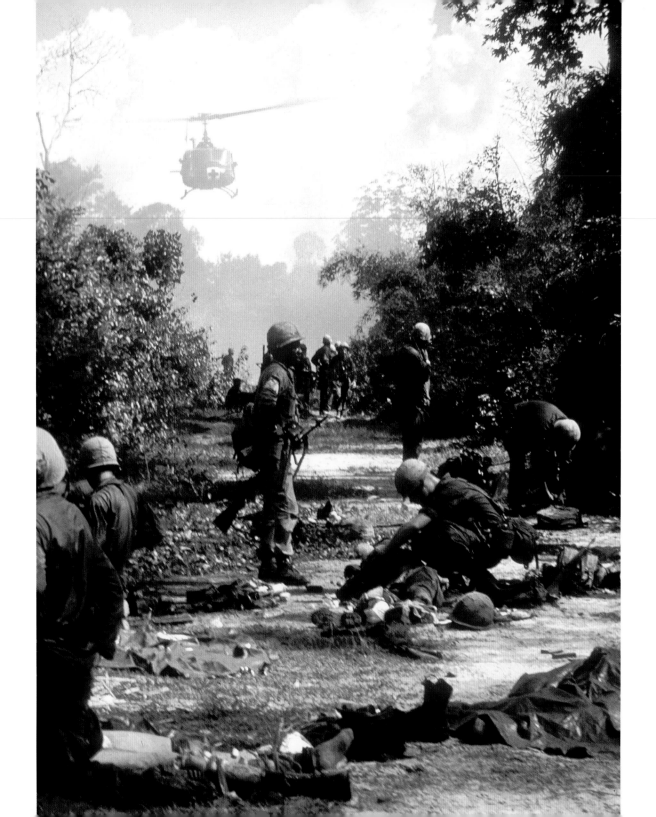

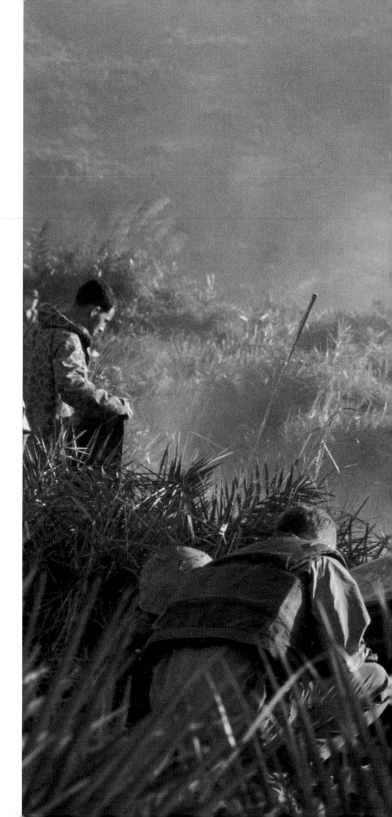

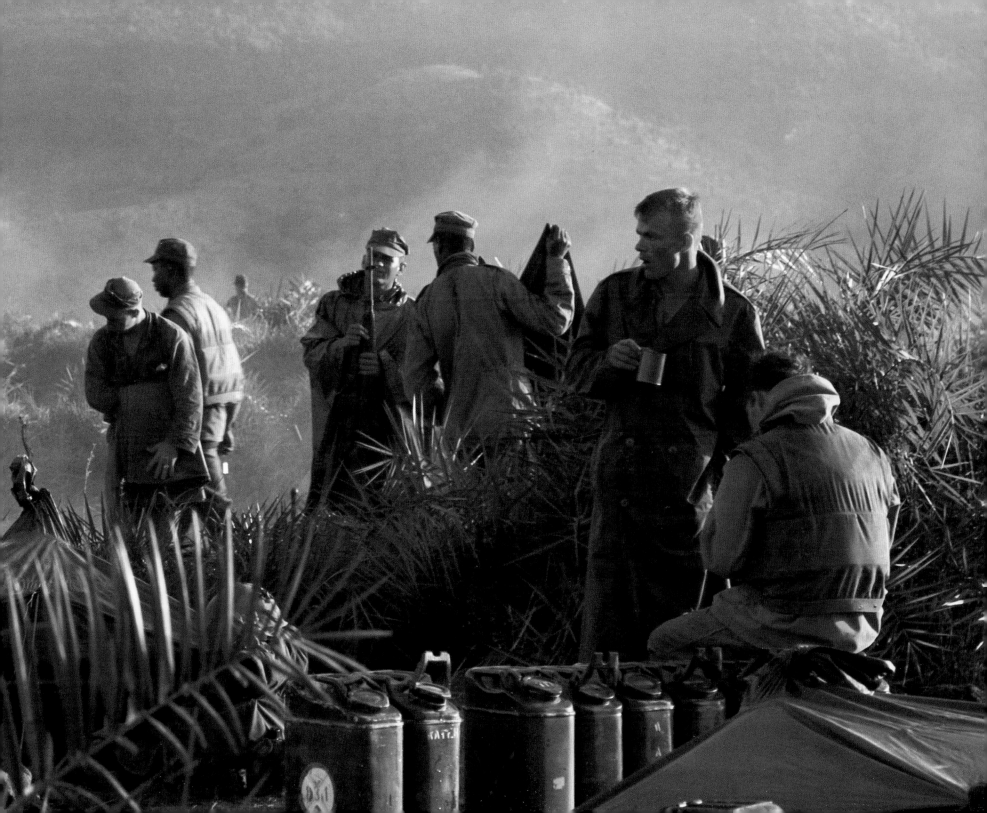

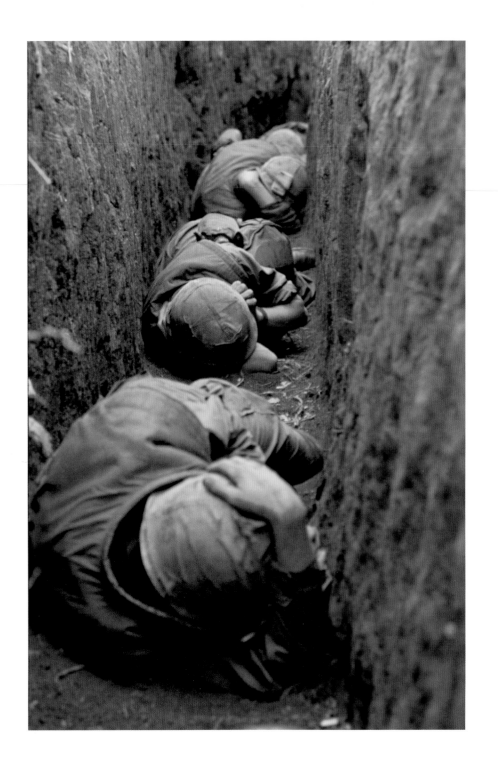

Robert Ellison *photographer* / Ray W. Stubbe *writer*

KHE SANH

Khe Sanh's trenches mirror the war's gash into my soul. Struck within its networks, then and now, images of men I came to know as their chaplain during the six months prior to the siege continue to explode within me.

At Khe Sanh, we dug deeper and deeper. Deadly incoming—up to 1,600 rounds a day—instantly leveled all aboveground structures and sculpted moonscape devastation. Two craters outside the Battalion Aid Station were so deep, I could stand in them and my head would be below the surrounding surface. We all knew: there was no safe place in Khe Sanh.

Since groups larger than six were prohibited (one round might kill everyone), worship services were small in size and frequent in number: a short prayer, a two-sentence sermon, a reading from the Bible, Communion, and a blessing—all within ten minutes—were repeated from trench to trench a dozen times daily. Sometimes, since the incoming was so intense, all I could do to communicate God's love was to hug. Once, I was alone and my prayers reduced to babblings as I bounced from the shock of explosions of nearby land mines. I held the hand of one painfully wounded man who asked me to say the Ninety-first Psalm, and prayed with another who shared his joy over a wrestling scholarship and his imminent departure. A few days later, he was killed. I stayed overnight with a 106mm recoilless rifle squad. We shared coffee and conversation. The next day, I pulled out and carried a headless Marine from the rubble after that position took a direct hit.

Khe Sanh was alive with death. Another chaplain, Father Brett, was killed when one of the Khe Sanh trenches took a direct hit. At Graves Registration, I prayed over the corpse of a man I had just baptized a few days earlier.

My bunker was crowded with wounded waiting through the night to be evacuated. I slept atop a field desk. Nearby, a Marine I knew well, Rick, dabbed his head with a roll of toilet paper. The floor below was filled with his bloody, crumpled papers. I was startled to see him the next day digging deeper trenches in the recon area. "That wasn't my blood," he explained. "It was the blood from others in the trench that were killed."

ROBERT ELLISON was born in 1945 in Gouverneur, New York. Arriving in Vietnam for the 1968 Tet Offensive, he spent several weeks in Khe Sanh with the Marines at the besieged base. Ellison's work included some of the most reproduced images of the war and was featured in a *Newsweek* cover story, but he did not live to see it published. On his way back to the Marine camp, as his plane approached the Khe Sanh airstrip, it was waved off to permit the landing of another aircraft. As it circled, the plane crashed into a nearby hill, killing all aboard, including the twenty-three-year-old Ellison. He was posthumously awarded the Overseas Press Club's award for best magazine reporting from abroad. Robert Ellison and the Marines on that fatal flight into Khe Sanh are buried in a mass grave in a military cemetery in Missouri. His work is displayed in the award-winning book *Requiem*.

Born in Milwaukee, Wisconsin, on August 15, 1938, RAY W. STUBBE joined the U.S. Navy in 1955. Upon completing studies at the Northwestern Lutheran Theological Seminary in 1965 and earning a postgraduate degree at the University of Chicago, he became a commander in the Navy's chaplain corps. Stationed in Vietnam from 1967 to 1969, he was one of three chaplains present at the siege of Khe Sanh. In addition to being awarded the Bronze Star with "V" for valor, he is also the recipient of a Legion of Honor award. The subject of numerous television programs, founder and president emeritus of Khe Sanh Veterans Association Inc., he is also the author of several books, including *Inside Force Recon, Khe Sanh Chaplain,* and *Valley of Decision.*

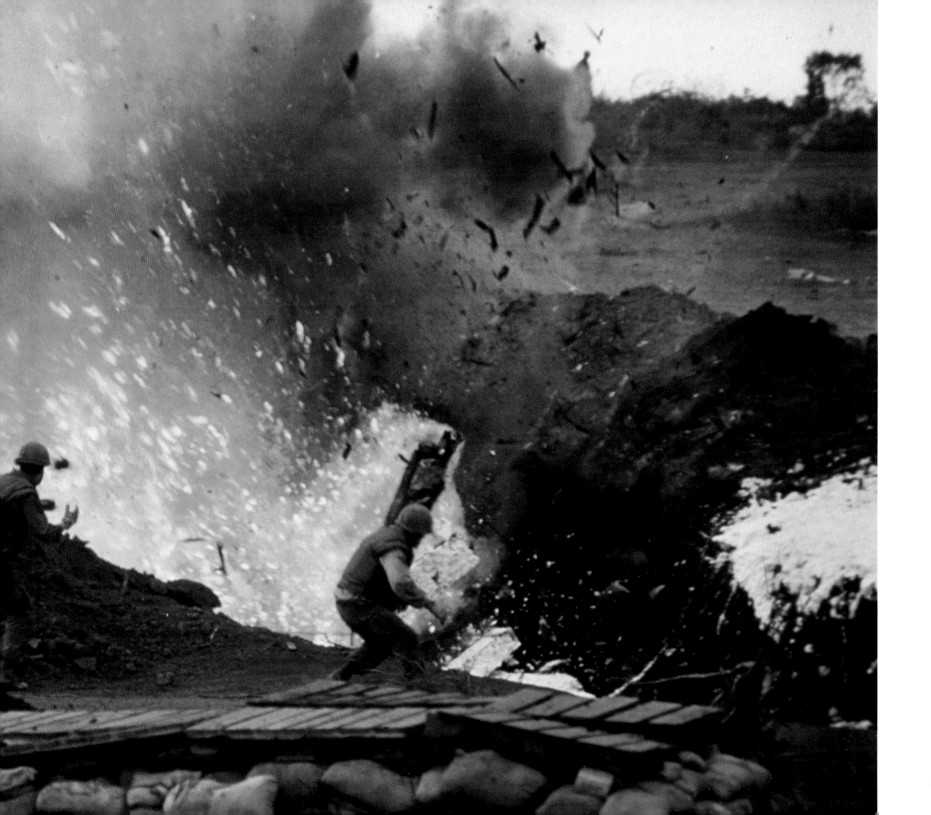

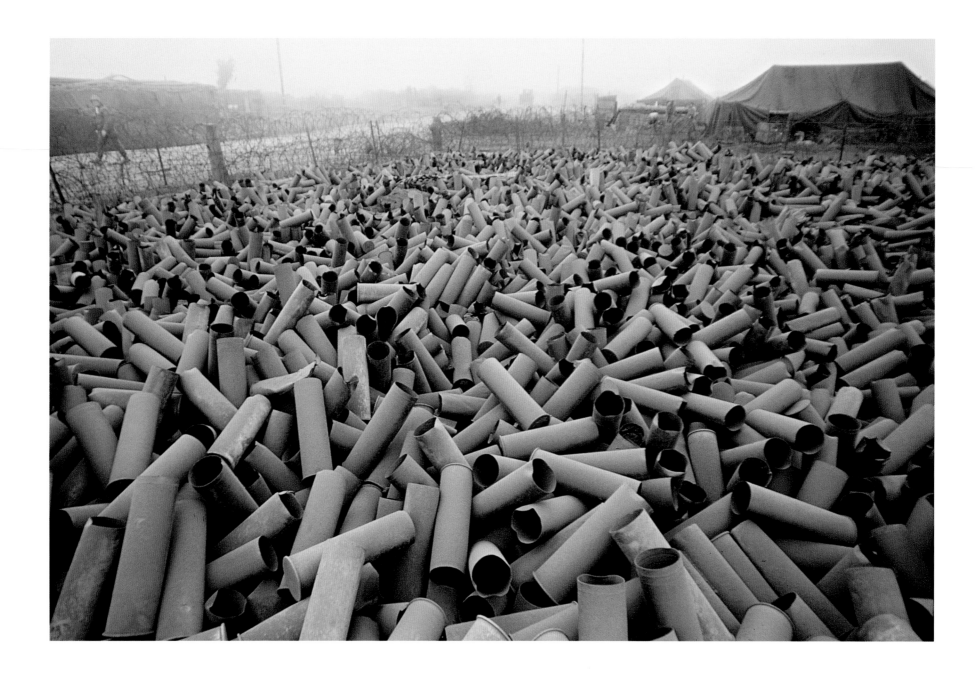

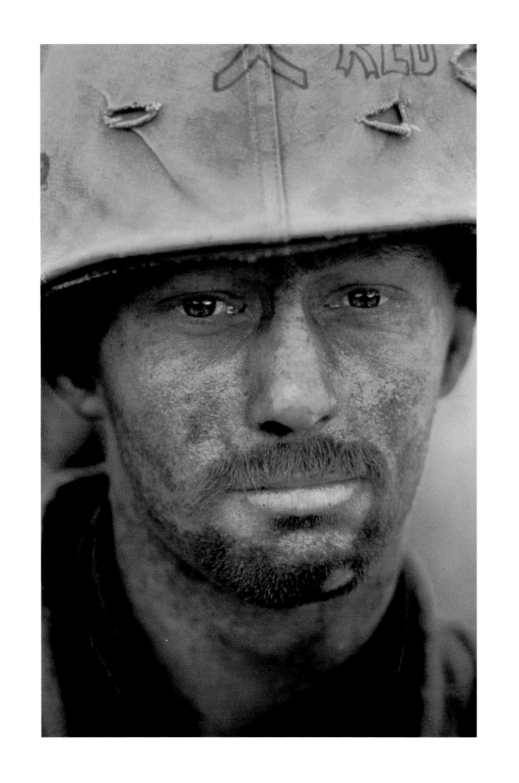

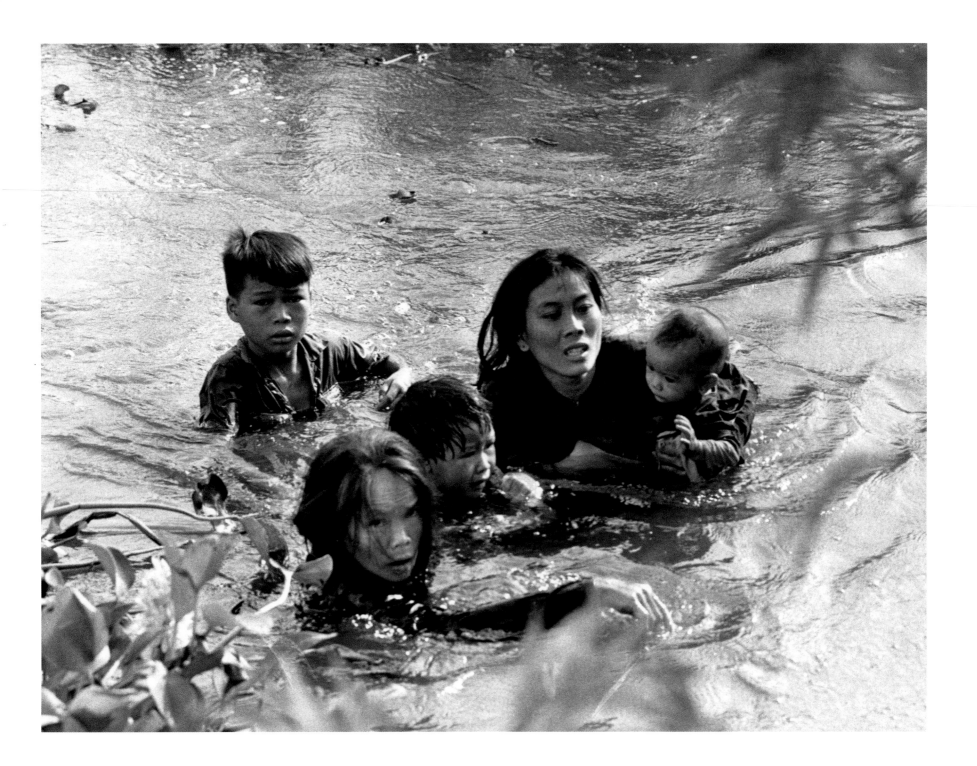

Kyoichi Sawada *photographer* / Neil Sheehan *writer*

LEST WE FORGET

When a great photographer takes a photograph, he creates in the images he captures on his film a larger, transcendent image that speaks of things beyond itself. Studying Kyoichi Sawada's extraordinary photograph of two Vietnamese peasant women struggling to cross a stream to save their family from the bombs of American warplanes, you begin to understand the Vietnamese nation and why the United States lost and deserved to lose its war in Vietnam.

Look at the face of the younger woman. It is a face of determination and resistance. The muscles over the high cheekbones are taut, so is the mouth, the teeth are set, the eyes do not look at the camera. Instead, they are fixed on the opposite shore—which she is determined to reach with the baby she holds in one arm and the toddler she supports with the other. The older woman, probably the children's grandmother, glances at the camera while she reaches toward that waiting shore with one arm and helps support the toddler with the other. These are the eyes of a woman who has known danger before and surmounted it. The boy is frightened, but his nerves are under control. Not panicking or rushing ahead to save himself, he follows, ready to help with the little ones if need be.

There is an absent figure: the father. He probably would have been a farmer of military age. He could have been dead, he could have been in hiding, or he could have been fighting with the guerrillas. No one who spent any time in the Vietnamese countryside during the war would have been surprised if the last were the correct explanation.

By the 1960s, the leaders of the United States were men who had lost the capacity to grasp reality, men overcome by hubris as they contemplated their power. And the citizenry, inebriated from the same cup, followed them to war. We were the new Romans holding back the barbarians at the frontiers of our beneficent empire. But the Vietnamese are a people who will not tolerate foreign domination. To achieve the unification and independence of their land, they would resist us as long as it took and pay whatever price was required in blood. They demonstrated that spirit with the strength of this mother saving her children.

In 1966, after he had been awarded the Pulitzer Prize for his achievement, Sawada found the family in the photograph and presented them with a print with which to remember that day they had crossed the stream to safety. Four years later, in neighboring Cambodia—another nation thrown into the furnace of the war by the leaders of the United States in their vain quest for victory—Kyoichi Sawada was killed.

KYOICHI SAWADA was born on February 22, 1936, in Aomori, Japan. Soon after he started to work for UPI in Tokyo in 1961, he became the Tokyo bureau chief. In 1965, UPI denied him a transfer to Vietnam, so he traveled there at his own expense. The amazing photographs he took during that trip earned him his desired transfer. Within a year, he won the Pulitzer Prize for his moving photograph of a mother and her children fleeing to safety across a river. He also won the World Press Photo Contest, an Overseas Press Club award, and the US-Camera Achievement Award for this photo. He died on October 28, 1970, in Cambodia.

Born in 1936 in Holyoke, Massachusetts, NEIL SHEEHAN graduated from Harvard University, A.B. cum laude. After serving in Korea, he went to Vietnam in 1962 as bureau chief for UPI and as a correspondent for *The New York Times*. After 1964, he reported on the Vietnam War from Saigon, then later from Washington, D.C. In 1971, he obtained the classified Pentagon Papers from Daniel Ellsberg; his story in the *Times* about the top-secret documents became the most celebrated news story of the decade. He spent some sixteen years on his best-known work, *A Bright Shining Lie,* a biography of Lieutenant Colonel John Paul Vann that illuminates much of the war's history. This monumental book won universal acclaim and received the Pulitzer Prize. It was followed by *After the War Was Over*.

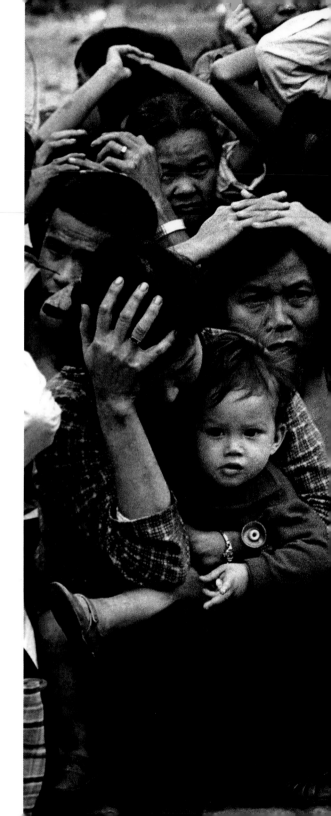

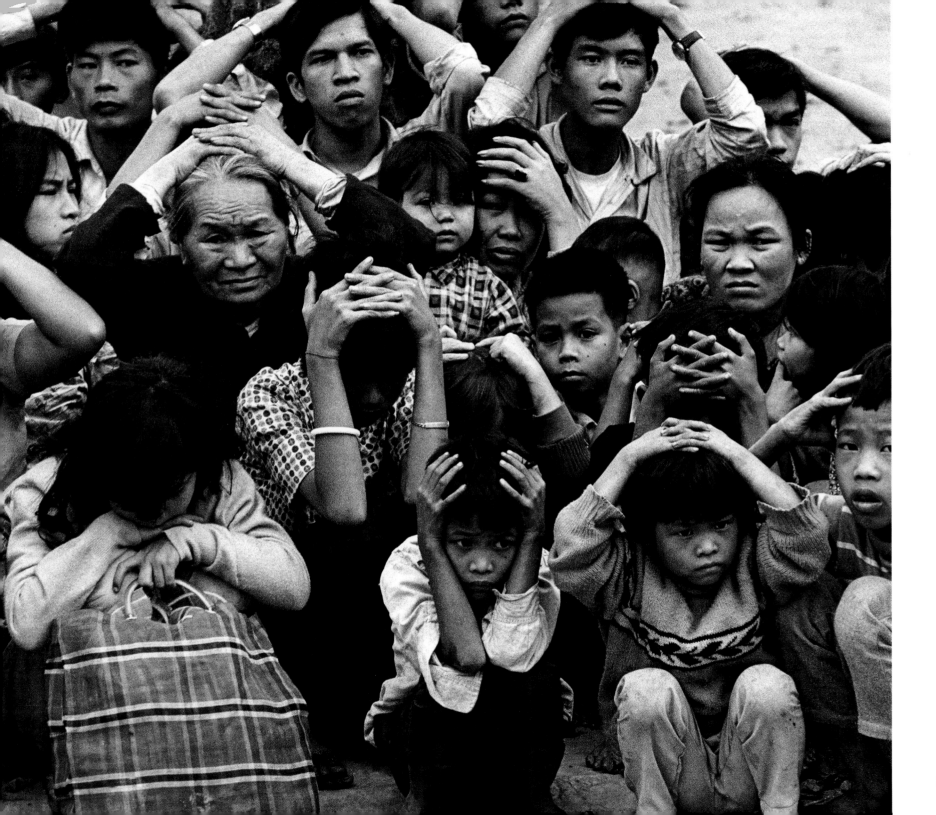

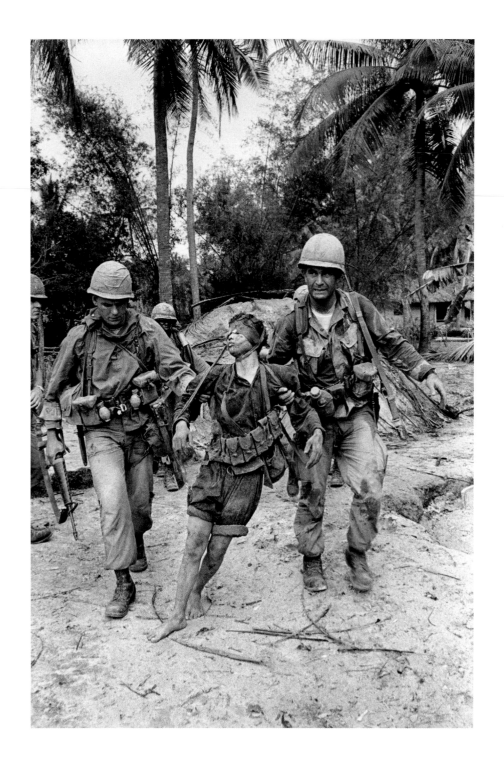

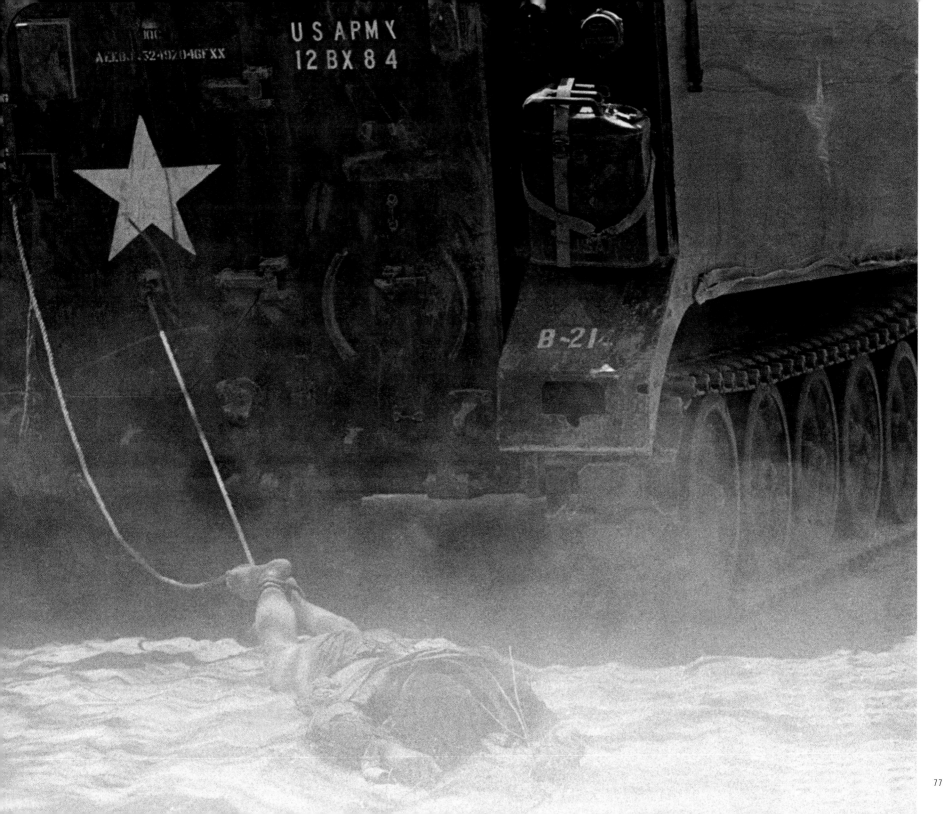

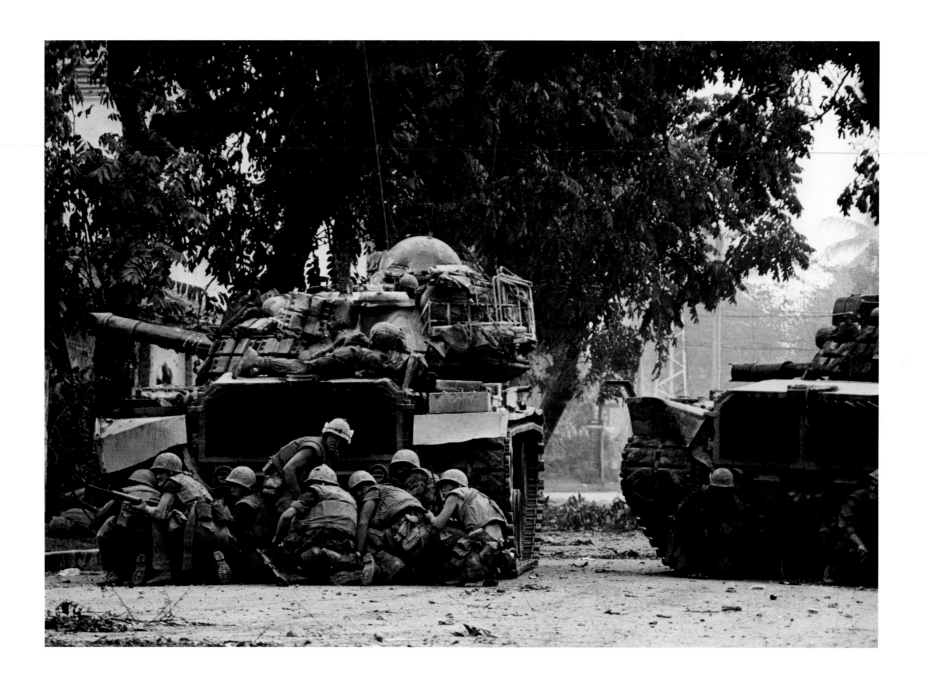

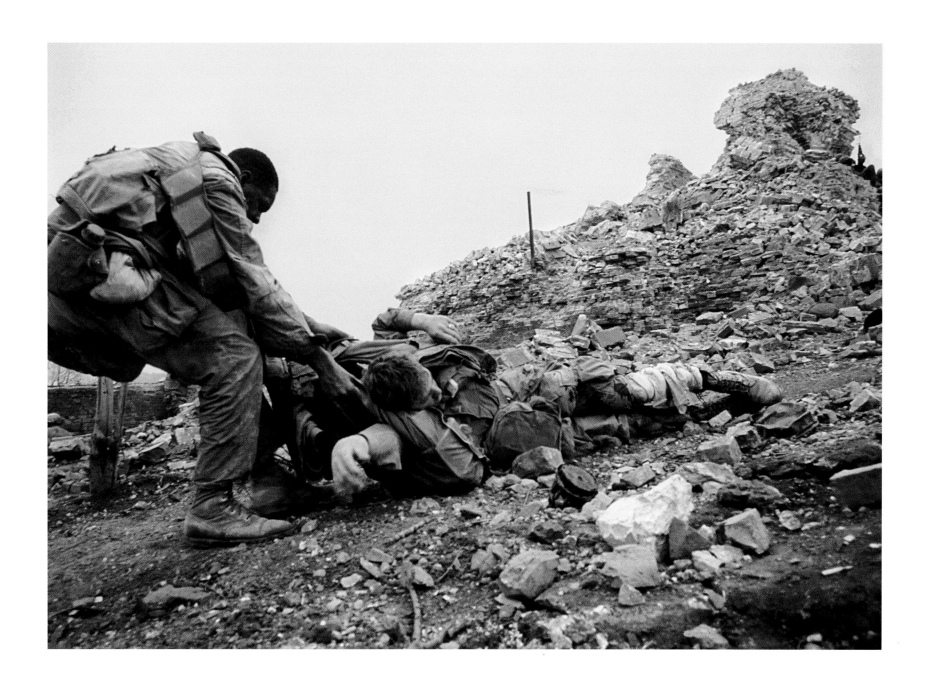

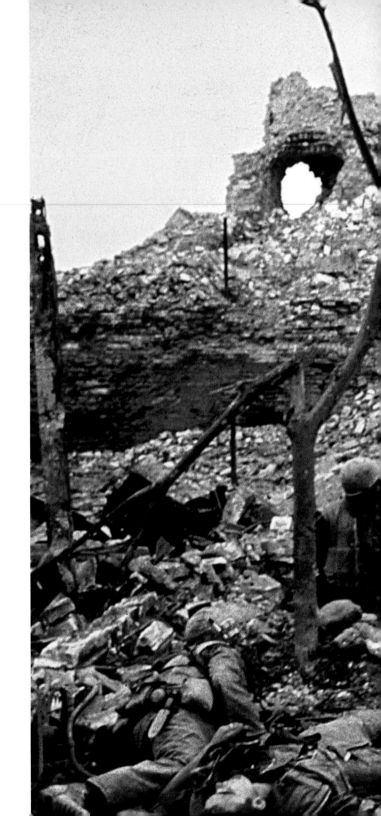

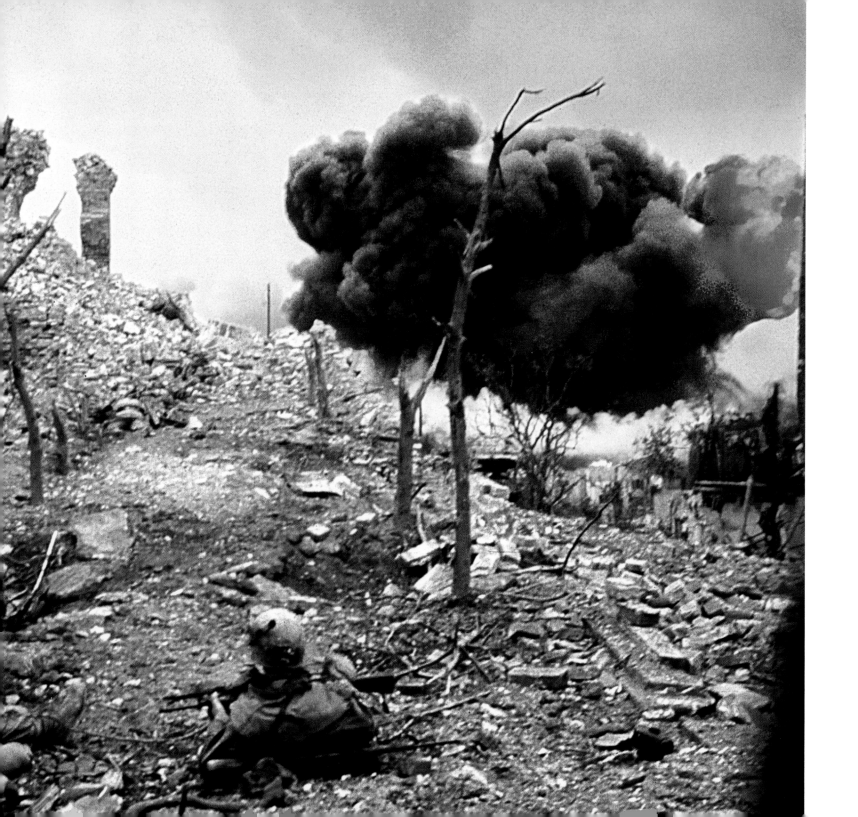

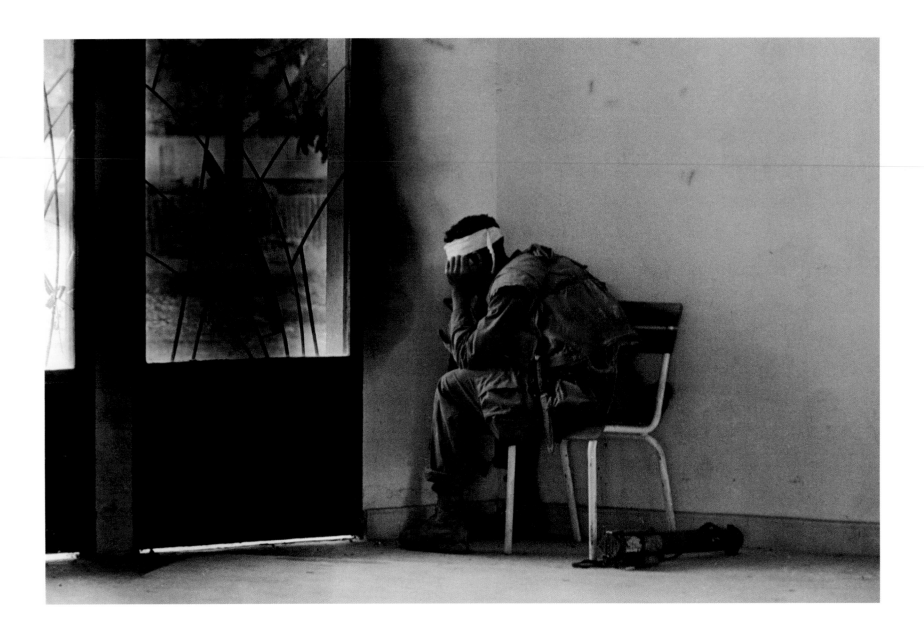

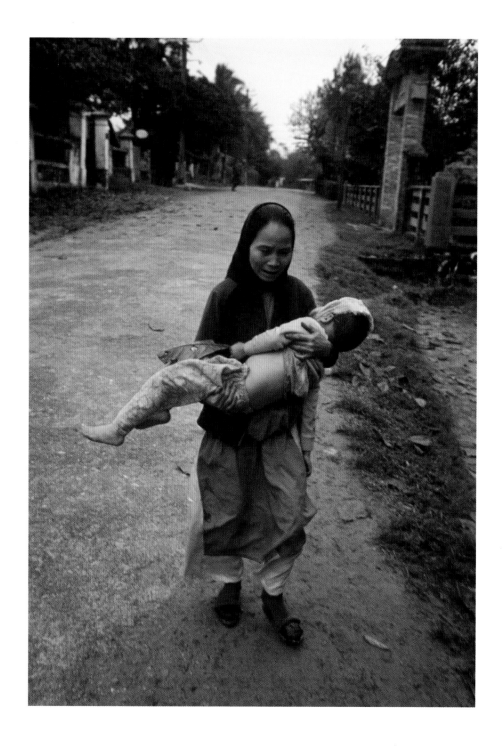

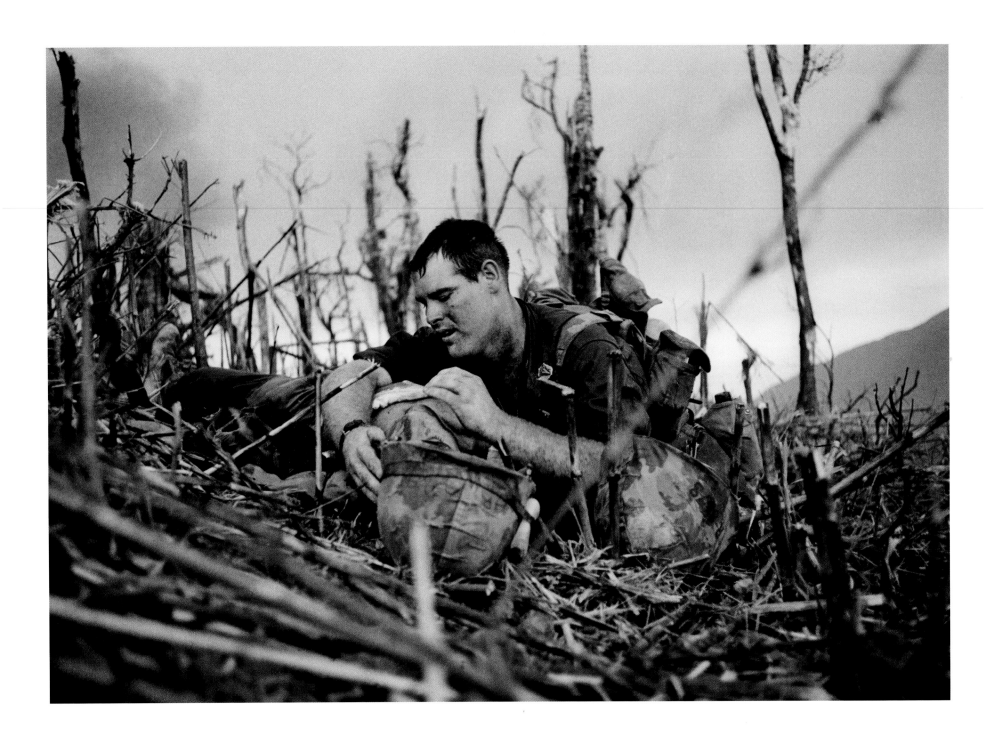

Catherine Leroy *photographer* / Wayne Karlin *writer*

KISSING THE DEAD

The hill is 881 South, near Khe Sanh, assaulted by the Marines in May 1967. A corpsman, hunkered down in a small nest of splintered, burnt-out trees, works desperately and futilely on a Marine who has just been hit. In the first photo of this series of three, he presses a dressing onto the man's chest, holding the bandage's other edge down with the weight of his right forearm, his right hand steadied by its grip on the rim of the Marine's helmet: a posture that, when we look at the intent tenderness on the corpsman's face, has to recall to us the cradling of a child or a lover.

In the second photo, he has rested his head on the Marine's chest and is listening, under the terrible noise of battle, for a heartbeat. In the third, he is looking up in anguish toward the place where the enemy or God or some answer he knows by now is not there, must be. His mouth is open, as if he is screaming an objection; or perhaps he is raising his face from trying to blow breath back into the man's mouth—an act an ex-medic friend of mine recalled "kissing the dead."

The summer before this battle, the helicopter in which I was flying gunner landed east of Hill 881 and we loaded it with dead and wounded Marines from another fight. Looking at these images, I think about how that dead man would also soon be handed up into the maw of a helicopter. All you can see of him next to the corpsman are bits and pieces of his equipment—a helmet, a bottle of bug spray still banded to it, part of a flak jacket, a canteen—and that's what brings me back, flips that image into others usually kept dormant in my mind.

On the deck of a helicopter, the dead looked like discarded equip-ment and shed garments. Looking at their clothing, sometimes you would think how that morning or the night before, their fingers had fastened buttons and strapped gear that now other fingers would unfasten. Only people who have not been in war or cancer wards or bad wrecks hold to the stupid confidence that what their fingers fasten in the morning will be unfastened later by the same fingers, or by the fingers they would choose. Looking at the dead on the deck, you saw they were just a tangle of ragged, filthy clothing and equipment. Yet at the same time they looked like you. Their boots were caked with red mud and looked just like your boots. And then you'd understand that they were your boots.

The corpsman in these photos understood that but he sat up anyway, exposed, to try to save that life, and then he moved up that hill, into the fire that shredded so many. Wasted. There was never a more accurate word. To say those men were thrown away on that hill does not diminish them. It diminishes those who threw them onto that pitted, splintered slope, and stayed back behind the safety of oceans and cheered them on, as such cheerleaders always did, as they still do. One should probably not use the archaic word *nobility* when describing war. But there is no other word for the courage and willingness to sacrifice of the corpsman and the men who flung their bodies up that useless hill they knew they would take just to give back . . . or of the men who defended its seared soil as if it held the bones of their ancestors. What this series of photographs reveals about those men is a great and contradictory truth about war: it's obscene and it's noble. Its obscenity grows from their nobility, from the waste of so many who would and did give so much.

CATHERINE LEROY was born in Paris in 1944. She was twenty-one when she set out for Vietnam. Two years after arriving there, Leroy was captured by the North Vietnamese Army during the Tet Offensive in Hue. She returned to Saigon having documented the North Vietnamese Army in action. She has won many awards, including the George Polk, the Sigma Delta Chi, and the Art Directors Club of New York. For her coverage of the 1976 civil war in Lebanon, she received the Robert Capa Award, the first woman to do so. In 1983, with Tony Clifton, she published *God Cried*. In 1997, she was honored by the University of Missouri for distinguished service in journalism.

Born in 1945 in Los Angeles, California, former Marine helicopter gunner WAYNE KARLIN is one of the most accomplished writers to have served in the Vietnam War. His novels include the Vietnam War–influenced *Lost Armies* and *US*. He coedited the first anthology of Vietnam War–veteran fiction, *Free Fire Zone*, and *The Other Side of Heaven: Post War Fiction by Vietnamese and American Writers*, and he is the author of *Rumors and Stones: A Journey*. Karlin's short stories have appeared in various literary magazines, and have been widely anthologized. He has received five State of Maryland Individual Artist Awards, a fellowship from the National Endowment for the Arts, a Critics' Choice Award, and the Paterson Fiction Prize.

CATHERINE LEROY

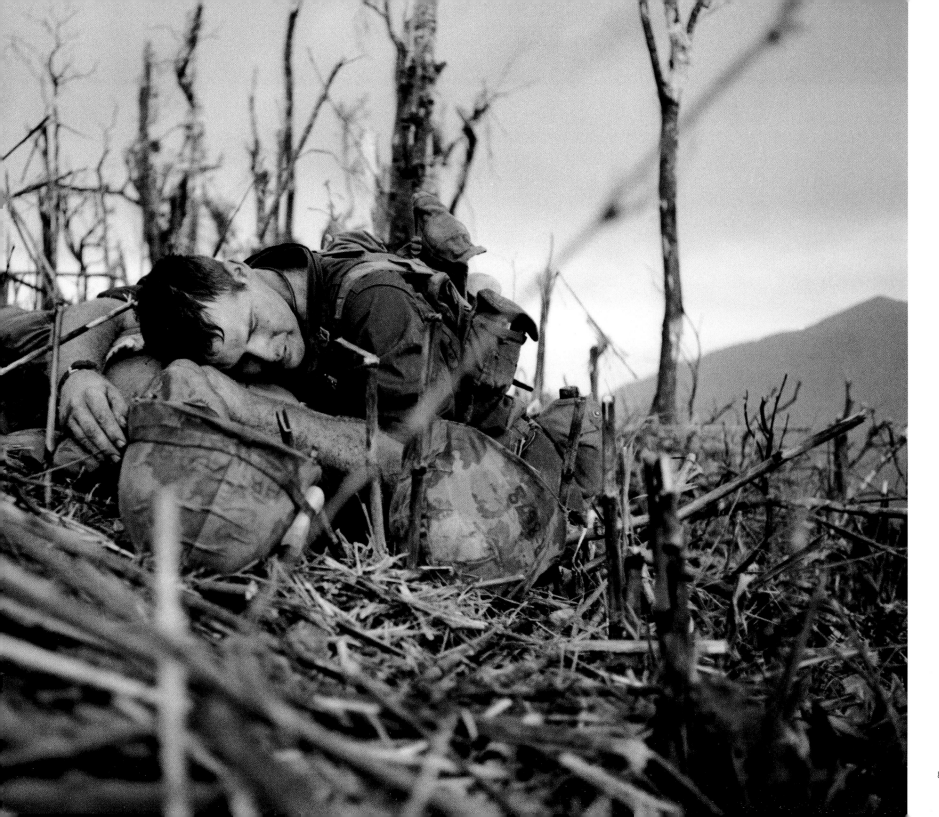

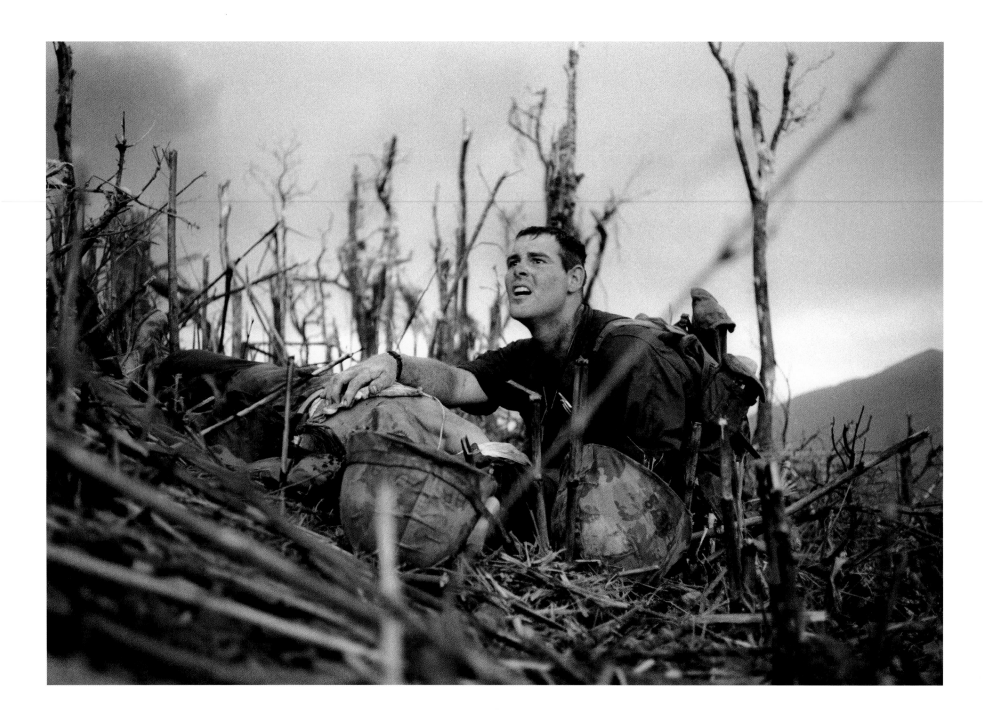

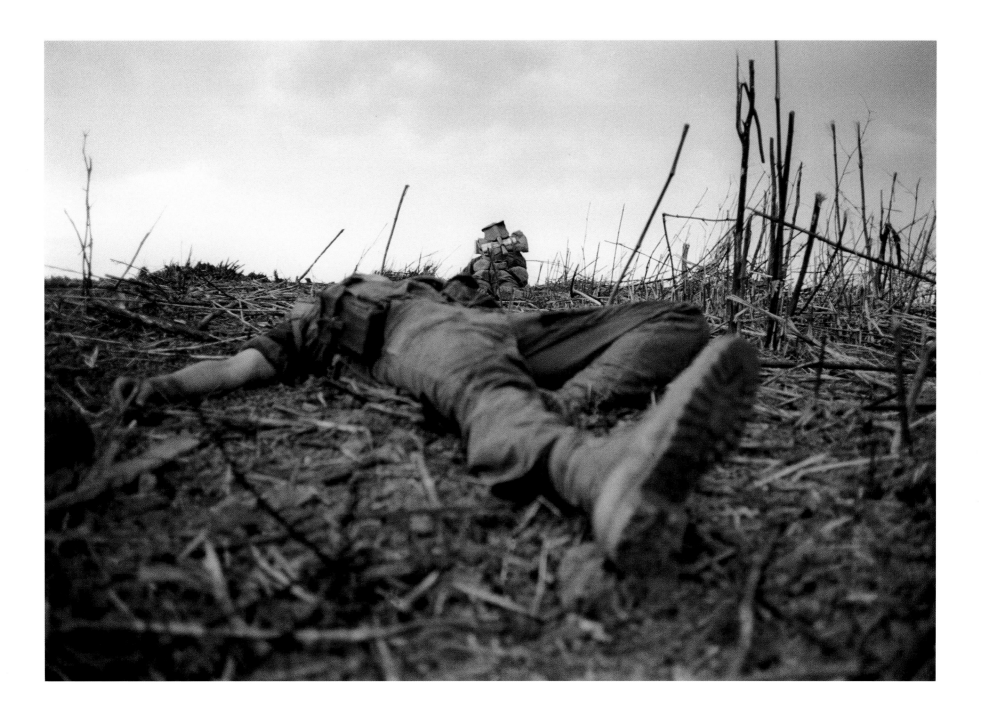

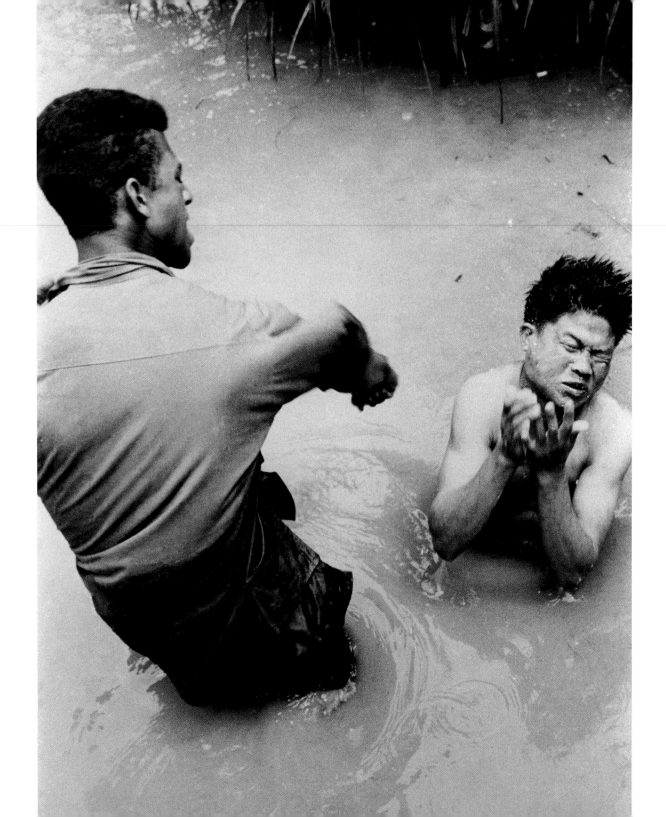

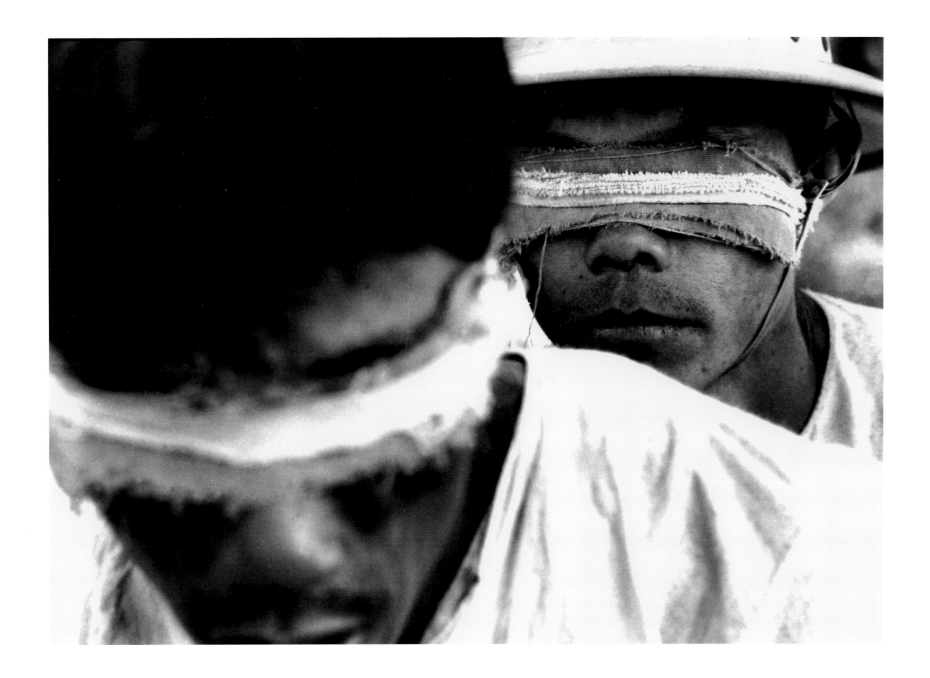

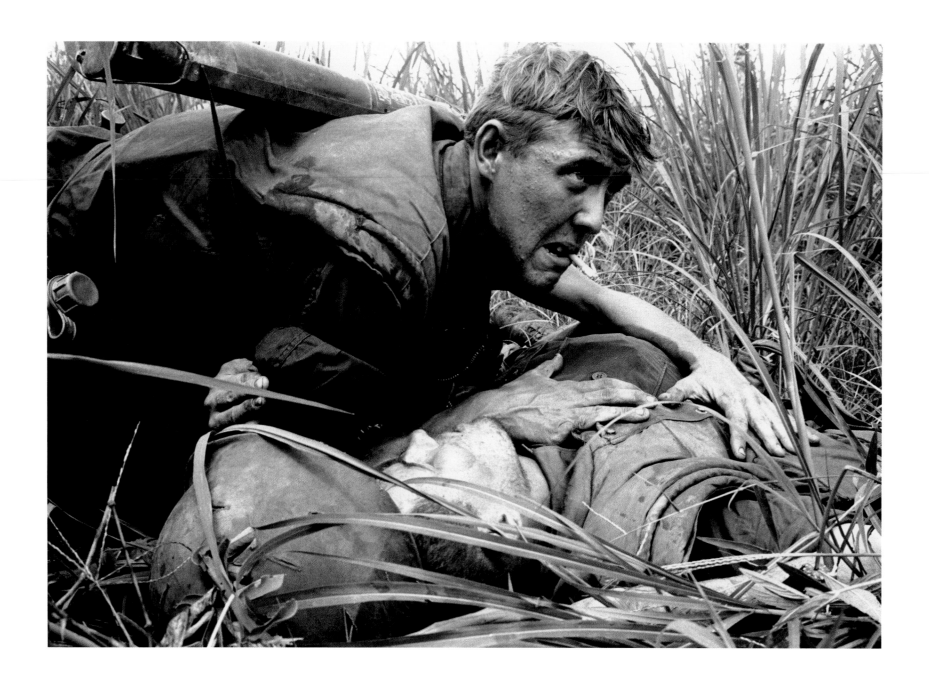

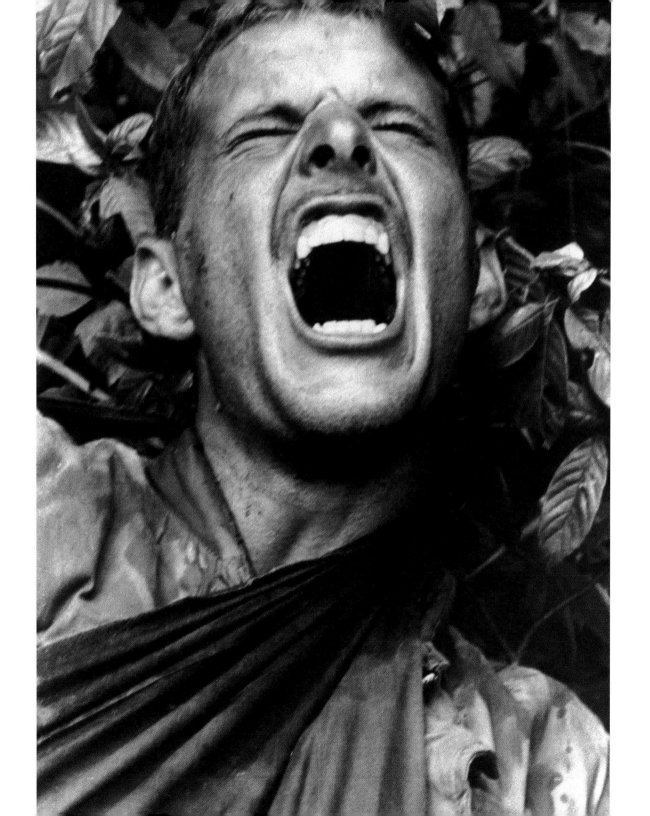

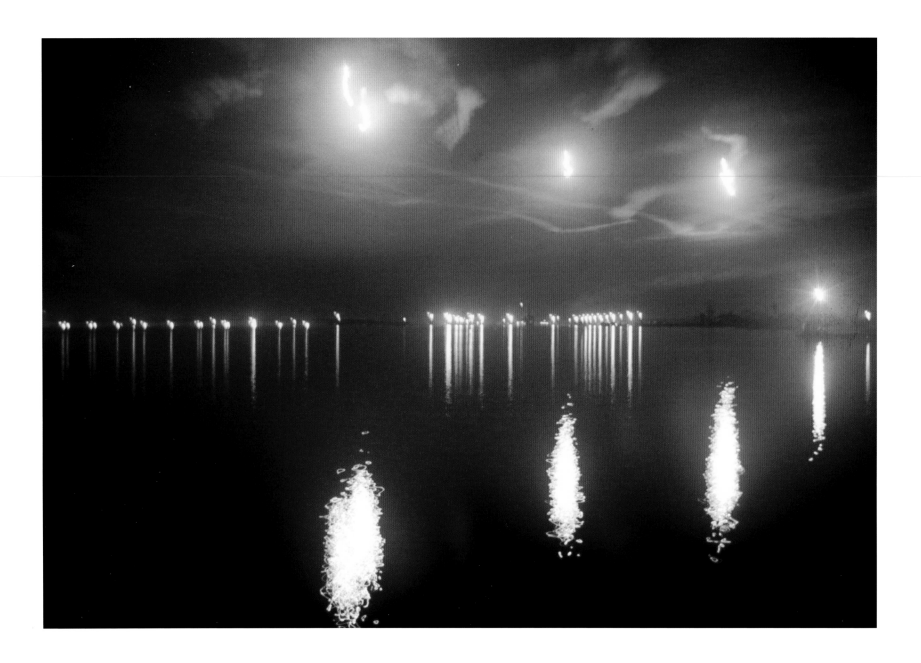

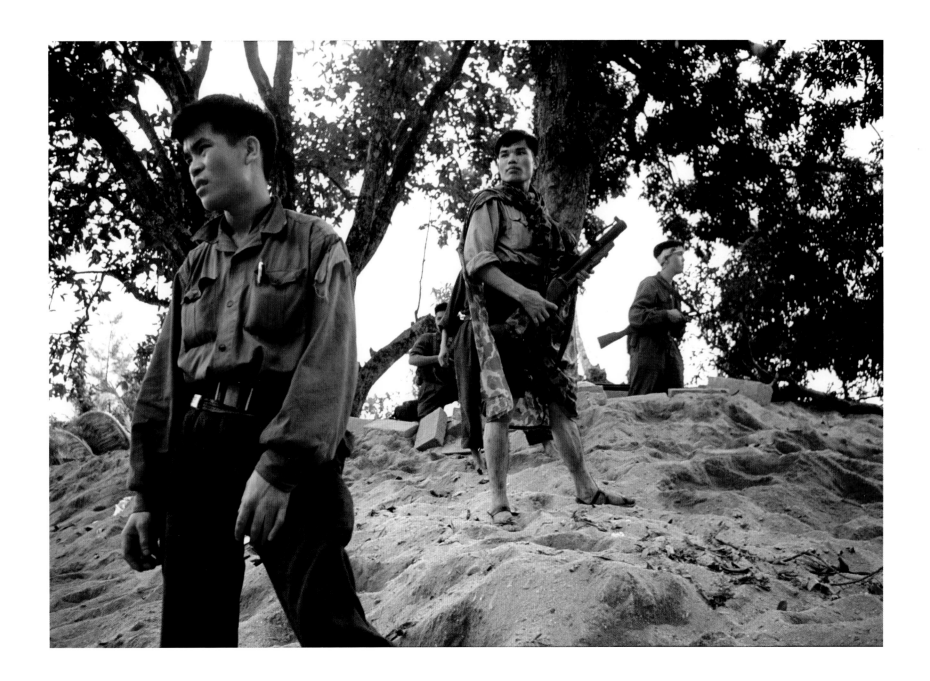

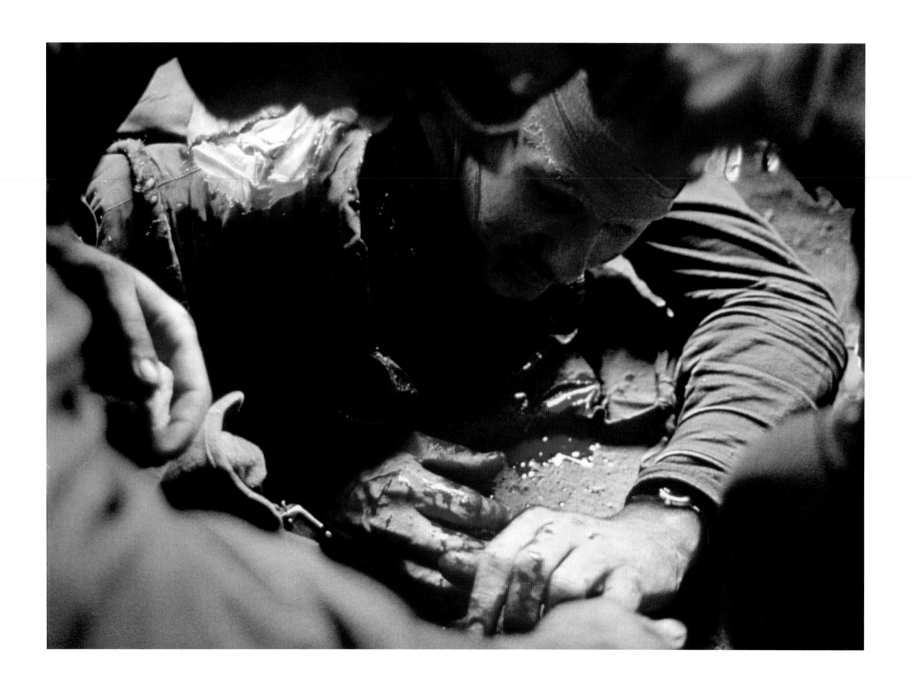

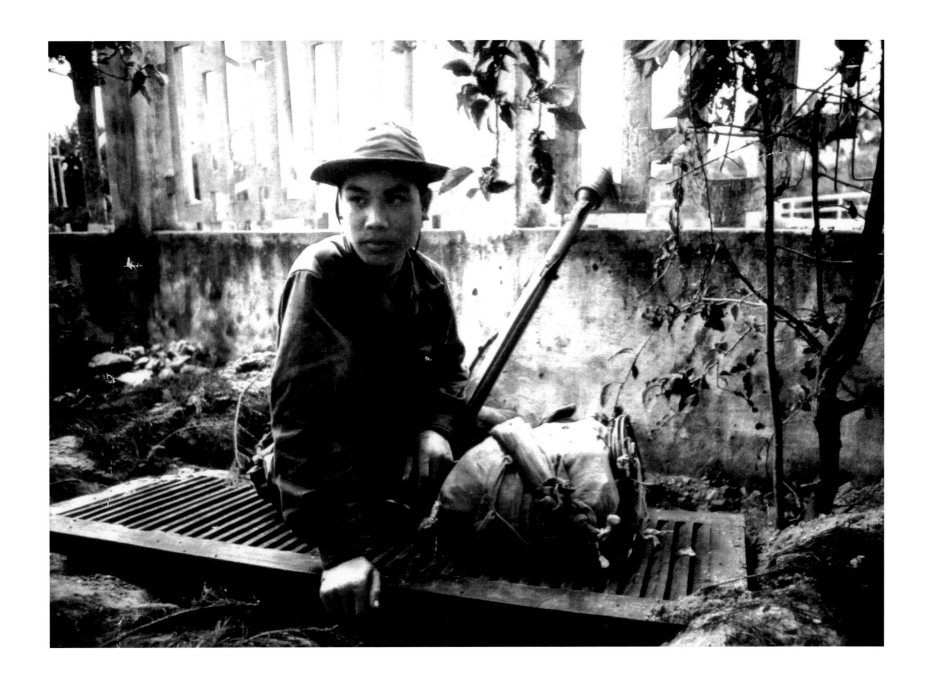

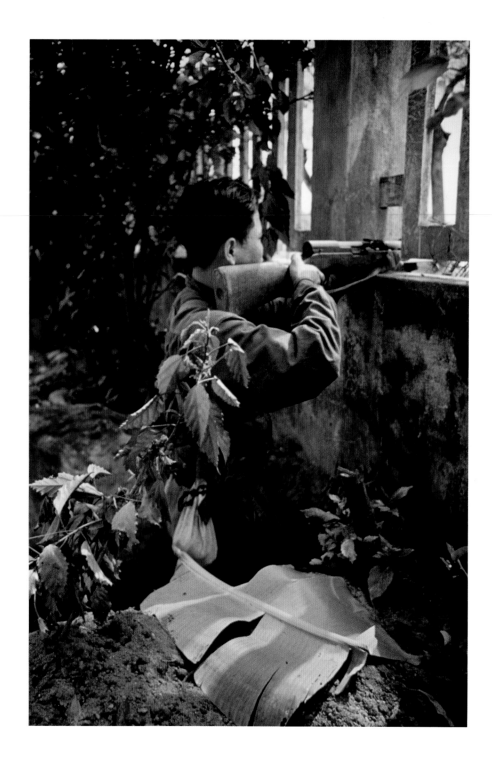

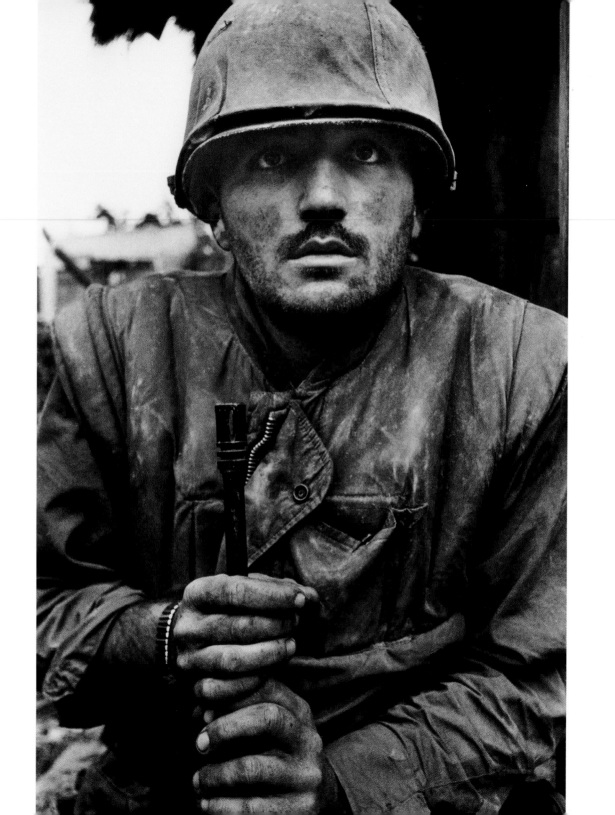

Don McCullin *photographer* / Philip Caputo *writer*

THE UNIVERSAL SOLDIER

His eyes were the first thing I noticed, because I didn't see them. I was aware of them in the way you're aware of anything that's invisible but tangible, like heat or cold or a sudden change in air pressure. I felt their lightless, distant stare, almost completely hidden in the shadow of his helmet's brim. It was only after I'd looked at this photograph for a while that I saw them in the conventional sense: four white crescents cradling dark pupils, whose expression was so haunted that I couldn't meet their gaze for more than a few seconds before moving on to the dirt-smudged, bearded face, the filthy flak vest, and the hands, clutching the barrel of an M16 rifle.

The hands are almost as arresting. There's a tension in them, even desperation, as if the Marine were a drowning man clinging to the one thing that can save him. In fact there is a tension in his entire body, a coiled quality that seems to represent some knife-edge balance between terror and ferocity. He is predator and prey, active agent and passive sufferer, which pretty much defines what a combat soldier is.

Though he's often described as shell-shocked, I don't think he is. The set of his mouth and jaw, the slightly forward thrust of his shoulders, and the taut grip on his weapon suggest a man waiting to go into battle. His eyes tell us he's been there before, and that he knows what's waiting for him. He is without a shred of illusion; his only hope is to get through the next five minutes, maybe the next thirty seconds. That's his idea of a

future; and if he survives and lives on to an advanced age, he'll never be older than now.

This is one of the most remarkable images of war ever made. Not of the Vietnam War, but of all war at all times. Change this Marine's helmet for a blue flannel cap, and he's at Antietam. In a tin hat, he's a Tommy at the Somme. Dress him in a thick wool coat instead of jungle fatigues, and he's a Russian at Stalingrad, an American at the Bulge. Exchange his M16 for an M1, and he's at the Chosin Reservoir.

He is, I've come to realize, myself, after a helicopter assault into a landing zone raked by mortar and machine-gun fire one late January morning in 1966.

I chose this picture to be on the cover of *A Rumor of War.* We tried to find out who this Marine was but failed—which I think is fitting. To give him a specific identity would be to lose something precious. He is, in his anonymity, the Universal Soldier.

We hope he survived and went home with body and mind intact. We hope he is now living somewhere in America, perhaps putting a kid through college, perhaps awaiting the birth of his first grandchild. We hope his nights are no longer rent by dreams of blood and fire and chaos. We hope God's peace is upon him, because God knows he's earned it. We hope those eyes of his, gazing upon tranquil scenes, have recovered their lost light.

DON McCULLIN was born in London, England, in 1935. From 1964 to 1984, he covered the battlefields of Cyprus, the Congo, Biafra, Vietnam, Cambodia, Bangladesh, El Salvador, and the Middle East. He is the author of numerous books, including his acclaimed autobiography *Unreasonable Behaviour.* McCullin was made Commander of the British Empire (CBE) by Queen Elizabeth II in 1992—the first photojournalist to receive such a high distinction. Since 1995, he has been affiliated with Contact Press Images.

Born in 1941 in Chicago, Illinois, PHILIP CAPUTO landed at Da Nang in 1965. A Marine lieutenant with the first U.S. ground combat unit committed to fight in Vietnam, he returned home after a sixteen-month tour of duty. As a correspondent for the *Chicago Tribune,* he won a Pulitzer Prize and covered the fall of Saigon in 1975. Says Caputo, "I was with the first combat unit sent to the war, then I was among the last Americans to be evacuated from the place." He is the author of three screenplays and a dozen books, including *A Rumor of War, Horn of Africa, Del Corso's Gallery, Indian Country, Means of Escape, Ghosts of Tsavo,* and *In the Shadows of the Morning.* His latest novel, *Acts of Faith,* is to be published in the spring of 2005 by Alfred A. Knopf.

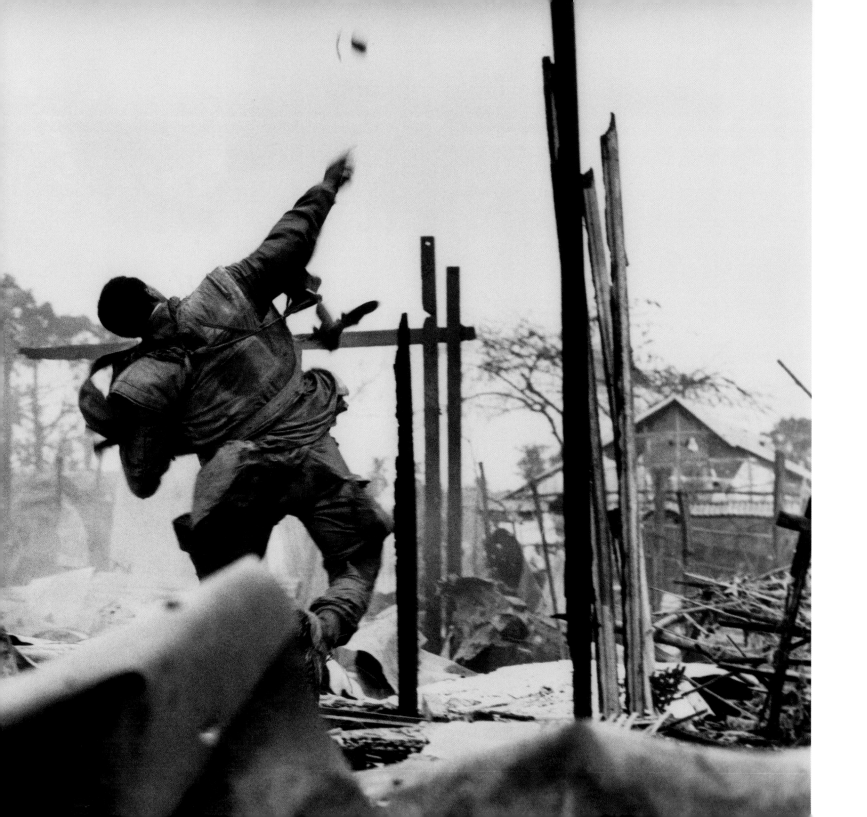

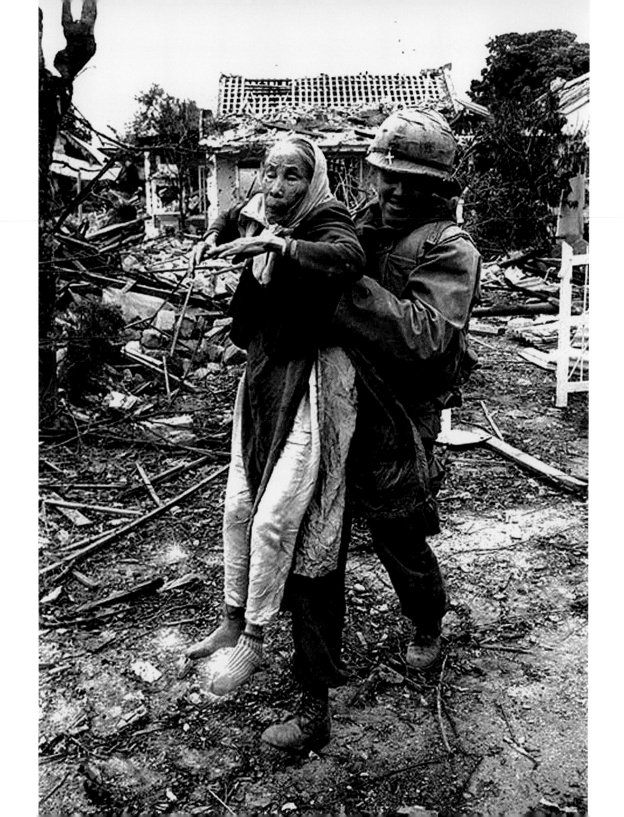

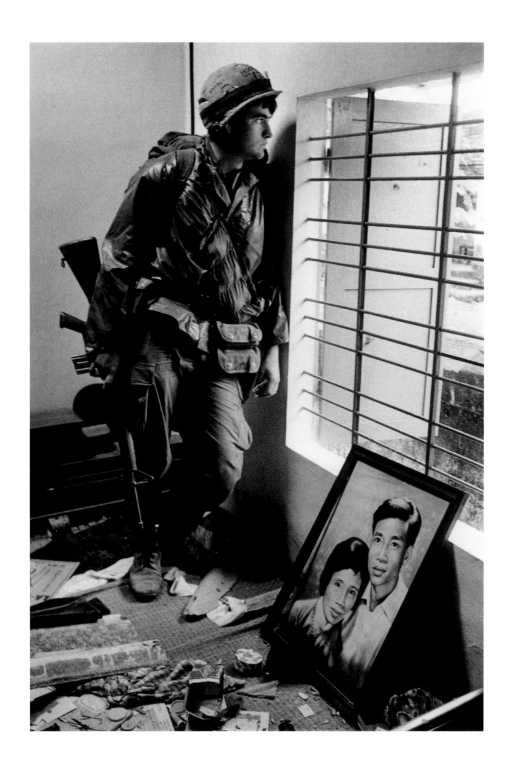

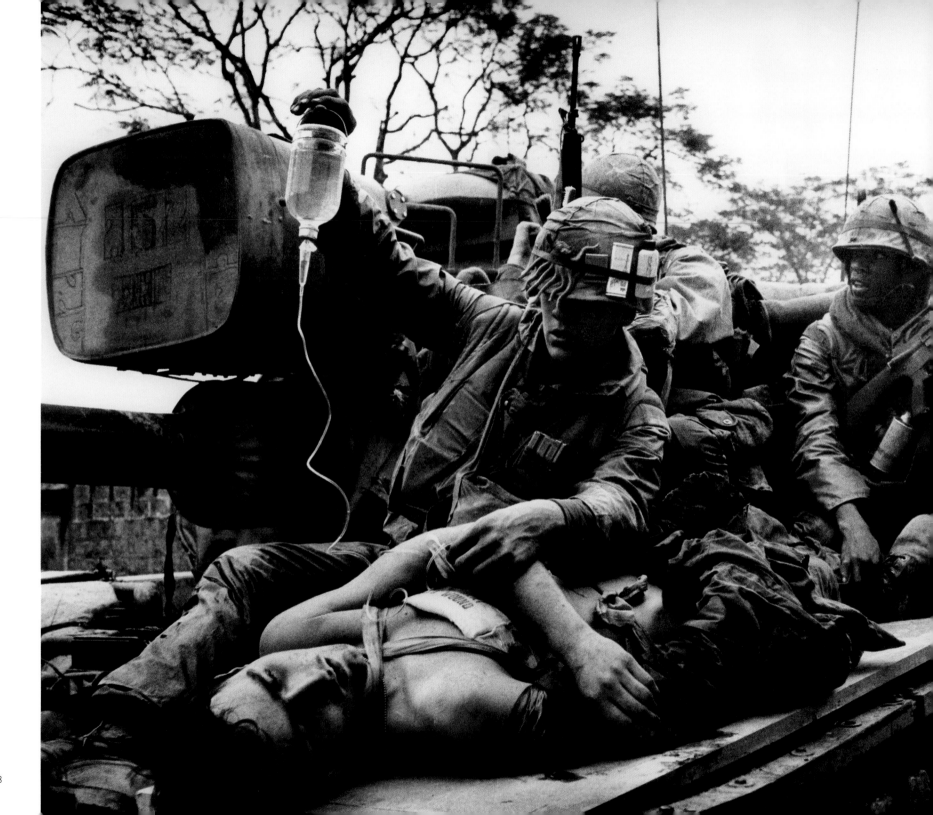

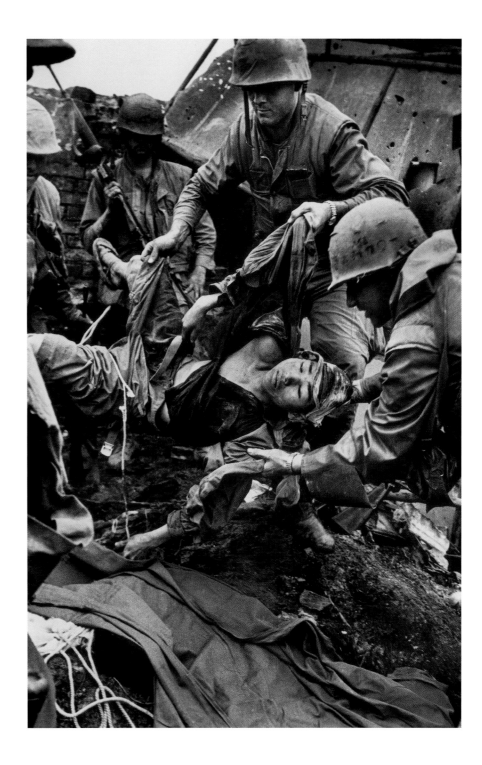

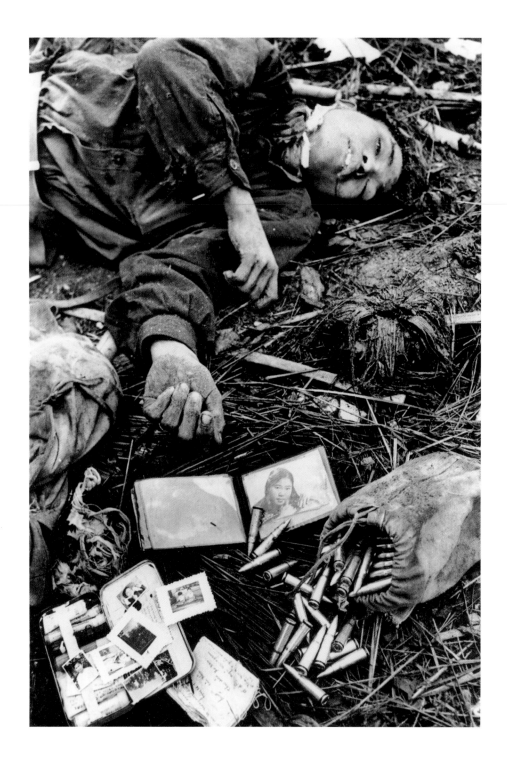

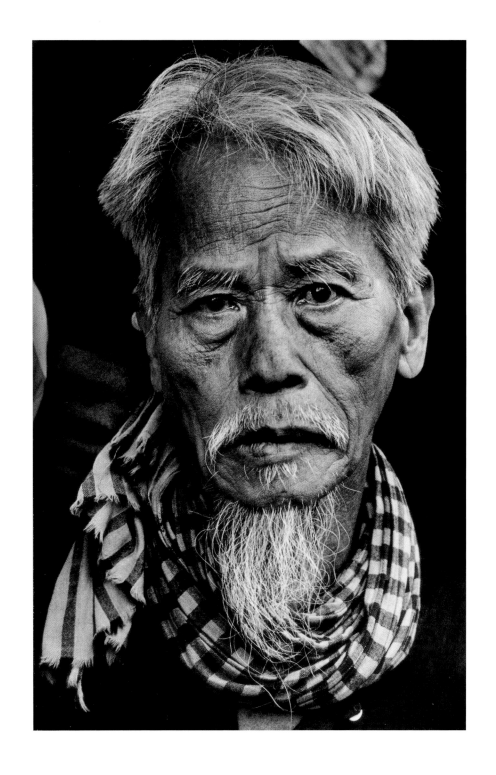

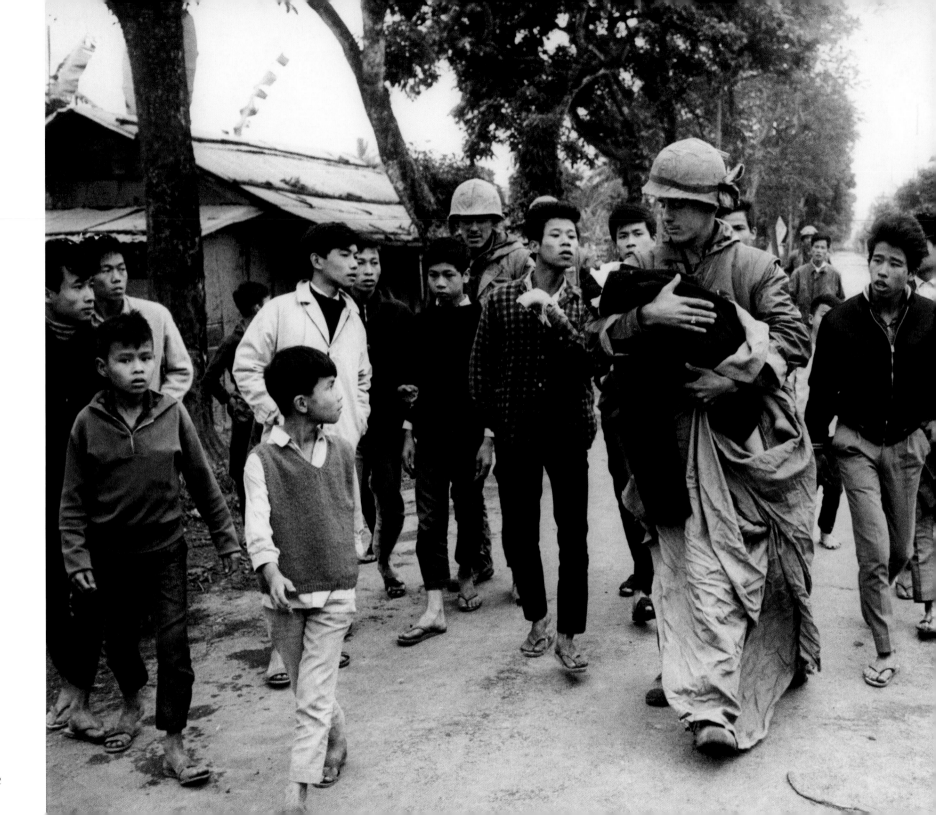

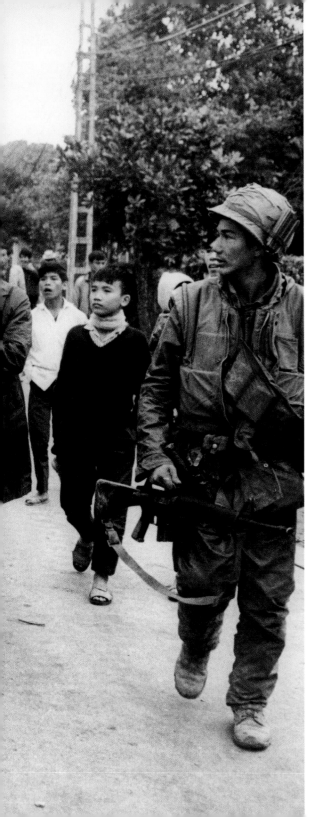

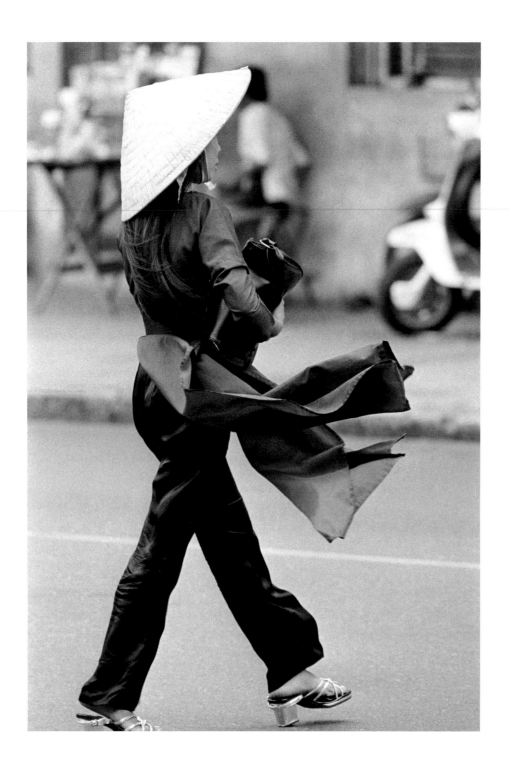

David Hume Kennerly *photographer* / Joseph L. Galloway *writer*

DREAM WALKING

She crosses a busy street, resplendent in her best *ao dai*, which caresses her body and the wind as she walks, at once demure, covered neck to ankle, yet revealed as the thin rayon clings to her subtle curves. She is delicate and shy and unworldly on the outside, but her backbone is of the finest steel, her courage unquestioned.

Early in our war, there were quiet days when we would jeep the highway between Da Nang and the old city of Hue. There each would hire his own sampan and be poled into the middle of the Perfume River to lay back on bamboo mats and be rocked by the breezes. Above, on a high bridge later destroyed by war, an endless stream of Vietnamese coeds bicycled home from the university at day's end, all wearing the pure white *ao dai* of the young, innocent girl. All wore their shining black hair waist length, some with it cut square across the ends, others with it untrimmed. They were visions shimmering in the heat, so lovely, so beyond our reach.

I dream of them still and wonder if they somehow survived Tet, survived the war, and gave birth to new generations of girls who bicycle across the Perfume River and into the dreams of young men. They must have survived; they are quintessential survivors, with that tough inner core so fitting in a nation born of a revolution in A.D. 40 led by two sisters, Trung Tac and Trung Nhi.

The sisters gathered an army of 80,000 to drive out the hated Chinese. Legend says the sisters chose thirty-six women, including their own mother, to general their army. They captured sixty-five fortresses and Trung Tac became, briefly, ruler of independent Vietnam. The people enjoyed their freedom for just three years before the Chinese returned, as ever. The Trung sisters committed suicide to uphold their honor.

A Vietnamese proverb says that when war strikes close to home, even the women must fight. They fought on both sides during the ten-year American war. In the North, the Communists mobilized more than 200,000 women for service in the regular army, militia, and local forces.

For a time, the South had its own dragon lady, Madame Nhu, as well as first ladies like Madame Thieu—who departed into a world of numbered Swiss bank accounts with suitcases filled with diamonds.

It was the women, major and minor wives of powerful men, who oversaw the money, the treasure, the loot. It was for the women to dole out pocket money to bad-boy husbands. The man might rule a nation, but at home he was no more than a lodger, a tenant. True power in Vietnam always lay elsewhere, and it wore a delicate *ao dai*.

If I could go back in time to that other Vietnam, it would not be to the war of my youth, but to the Perfume River and to those remarkable young women.

DAVID HUME KENNERLY was born in 1947 in Roseburg, Oregon. Since 1966, he has been a contributing editor to *Newsweek*. He went to Vietnam in 1970 for UPI, where he won a Pulitzer Prize. He was the personal photographer of President Gerald R. Ford. He became a contracted photographer for *Time* and photographed numerous heads of state, including Fidel Castro, Anwar el-Sadat, and Mikhail Gorbachev. His books include *Shooter, Photo Op, Sein Off,* and *Photo du Jour,* which was exhibited at the Smithsonian Institution Arts and Industries Building in 2002. He has received awards from the World Press, the Overseas Press Club, and the National Press Photographers Association.

Just three weeks before Pearl Harbor and America's entry into World War II, JOSEPH L. GALLOWAY was born in Texas. Coauthor of the bestseller *We Were Soldiers Once . . . and Young,* he spent nearly three years in Vietnam during the war for UPI and has since returned four times. Although it has been forty years since his first war assignment, he is still covering America's wars, most recently in Iraq. General Norman Schwarzkopf called Galloway "the finest combat correspondent of our generation— a soldiers' reporter and a soldiers' friend." He has two grown sons and lives in Washington, D.C. The senior military correspondent of Knight Ridder newspapers, Galloway has a syndicated weekly column.

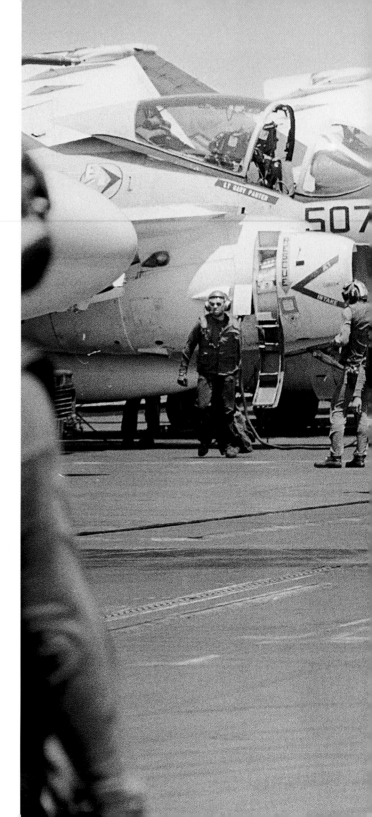

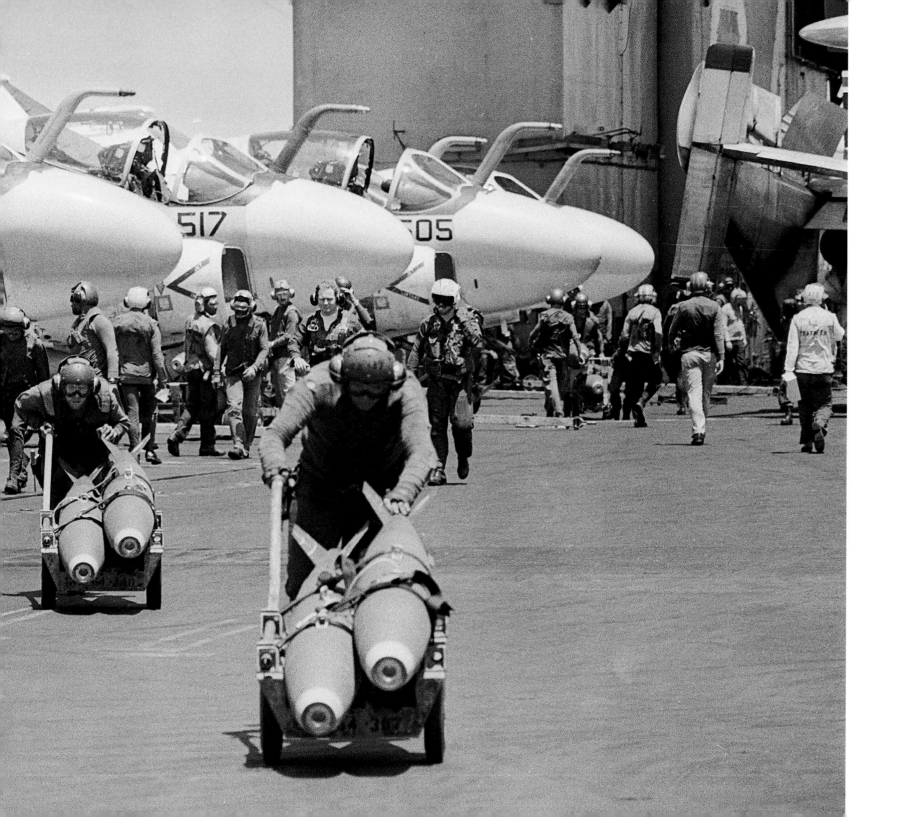

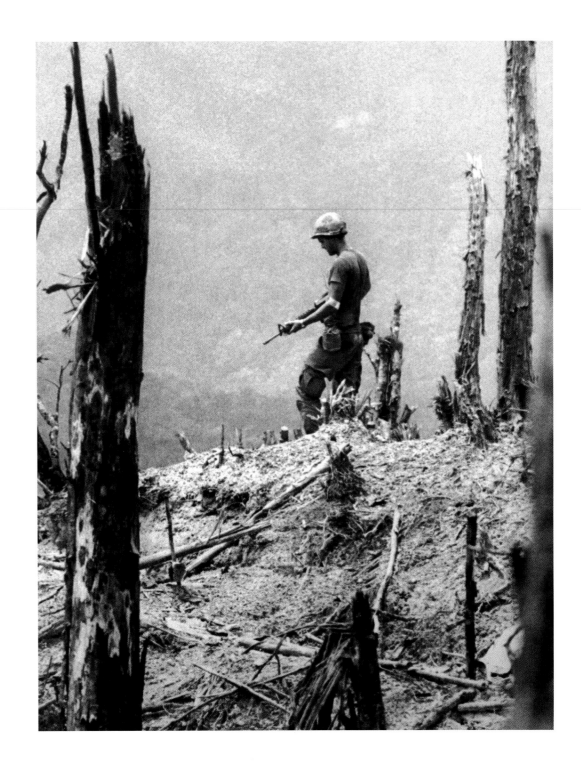

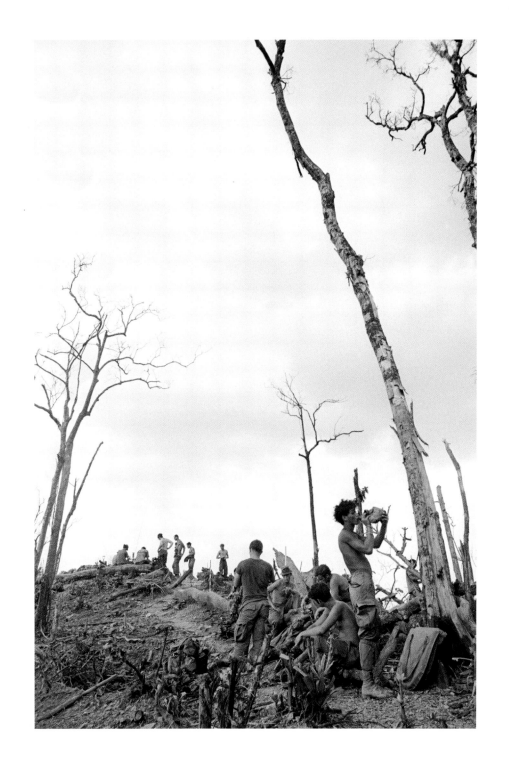

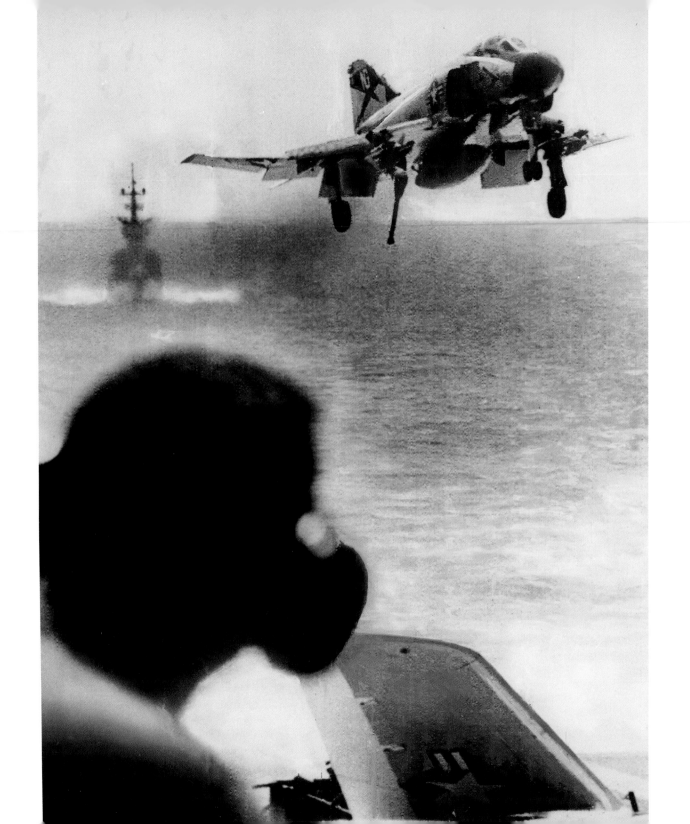

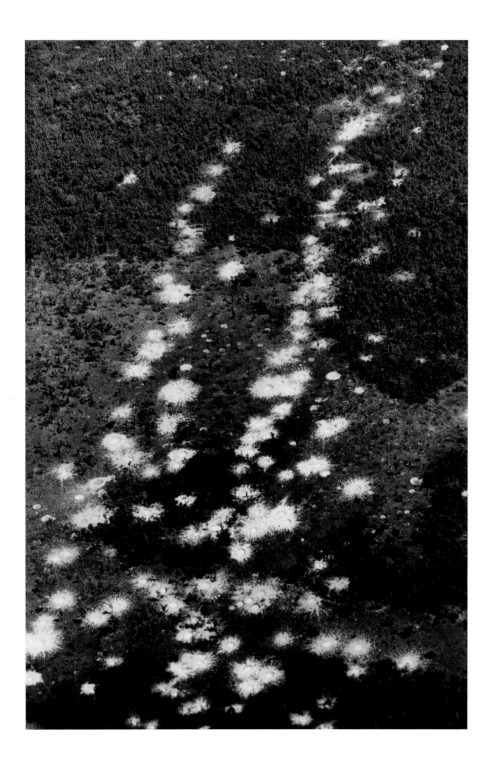

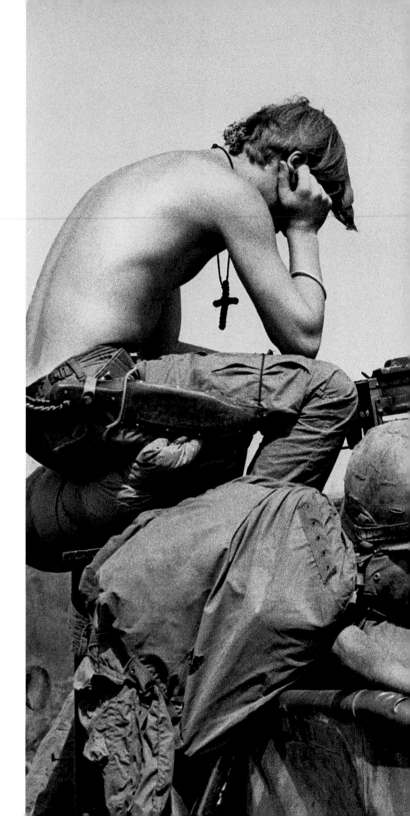

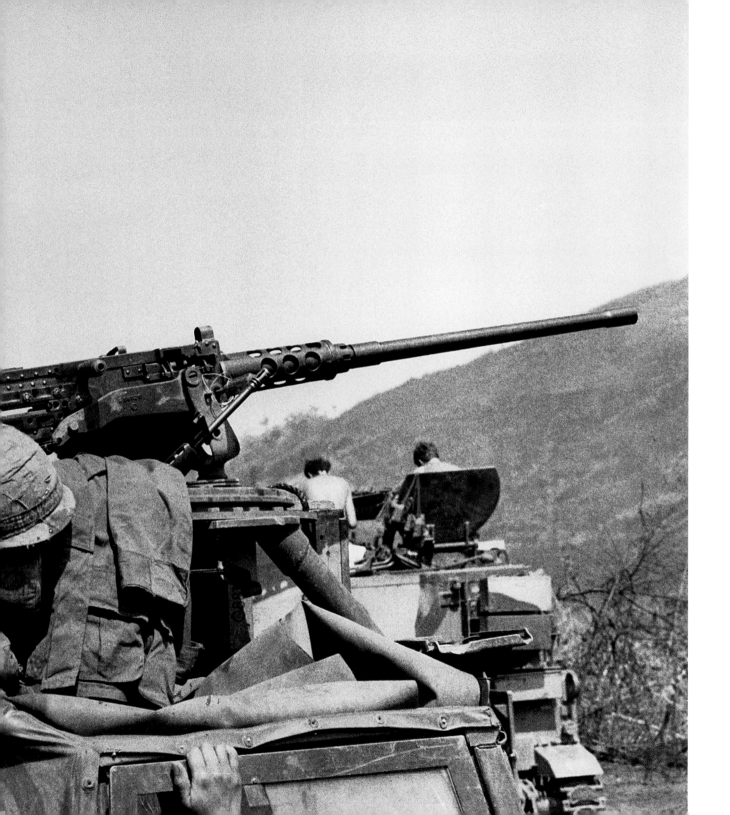

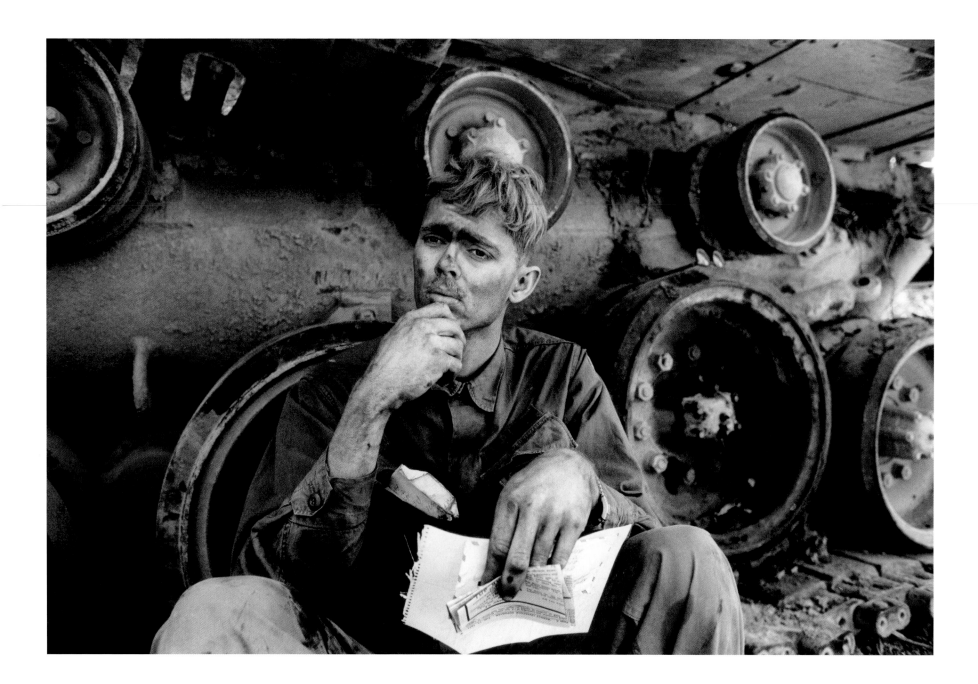

David Burnett *photographer* / Tim O'Brien *writer*

A LETTER FROM HOME

In David Burnett's haunting image, fixed in time, liberated from time, I see a sad, familiar yearning on the face of this young soldier, a longing for all that he cannot have, all that he may never have: a family, a child, a wife, a backyard barbecue with neighbors, a cold beer, a Big Mac, clean sheets, clean socks, a mother's touch, an uncomplicated laugh, a solitary walk through the woods, a Christmas with pretty lights and mistletoe. I see the heat of the Vietnam day.

I see the filth baked to his face. I see the looming machinery of war. I see the long, deadly nightmare that lies ahead for this soldier, all the toil and danger and frustration and terror and guilt and self-pity and second thoughts and moral ambiguity. Most vividly, though, I see a kind of wistful, old-man wisdom in the soldier's eyes, in the thoughtful tilt to his head, as if he has now come to understand things he had never before understood. He understands his own mortality. He understands loneliness. He understands that which is truly valuable in our world, and that which is so often taken for granted, all the simple things. At war, he now understands peace.

I see the young man I once was and will never be again. As though gazing into some historical mirror, I recognize my own fear and distress of thirty-odd years ago, my own pensiveness, my own craving for something better. I am reminded of how impossibly old I have become.

How little things change. How human beings always find such wonderful reasons to kill one another. How this young man's sad eyes could just as well be the eyes of a Civil War soldier, or the eyes of a POW on this evening's news broadcast out of Baghdad.

Who knows, really, what the young man is contemplating at this fast-frozen moment in time? But I do know, with near certainty, what he is not contemplating. He is not contemplating military strategy. He is not contemplating geopolitics. He is not contemplating how splendid it would be to sign up for a new war. He is not contemplating how patriotic and poignant and beautiful it would be if his unborn son were someday to fight a war of his own.

DAVID BURNETT was born in 1946 in Salt Lake City, Utah. He started his career during the Vietnam War with *Time* and *Life,* and has worked in over sixty countries: covering conflicts such as the coup in Chile (1973), the revolution in Iran (1979), the famine in Ethiopia (1984), and the fall of the Berlin Wall (1989). The 1993 Robert Capa Gold Medal and the 1979 World Press Photo Award are among the numerous awards he has received. He has also authored *E-motion: The Spirit of Sport,* based on his coverage of the Summer Olympics from 1984 to 2000. He has photographed every American president from John F. Kennedy to George W. Bush, and is co-founder, with Robert Pledge, of Contact Press Images.

Born in 1946 in Austin, Minnesota, TIM O'BRIEN graduated with a political science degree from Macalester College in 1968. Drafted, he reported for service and was sent to Vietnam with the "unlucky" Americal Division involved in the My Lai massacre. He was assigned to the 3d Platoon, A Company, 5th Battalion, 46th Infantry, as an infantry foot soldier. After Vietnam, O'Brien attended graduate school at Harvard. An internship at *The Washington Post* led to a career in journalism. This gave way to fiction writing after publication of his memoir *If I Die in a Combat Zone: Box Me Up and Ship Me Home.* A Pulitzer Prize nominee for his novel *The Things They Carried,* O'Brien is the author of several books, including *Going After Cacciato, In the Lake of the Woods, Northern Lights,* and *July, July.*

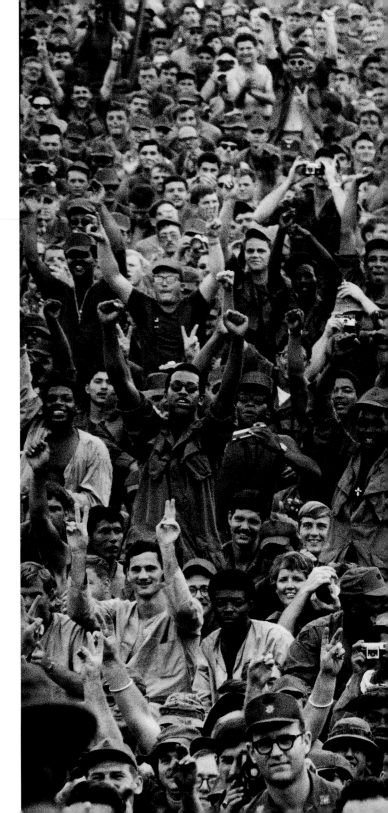

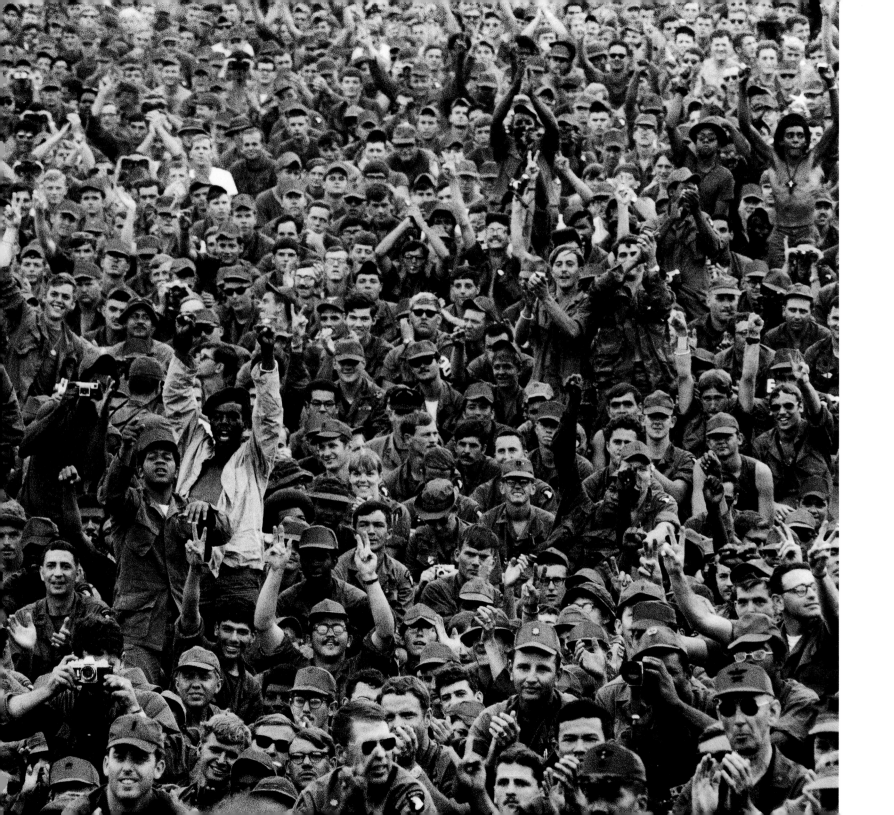

127

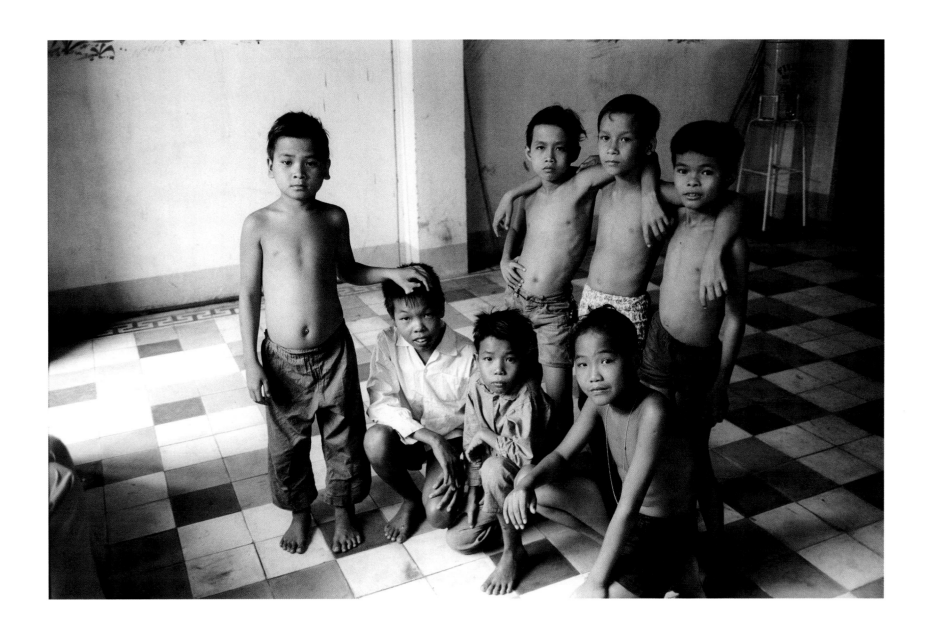

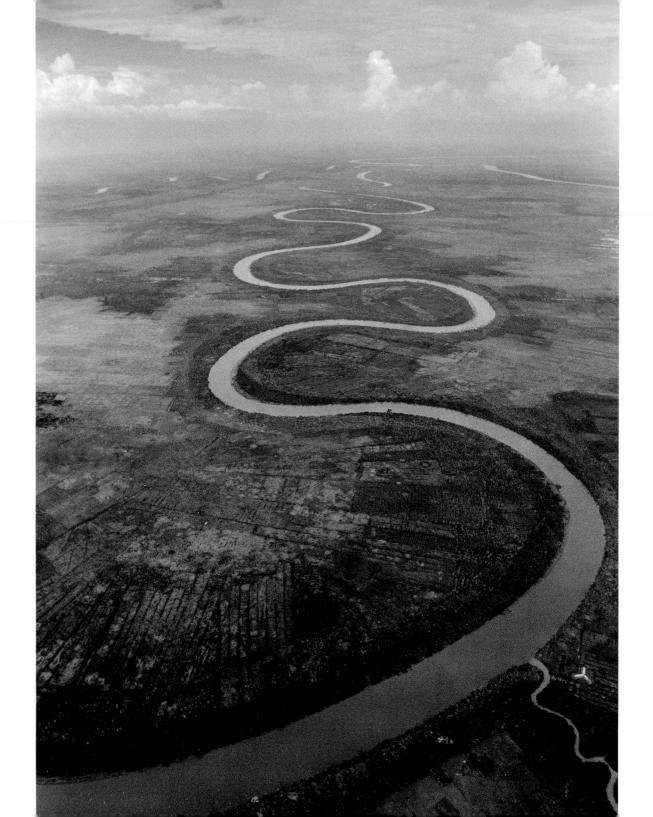

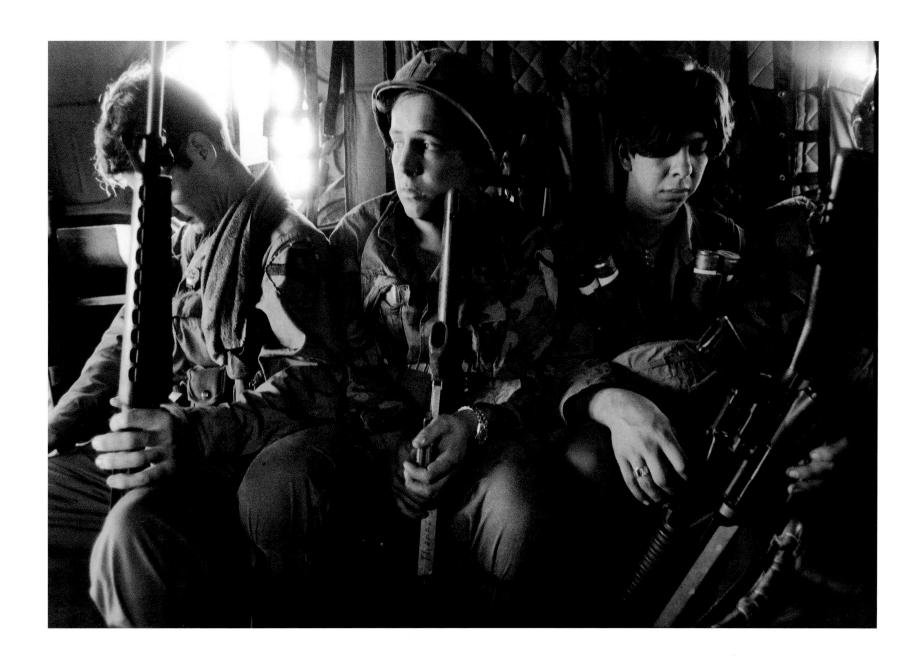

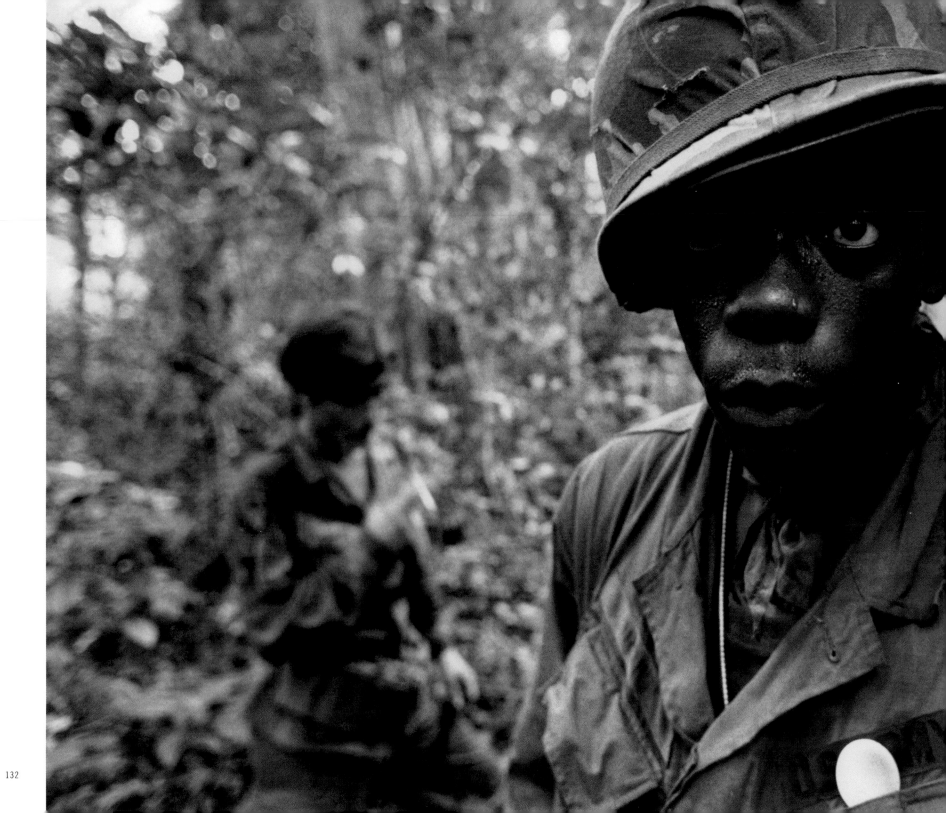

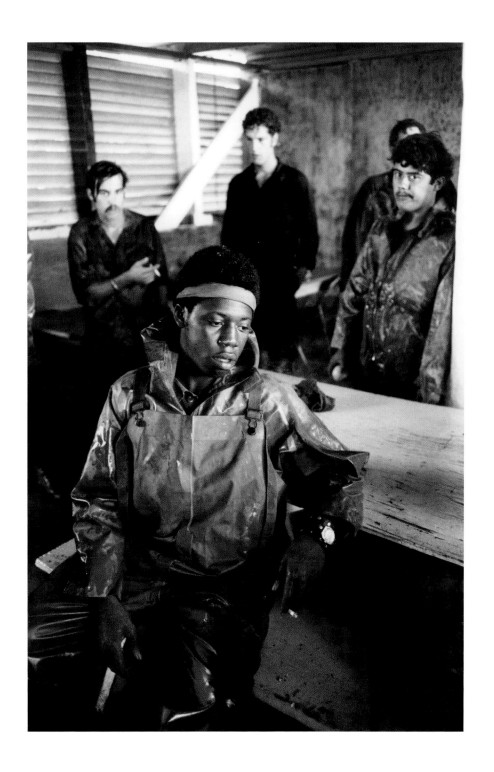

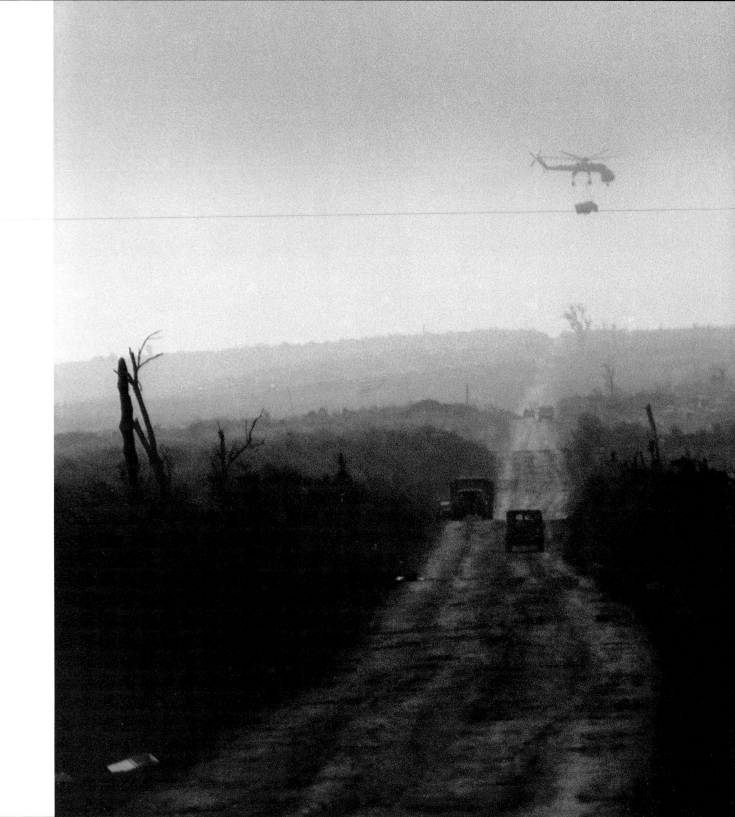

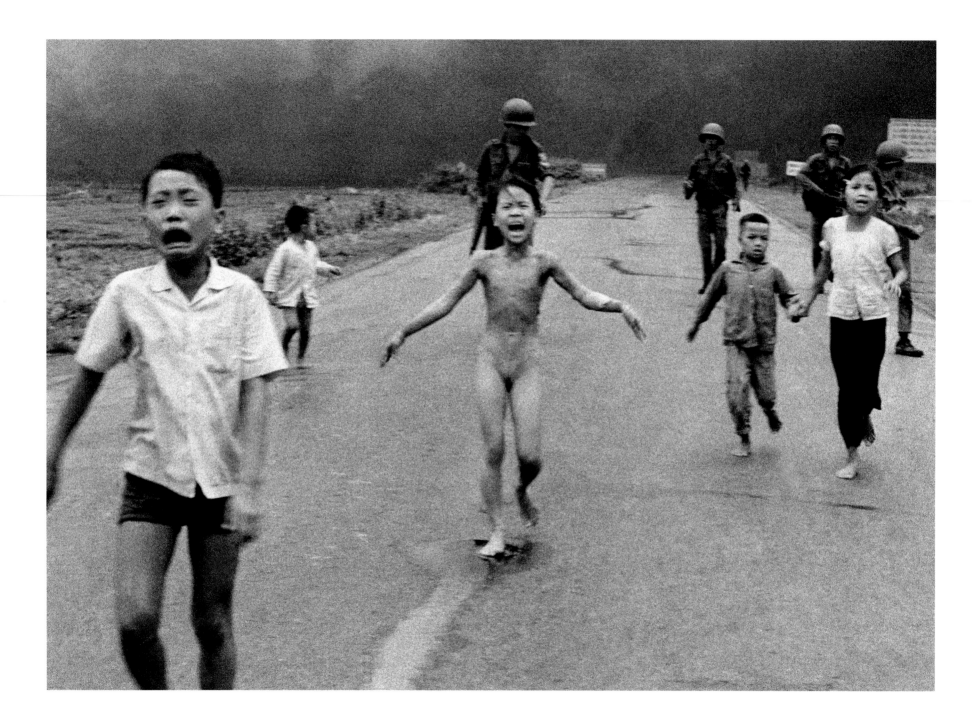

Nick Ut *photographer* / Bruce Weigl *writer*

NONG QUA

Her arms looked like wings, trying to beat her away from the burning village, away from her own burning body.

You may almost stand there beside her. You may breathe the fiery air she breathed. There is no way to say this. As Phan Thi Kim Phuc approached a group of journalists and photographers gathered on the highway to watch what they could of a battle during the Vietnam War, over and over the nine-year-old girl said *nong qua, nong qua* ("too hot").

On June 8, 1972, at one in the afternoon, the South Vietnamese Air Force dropped, on the edge of the village of Trang Bang, several different kinds of bombs, including napalm, which is its own hell, and which is part of this story. Phan Thi Kim Phuc must have been with her family. It was the summer holiday from school. Her mother and father ran a small restaurant near the Cao Dai temple. Even though they knew the North Vietnamese had already entered the city, they weren't entirely afraid and they didn't believe that their lives were in immediate danger. If you lived in Tay Ninh province during the American war in Vietnam, war was a constant background. In June in Tay Ninh province, the heat is like a heavy blanket that you can't unwrap. Kim Phuc must have been out of the heat, perhaps eating with her large extended family. I can see her there, as easy as it is to close my eyes. She must have felt first the concussive heat, although she says she saw the airplane, saw the fire, and got burned. She has reduced it to that. Running beside her that day and to her right is her older brother, who lost an eye to his wounds. Behind Kim Phuc and to her left is her five-year-old younger brother. Behind him are two cousins: the three of them miraculously escaped serious injury.

To tell this story right, you have to tell a story no one wants to hear. You have to know the facts and then forget them so that the story may be allowed to tell itself. There is nothing to the time and distance now because the story keeps happening inside of us and behind our closed eyes.

Once Kim Phuc had stopped running just past Nick Ut and the others standing on the highway, Ut heard her tell her brother that she thought she would die. The world around her had just been incinerated. She had torn off her burning clothes. Nick Ut and ITN correspondent Christopher Wain poured canteen water over her burns.

She holds her arms out at her sides because they are horribly burned, and they are not like wings, and they will not lift her away.

HUYNH CONG "NICK" UT was born on March 29, 1951, in the southern Mekong Delta province of Long An. The younger brother of AP photographer Huynh Thanh My, killed in 1965 while photographing combat action in the Mekong Delta, Ut was just fourteen years old when he was hired by AP's Horst Fass to mix photo-processing chemicals and keep the darkroom tidy. By 1967, little brother Ut had become an accomplished news photographer. His photos taken during the Tet Offensive testified to his courage and abilities. When he was twenty-one, Ut—by then called, affectionately, "Nick"—took one of the most recognized photographs of the Vietnam conflict, winning the Pulitzer Prize for Photography in 1973 for his picture of a nine-year-old girl, Phan Thi Kim Phuc, running away from the fire of napalm. The photograph also won awards from the World Press, Sigma Delta Chi, George Polk, the Overseas Press Club, and the Associated Press Managing Editors. Ut was evacuated during the last week of the Vietnam War. Now an American citizen living in Los Angeles, he continues to work as an AP photographer.

Born on January 27, 1949, in Lorain, Ohio, BRUCE WEIGL enlisted in the Army at eighteen and served in Vietnam with the 1st Airborne Cavalry, where he earned a Bronze Star. In 1979, he received a Ph.D. from the University of Utah. He is the author of thirteen collections of poetry, most recently *Song of Napalm, New and Selected Poems,* and *The Unraveling Strangeness.* In 2000, he published his memoir, *The Circle of Hanh.* For his work, Weigl has twice been awarded the Pushcart Prize, as well as a Paterson Poetry Prize and another from the Academy of American Poets. He is currently Distinguished Professor of Arts and Humanities at the Lorain County Community College.

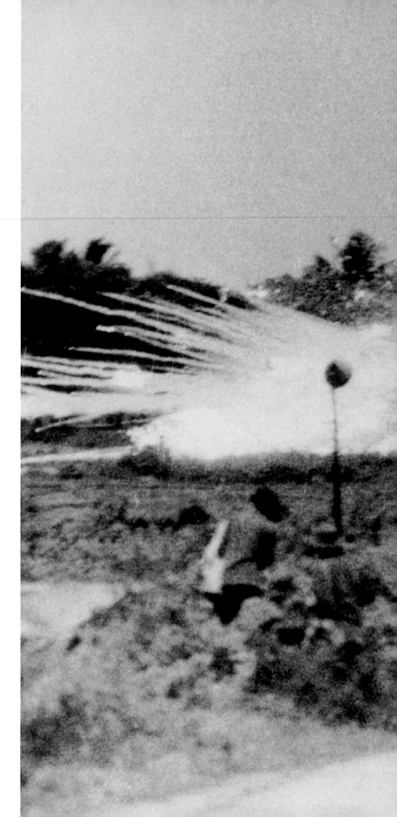

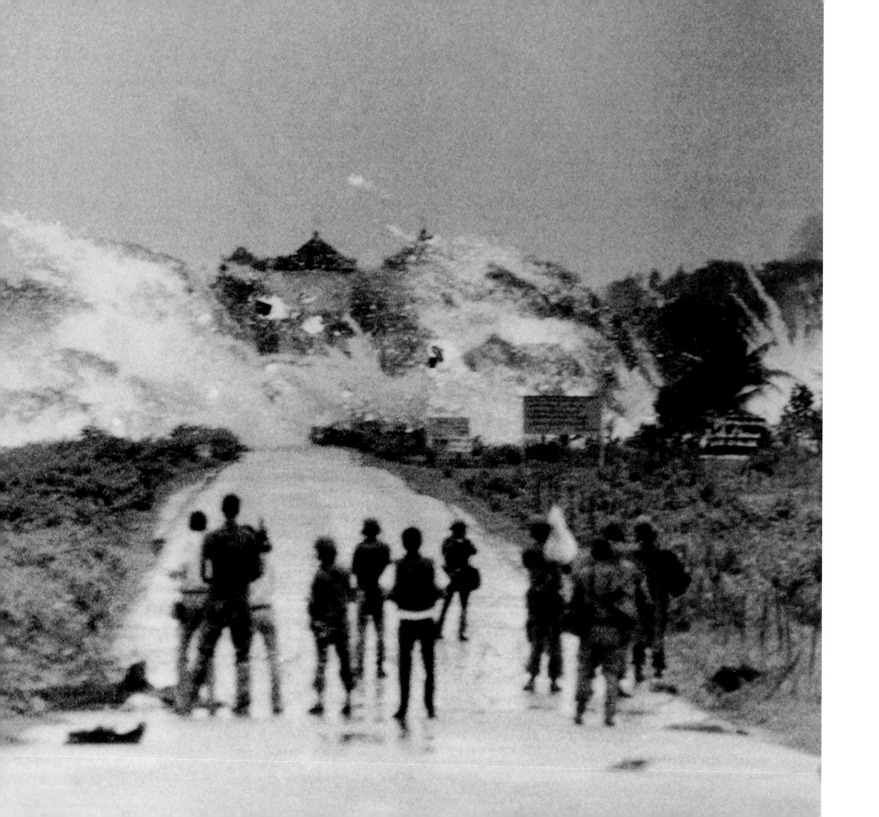

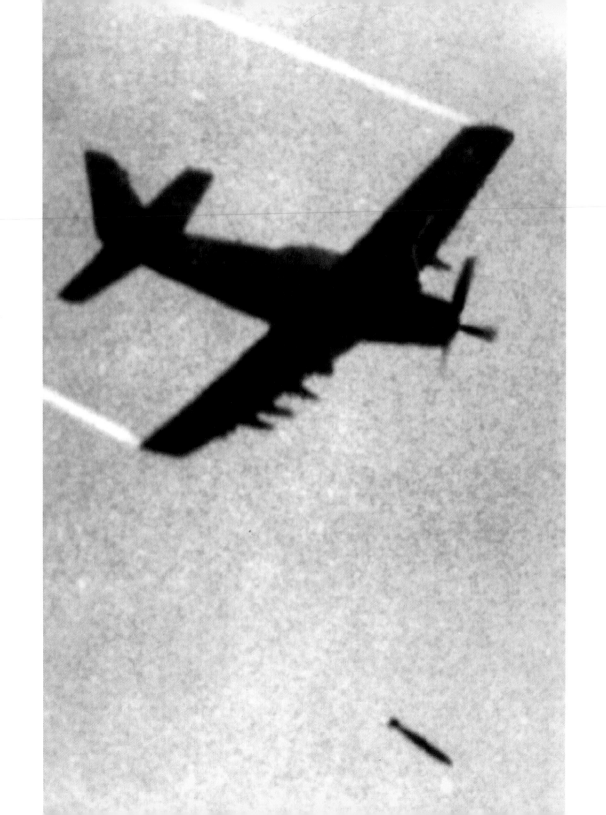

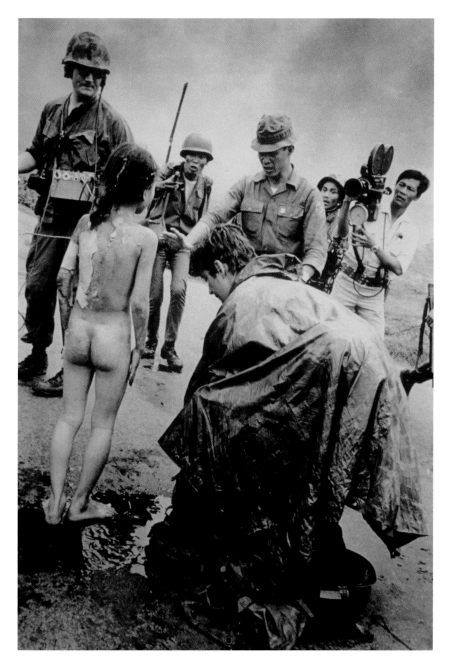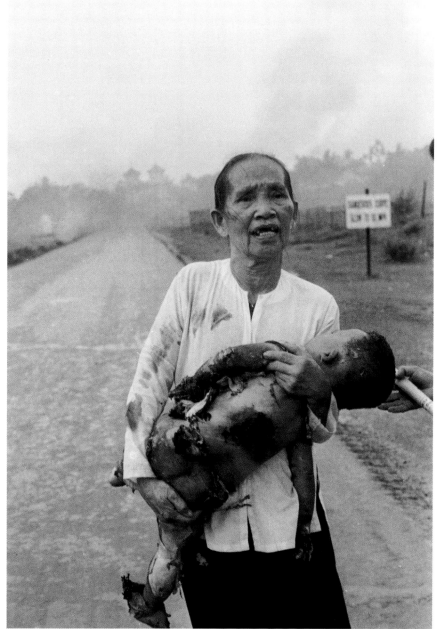

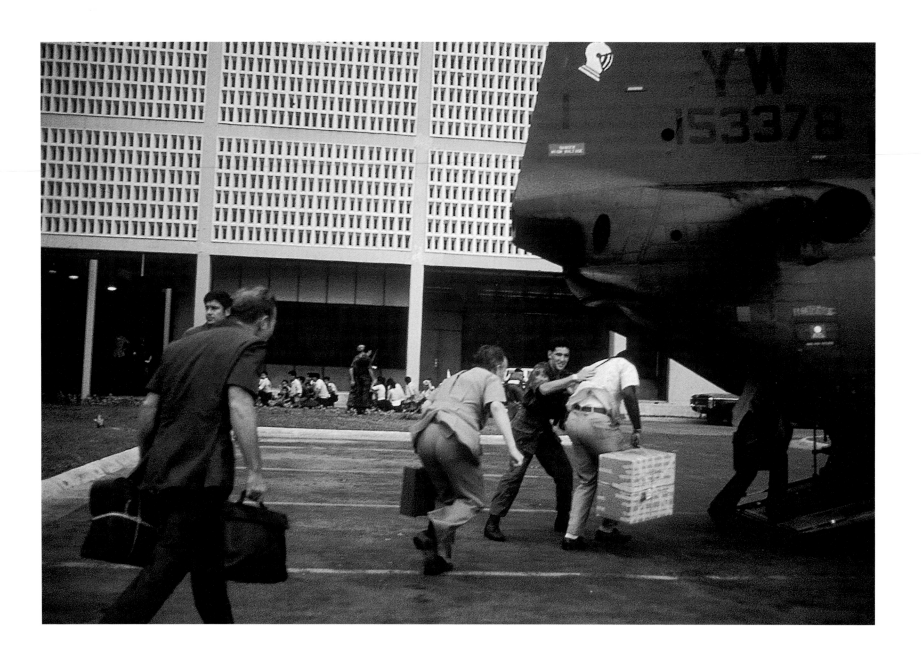

Nik Wheeler *photographer* / Loren Jenkins *writer*

THE LAST DAY

The end of the Vietnam War announced itself at the close of April 1975 with one last dawn rocketing of Saigon's Ton Son Nhut Airbase. The explosions were followed by the Armed Services Radio playing "White Christmas" in 98-degree tropical heat—the final code words for the U.S. to evacuate Saigon.

The final act of the Vietnam War played itself out in a frenzy of confusion at the U.S. Embassy, for a decade the seat of American dominion in South Vietnam, a modern, six-story building girded by a fifteen-foot white concrete fence topped with coils of barbed wire.

At its steel gates, thousands of Vietnamese milled—not in anger, but in fear of being left behind. On the other side of the walls, an assortment of CIA agents and State Department volunteers roamed the grounds, armed with weapons that ranged from antiquated tommy guns to hunting knives. Above, on the parapets, Marines used rifle butts and fists, repulsing those who tried to crawl up.

The tamarind tree that had shaded the ambassador's car had been cut down and dragged to the side to turn the asphalt parking lot into a helipad. Beyond it, by the swimming pool, thousands of Vietnamese allowed into the compound by virtue of past association with the U.S. authorities were herded together. They squatted on the ground, looking fearful amidst pathetic piles of small suitcases, cardboard boxes, and bundles of clothing.

Streamers of shredded embassy documents cascaded out of embassy windows as if this were a ticker-tape parade. Columns of smoke poured from offices as confidential documents were burned. Three burly CIA agents in flak jackets brought out a wheelbarrow heaped with a pile of crisp hundred-dollar bills and dumped it into the incinerator.

I met up with Nik Wheeler on the cafeteria's roof. He was calm, detached, and professional as he methodically clicked away at the motley gathering of Vietnamese, recording visages of confusion and pain, fear and defeat.

Big, gangly CH-46 Sea Knight helicopters from the Seventh Fleet, standing off in the South China Sea, arrived in relays. One would plop itself down in the parking lot while a second would alight on the roof of the embassy. With engines idling and rotors lazily swirling, Marine crew chiefs rushed lines of waiting Vietnamese and Americans on board. The engines revved, the helicopter would lumber upward to make room for the next. It went that way all day and then into the night. The random chaos of the morning soon settled into a routine. Helicopters came and went. Lines of refugees—by now, stoic and resigned—shuffled into the rear doors to be whisked out to sea. And even the clamor in the street outside seemed to have died with the sun.

Eventually, the embassy grounds were thinned. The Marines on the walls retreated into the embassy building proper, barring its doors, while those inside remaining to escape moved up toward the roof, floor by floor.

Around four in the morning, Ambassador Martin put his private secretary and his pet poodle, Nitnoy, into one helicopter and caught the next one out. As his helicopter lifted off, his last view of the country was a giant fireworks display as the Bien Hoa ammunition dumps erupted . . . and a long line of lights stretched north for miles as victorious North Vietnamese Army truck convoys drove the final miles to victory.

NIK WHEELER was born in 1939 in Hitchin, England. He started his professional career as a war photographer in Vietnam for UPI. His pictures were published in newspapers all over the world. He moved to Beirut in the early 1970s, and freelanced throughout the Middle East for several European magazines. In 1975, he photographed the fall of Saigon for *Newsweek*. His first book, *Return to the Marshes* (1977), with Gavin Young, grew out of a *National Geographic* assignment. Based in California, he is the cofounder of the award-winning *Traveler's Companion* guides. He has amassed a library of 350,000 images from sixty countries around the globe.

Born in 1940 in New Orleans, Louisiana, LOREN JENKINS studied political science at the University of Colorado and Columbia University. Jenkins spent twenty-five years overseas as a correspondent for UPI, *Newsweek,* and *The Washington Post,* reporting from locations that included Saigon, London, Madrid, Paris, Beirut, Hong Kong, and Rome. Jenkins was *Newsweek*'s last bureau chief in Saigon. For his *Washington Post* coverage of the Israeli invasion of Lebanon and its aftermath, he won the Pulitzer Prize for international reporting in 1983. He has also won several Overseas Press Club awards for economic and environmental reporting. He joined NPR in 1996 as senior editor, managing the network's award-winning international coverage.

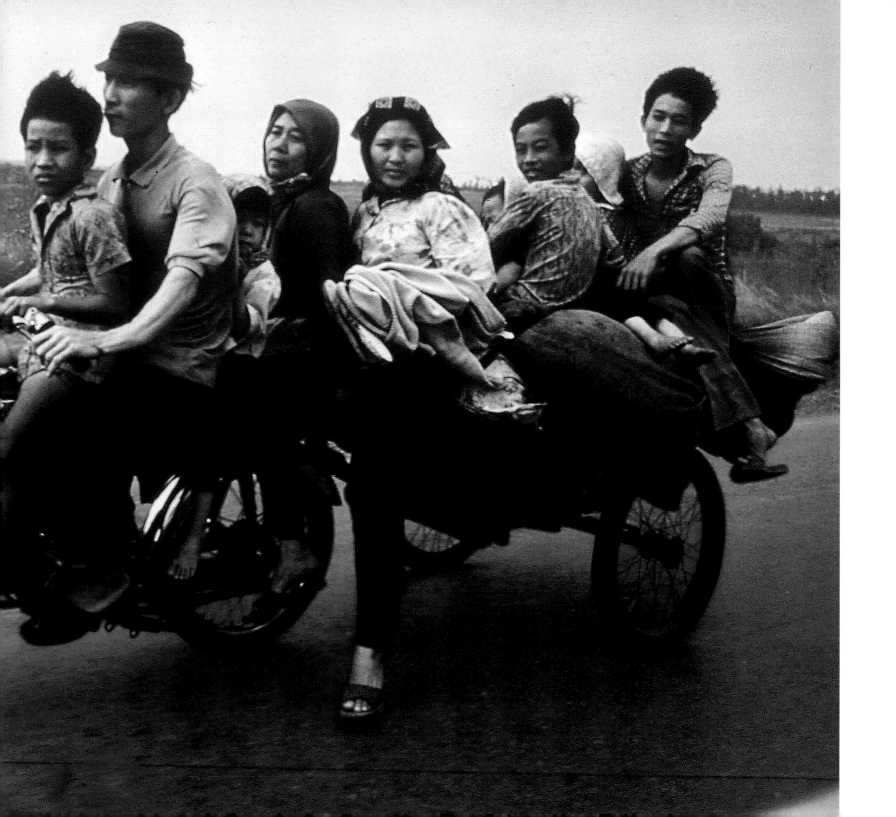

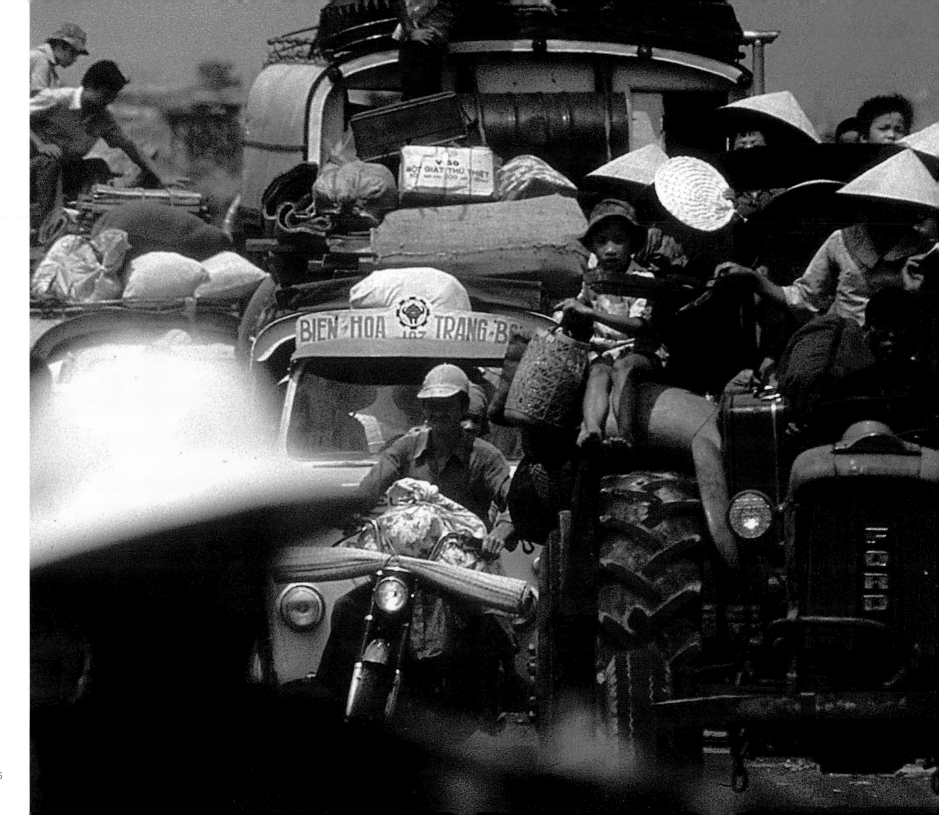

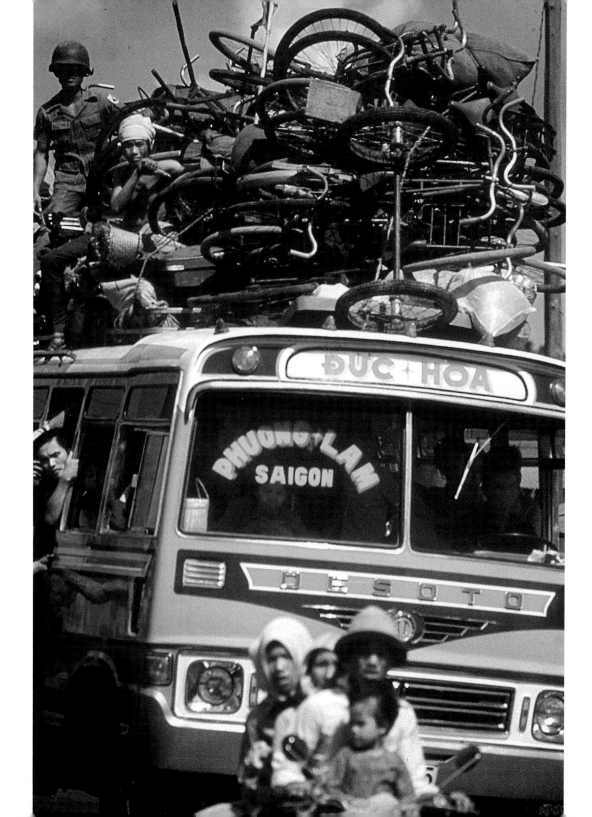

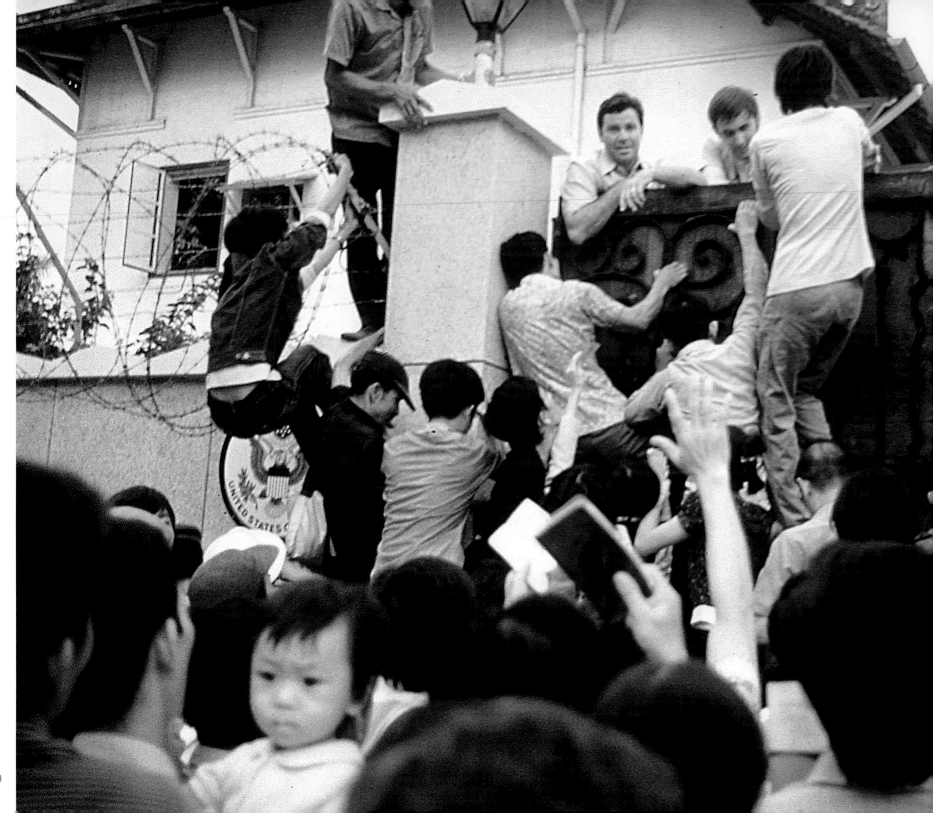

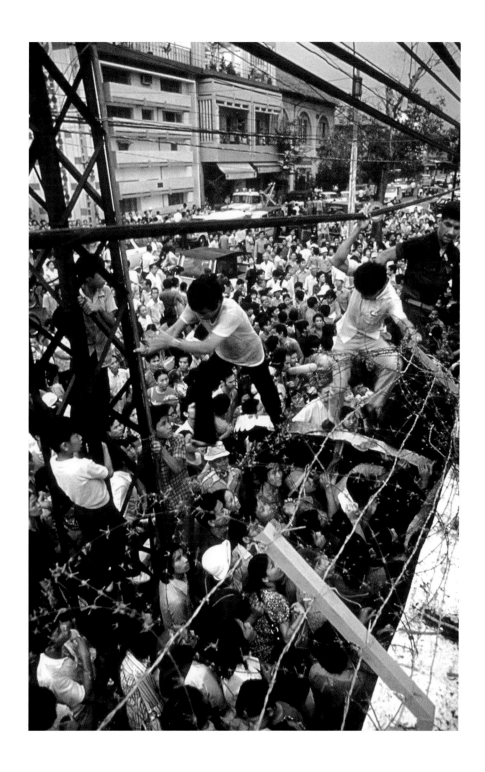

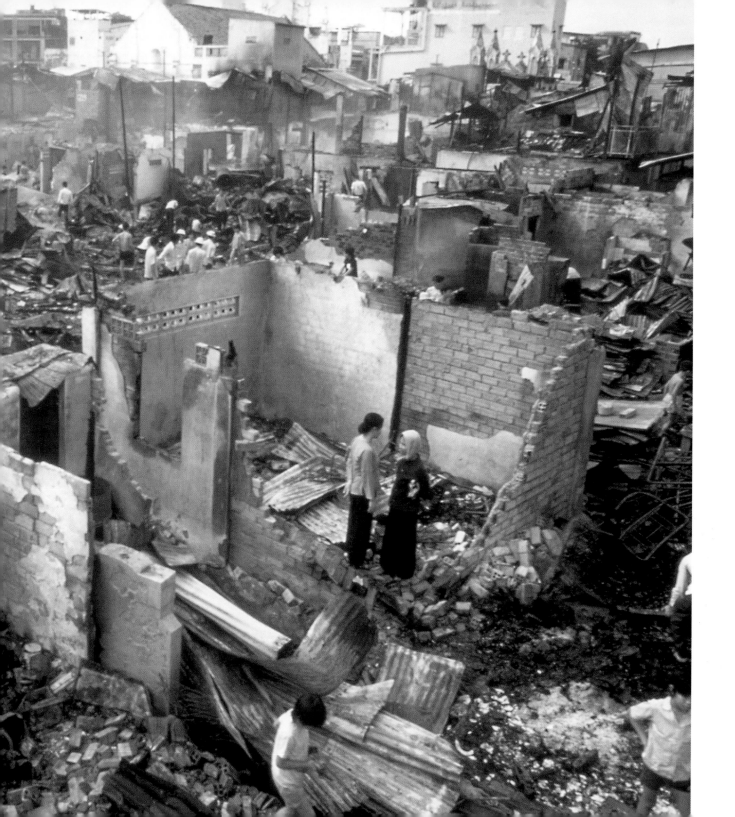

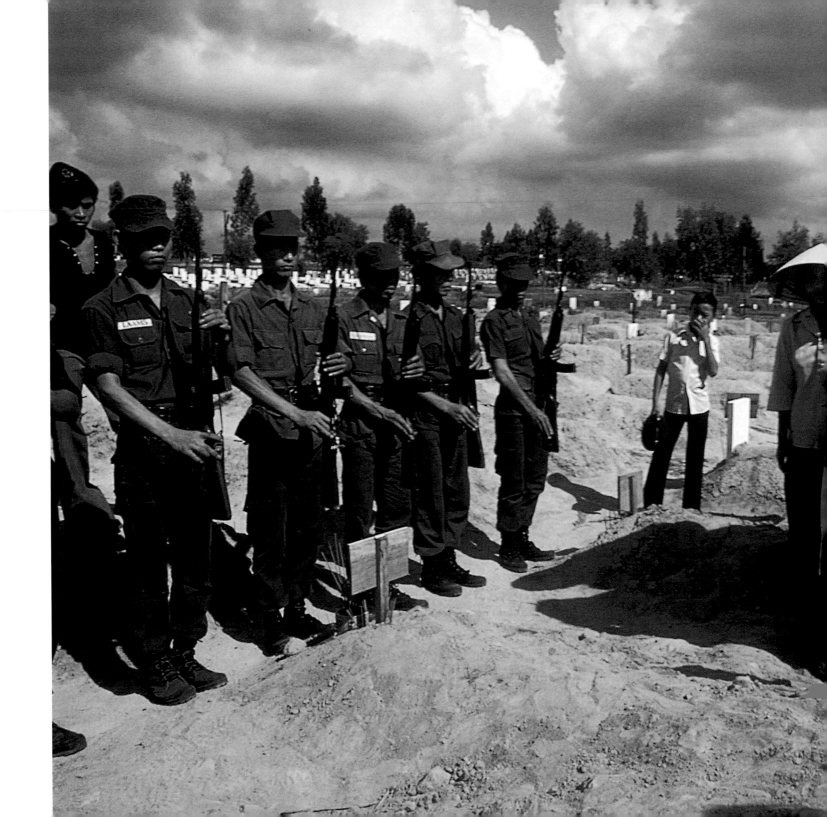

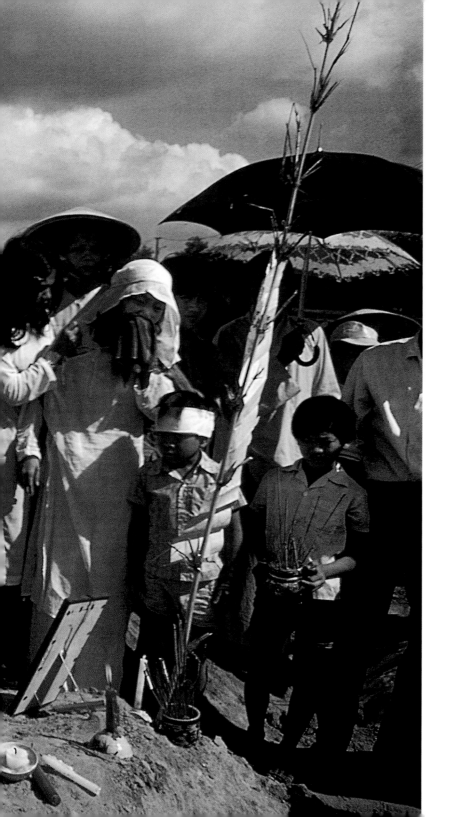

HUBERT VAN ES was born on July 6, 1941, in Holland. After graduating from college, he started working as a photographer with Nederlands Foto Persbureau Amsterdam. Later, he moved to London and worked for the Dutch music magazine *Muziek Parade*. Van Es joined the the *South China Post* in Hong Kong as their chief photographer in 1967. Based in Saigon between 1968 and 1975, he freelanced for NBC, AP, and UPI. His picture of the evacuation of Vietnamese on the roof of the USAID Building on April 29, 1975, has been the most reproduced photograph of the war. Van Es lives in Hong Kong, where he freelances for European and American magazines.

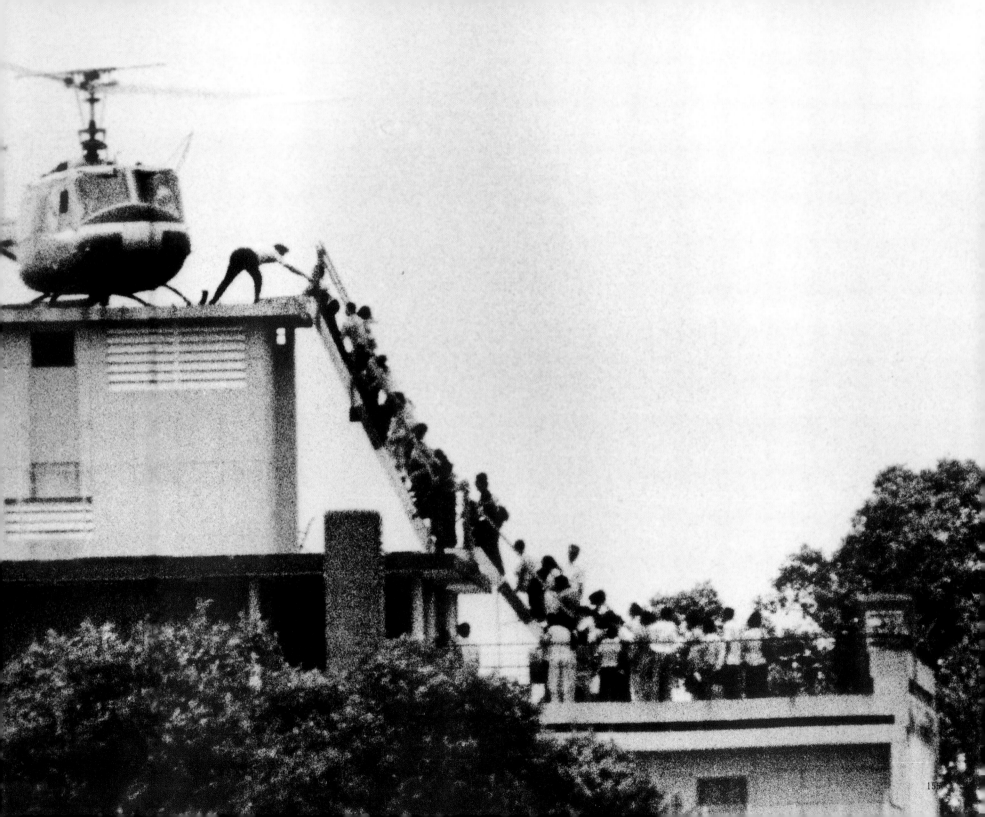

155

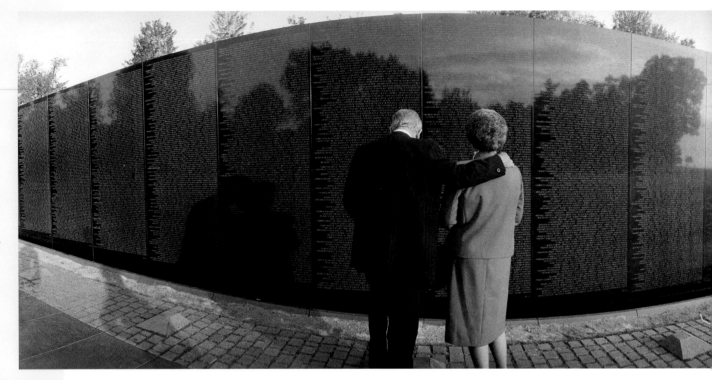

The biography for **DICK SWANSON** is on page 52.

A veteran war correspondent and former divinity student, **CHRIS HEDGES** was born on September 18, 1956, in Vermont. He is the author of *War is a Force That Gives Us Meaning*, based on his experiences in the Balkans, the Middle East, Africa, and Central America. Before joining the staff of *The New York Times* in 1990, he worked for the *Dallas Morning News*, *The Christian Science Monitor*, and National Public Radio. In 2002, he received the Amnesty International Global Award for Human Rights Journalism, and also shared the Pulitzer Prize awarded to *The New York Times* for its coverage of global terrorism.

Dick Swanson *photographer* / Chris Hedges *writer*

THE WALL OF WAR

The wall is as close as war memorials can come to being antiwar. It creates a sacred space, a space where we can step outside the profane concerns of daily life and grapple with the ultimate meaning in our lives, the sacredness of life, the brevity of it, and the godless enterprise of war.

But war memorials, even this one, are suspect. There are no images in war memorials of men, their guts hanging out of their bellies, crying for their mothers or being unceremoniously dumped in body bags. There are no sights of small children burned beyond recognition. There are no blind and deformed wrecks of human beings limping through life. And the war makers, those who made the war but never paid the price of war, live among us, writing thick memoirs, giving sage advice, our elder statesmen, our war criminals. What do they think when they come here? Do they understand the betrayal they carried out? Do they feel guilty? Do they see their own face in the polished granite? I doubt it.

A war memorial that truly explains war would be too subversive to be allowed on the Mall in Washington. Those who return from war, if they have the power and strength to look inward, understand the darkness within all of us. They have learned that the line between the victims and the victimizers is razor thin, that human beings, when the restraints are cut, can be intoxicated by mass killing, and that war, rather than being noble, heroic, and glorious, banishes all that is tender and decent and kind. They know that the face of war is the face of death.

Those who survive have a righteous anger, a prophetic anger, at those who lied to them—the state, the religious institutions, the media—all who painted war as a great and glorious crusade. Those we remember in memorials were killed not only by those they fought in Vietnam, but those at home who turned them over to the meat grinder of war even as they knew that war could not be won.

There should be a way to honor the dead and not allow the state that failed them to be honored as well, to remind people that war is always about betrayal, the betrayal of the young by the old, idealists by cynics, and finally soldiers by politicians. There should be a way to keep the rage and anger about the old lie alive, not solemnize and bury it. But the mythmakers will never permit this to happen. The myth of God and country, our civic religion, is too powerful. And, in the end, we all want to believe in our goodness, not see our perfidiousness.

The plastic representations of war, the old cannons or artillery pieces rolled out to stand near memorials, become curious historical objects. We forget what these objects did to human bodies. It is a part of the cleansing of our memories of the reality of war: the denial of the complicity of state and industry in the death of our young. These memorials are easily twisted and used, not only to pay homage to those who made "the ultimate sacrifice" or those who survived, but, in the end, to dignify the slaughter, perpetuate the old lie of honor and glory, and set the ground for the next inferno.

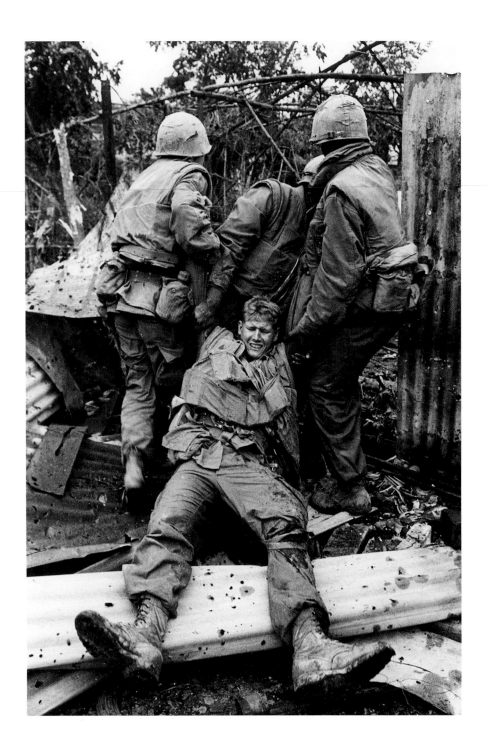

Parsing the Wound

FRED RITCHIN

"If your pictures aren't good enough, you aren't close enough," said Robert Capa, perhaps the photographer who did the most to make war up close and personal. He meant an emotional closeness, not just the physical proximity to bullets and wounds that is the unenviable task of the photographic observer.

But Robert Capa came from another era, that of the Spanish Civil War and World War II, when empathetic photojournalism was new, television had not yet become the relentless cyclops in the living room, and a photojournalist could choose a side to cover and feel reasonably comfortable in the rightness of his or her effort. In these earlier wars, Western photographers were present to support the democratic impulse against the fascistic one, bearing witness in a joint campaign to make the world a better place. Photographers shot film, soldiers shot bullets. And the photographers were there, as it turned out, to alert the world to war's human cost—pictures of terrified children, falling soldiers, the skeletal survivors of death camps—through publication in newspapers and recently established picture magazines. But they were there not to horrify readers, because while war was devastating, it was a necessary evil: good could still triumph.

The Vietnam War started out, in the minds of U.S. administration officials, as a repetition of these earlier struggles, a conflict with similar goals. Young photographers and journalists, some with virtually no experience, were encouraged to cover what government officials thought of as a concerted effort to bring democracy to the region. But these officials did not expect the agonizing imagery that resulted, an expanding collection of fractional seconds caught on film that would define and continually redefine the horror of that abstraction called "war." Encouraging young and often idealistic photographers to reveal the violent calculus of war meant that vivid, even untenable images would be widely disseminated, firing an emerging debate on the war's morality and goals.

These photojournalists explored the graphic power of the camera in ways that their predecessors could not or did not dare to do. During World War II, it was not until September 1943, nearly two years after the United States entered the conflict, that the War Department cleared for publication its first photographs of American

dead (an image appeared in *Life* from Buna Beach, New Guinea, of three faceless soldiers sprawled on the sand in a kind of repose). But in the Vietnam War the apocalypse was less easily contained. In images that were more palpably intimate, more shockingly horrific, photographers described a war that, while touted as a campaign for democratization, could be summed up for many of those on the ground by the title of photographer Don McCullin's book *The Destruction Business.*

The photographers had to try to comprehend scenes that elided the more familiar mythology of good and evil. It was the territory of actual war, the microcosm of bullet piercing skin, the universe of crumbling souls. In an attempt to parse landscapes of horror, intellectually confusing and morally ambiguous, photojournalism became a medium that interrogated layers of reality rather than providing simple answers. The photographers had transcended—some might have said "abdicated"—their traditional role as recorders of a monumental conflict who worked in the service of one side. It was not the riveting drama of black hats against white hats but the existential dread caused by the landing of an artillery shell in a rice field that engaged them.

The U.S. government has said, in the years since the withdrawal of troops from Vietnam, that it does not want "another Vietnam." There has been a justified fear among many governments that the devastating imagery that comes from depicting war's entrails would douse any enthusiasm their citizenry might have for an armed conflict. The first Persian Gulf War, for example, was conducted outside the reach of lenses. Photographers were mostly excluded from combat while television analysts debated simulations of various possible outcomes. Pictures from the point of view of a "smart" bomb, not a person, just before the bomb hit its apparently bloodless target were published, but very few photographs of troops fighting ever appeared. War was rendered as remotely virtual as a video game.

The strategy of exclusion was used often by governments in other conflicts, such as in South Africa, the Falklands or Malvinas, and Israel and Palestine. The published photographs of dead American soldiers being dragged through the streets of Mogadishu in 1993, for example, were a major reason why the United States did not intervene while genocide was expedited in Rwanda the following year. Who wanted to risk more such images?

In the most recent war in Iraq, the U.S. and British governments tried a new tack, "embedding" photographers with soldiers. Perhaps partially as a result of their dependence on these same soldiers, many visual journalists produced photographs that reiterate World War II–style images of heroism in the struggle to liberate occupied lands. Comparatively little attention was paid to the impact of the war on Iraqi civilians, and as the war

continues, it has become too dangerous for the foreign press corps to explore the communities surrounding them. Unlike during the Vietnam War, photojournalists and their colleagues are increasingly targeted in Iraq and elsewhere throughout the world.

Moreover, the war in Iraq is the first all-digital war, requiring that photographers work on constant deadlines, editing and transmitting their own work. Photographers who covered the Vietnam War often did not see the pictures from their film for weeks or even months. The contemporary digital photographer is increasingly under the thumb of editors who, competing with television and the Internet, may expect delivery of the images to be almost simultaneous with the event itself. The photographer under deadline pressure is pulled from the field when events may have only just begun. How does one create photographs that are in-depth, let alone original, in this new media environment?

And now, in the digital age, a growing competition is coming from amateur photographers—American soldiers, insurgents, Iraqi taxi drivers, employees of U.S. Defense Department subcontractors—who have made perhaps the most revelatory images, such as those of the abuses in the Abu Ghraib prison or of the coffins of American soldiers being prepared for shipment. Made digitally, these photographs, for better or worse, can be easily e-mailed and published on the Internet within minutes. The professionals are too often corralled into covering "photo opportunities"—the president in a flight suit, announcing MISSION ACCOMPLISHED, for example, or appearing to serve turkey to the troops.

The photography of the Vietnam War remains unique. It was an experiment in image making that no powerful government will ever again abide. The photographic legacy created by these men and women is no less than a visual definition of the abyss—with its bravery and terrifying carnage—that we call "war." It is an abyss that has in these pictures become, at least temporarily, a sacred space.

Captions

DANIEL CAMUS | ALL PHOTOS © ECPAD-*PARIS MATCH*

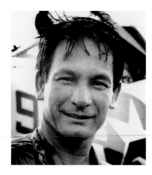

HENRI HUET | ALL PHOTOS © AP WIDE WORLD PHOTOS

LARRY BURROWS

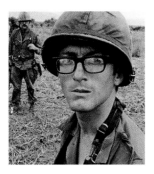

DANA STONE

GILLES CARON | ALL PHOTOS © CONTACT PRESS IMAGES

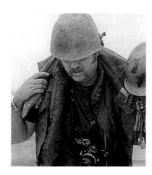

DICK SWANSON | ALL PHOTOS © DICK SWANSON

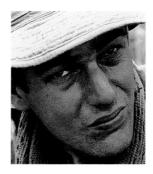

TIM PAGE | ALL PHOTOS © TIM PAGE

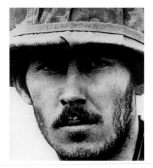

ROBERT ELLISON | ALL PHOTOS © BLACK STAR

66 Marines take cover during North Vietnamese artillery attack (Khe Sanh, 1968).

68–69 An ammunition dump explodes after being hit by a North Vietnamese artillery shell (Khe Sanh, 1968).

70 Spent artillery casings (Khe Sanh, 1968).

71 Portrait of a Marine (Khe Sanh, 1968).

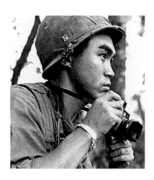

KYOICHI SAWADA | ALL PHOTOS © BETTMANN/CORBIS

72 A Vietnamese mother and her children cross a stream to escape the U.S. bombing of their village (Qui Nhon, 1965).

74–75 A group of civilians under arrest (Hue, February 1968).

76 An injured North Vietnamese soldier, led by soldiers of the 1st Cavalry Division (Bong Son, 1966).

76–77 The body of a Viet Cong soldier being dragged behind an armored vehicle for burial (Tan Binh, February 1966).

78 Marines take cover behind tanks during street fighting during the Battle of Hue (February 1968).

79 A Marine drags a wounded comrade (Hue, February 1968).

80–81 Marines near the destroyed citadel (Hue, February 1968).

82 A Marine take a rest during a lull in fighting (Hue, February 1968).

83 A Vietnamese mother carries her wounded child (Hue, February 1968).

CATHERINE LEROY | ALL PHOTOS © CATHERINE LEROY

84 Vernon Wike, a corpsman with 2/3d Marines, having crawled to a fallen Marine, applies first aid (Battle for Hill 881, 1967).

86–87 Wike tries to detect a heartbeat amid the deafening noise of the battle.

88 Wike looks up in anguish when he realizes that his comrade is dead.

89 Dead Marine (Battle for Hill 881, 1967).

90 A soldier of the 1st Air Cavalry Division punches a Viet Cong who was caught hiding in a stream (Bong Son, 1967).

91 Two Viet Cong prisoners (Mekong Delta, 1966).

92 Under fire near the DMZ, a Marine holds a wounded comrade. (Operation Prairie, 1967).

93 A Marine screams in pain. Operation Prairie, near the DMZ (1967).

94 Flares over the Da Nang River on the eve of the Tet Offensive (January 31, 1968).

95 A North Vietnamese lieutenant and his men guard a position near the Cathedral of Hue at the onset of the Tet Offensive (February 1, 1968).

96 A wounded Marine is attended by a corpsman (Hue, February 1968).

97 A North Vietnamese soldier atop his foxhole (Hue, February 1, 1968).

98 A camouflaged North Vietnamese sniper holds his position near the Cathedral of Hue (February 1, 1968).

99 A Marine is hit by North Vietnamese fire during the Battle of Hue (February 1968).

100–101 A Vietnamese mother holds her wounded child (Hue, February 1968).

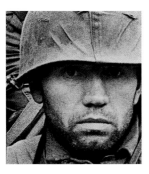

DON McCULLIN | ALL PHOTOS © CONTACT PRESS IMAGES

102 Portrait of a Marine during the Battle of Hue (February 1968).

104–5 A Marine throws a grenade during the Battle of Hue (February 1968).

106 A Marine chaplain carries an old lady who had been found trapped in the rubble during the Battle of Hue (February 1968).

107 A Marine looks through the window of a house, a portrait of a Vietnamese couple at his feet (Hue, February 1968).

108–9 Marines evacuate a wounded comrade (Hue, February 1968).

109 A wounded North Vietnamese soldier is evacuated by Marines (Hue, February 1968).

110 A dead North Vietnamese soldier and his plundered belongings (Hue, February 1968).

111 Portrait of an elderly Vietnamese man (Hue, February 1968).

112–13 A Marine carries an infant to safety (Hue, 1968).

DAVID HUME KENNERLY

114 A Vietnamese girl wearing the traditional *ao dai* crosses the street in Saigon (1971). © David Hume Kennerly

116–17 U.S.S. *Constellation* crewmen rush five-hundred-pound bombs to aircraft (1972). © Bettmann/Corbis

118 An American G.I. cautiously moving over a devastated hill near Firebase Gladiator (1972). © Bettmann/Corbis

119 American soldiers taking a break after fighting near Firebase Gladiator (1972). © Bettmann/Corbis

120 A Navy Phantom jet returns to the carrier U.S.S. *Constellation*. In the background is the destroyer escort U.S.S. *Badger* (1972). © Bettmann/Corbis

121 Bomb craters (1972). © Bettmann/Corbis

122–23 A U.S. soldier lost in thought (1971). © Bettmann/Corbis

DAVID BURNETT | ALL PHOTOS © CONTACT PRESS IMAGES

124 A letter from home (Lang Vei, 1971).

126–27 American soldiers at a USO concert in Da Nang (1971).

128 Street children play in Saigon (1971).

129 Group portrait of shoe-shine boys in Saigon (1971).

130 Cua Viet River.

131 Soldiers from the 1st Air Cavalry in a helicopter en route to an insertion near Xuan Loc (1971).

132–33 African American soldier on patrol.

133 Soldiers in a room, waiting and smoking.

134–35 On the road to Khe Sanh (1971).

NICK UT | ALL PHOTOS © AP WIDE WORLD PHOTOS

136 Badly burned, nine-year-old Kim Phuc runs from Trang Bang after a napalm
 attack by the Vietnamese Air Force (June 1972).

138–39 Napalm bombs falling on Trang Bang (June 1972).

140 A Vietnamese Air Force plane drops its load of napalm on Trang Bang (June 1972).

141 (left) A journalist pours water on Kim Phuc, minutes after she escaped from
 the napalm attack on Trang Bang (June 1972).

141 (right) A woman carries her badly burned infant after the attack on Trang Bang.
 The child did not survive (June 1972).

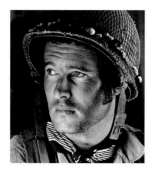

NIK WHEELER | ALL PHOTOS © NIK WHEELER

142 U.S. State Department employees run to a waiting Chinook helicopter on the
 grounds of the U.S. Embassy (April 28, 1975).

144–45 A Vietnamese family of nine flees toward Saigon on a custom-built
 motorcycle-driven trailer (April 28, 1975).

146–47 Thousands of refugees crowd Highway One on their way to Saigon in a
 tentative escape from the advancing North Vietnamese Army (April 27, 1975).

147 On Highway One on the way to Saigon (April 27, 1975).

148–49 Mayhem at the back gate of the U.S. Embassy, where thousands of Vietnamese
 try to gain access to the embassy grounds (April 28, 1975).

149 At the back gate of the U.S. Embassy (April 28, 1975).

150–51 The last rocket attack of the war (Cholon, April 28, 1975).

152–53 The widow and children of a Vietnamese officer killed in the last days of the
 war at a burial ceremony in the ARVN military cemetery near Bien Hoa.

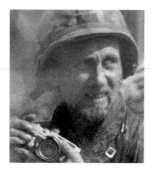

HUBERT VAN ES

154–55 A CIA employee helps Vietnamese evacuees on the roof of the USAID Building
 into an Air America helicopter during the evacuation of Saigon (April 29, 1975).
 © Hubert Van Es

DICK SWANSON

156–57 A couple stands in front the Vietnam Veterans Memorial Wall, Washington
 (1985). © Dick Swanson

AFTERWORD

158 Marines evacuate a wounded comrade, Battle of Hue (February 1968).
 Photo by **DON McCULLIN**, © Contact Press Images

Chronology

March 13, 1954 100,000 Viet Minh soldiers, under General Vo Nguyen Giap, begin their assault against the fortified hills protecting the Dien Bien Phu air base, which is defended by 11,000 soldiers of the French Expeditionary Corps.

May 7, 1954 At 5:30 P.M., after fifty-seven days of hell, Dien Bien Phu is overrun. Of the French soldiers, 1,726 have been killed and 4,436 wounded; among the Viet Minh, 8,000 killed and 15,000 to 20,000 wounded. French survivors are marched for up to sixty days to prison camps five hundred miles away; 70 percent die during the march or in captivity.

July 21, 1954 The Geneva Accords divide Vietnam in half at the seventeenth parallel, with the north ceded to Ho Chi Minh's Communists. The accords provide for elections to be held in all of Vietnam within two years to reunify the country. The United States opposes the elections, fearing a victory by Ho Chi Minh.

1962 The number of U.S. military advisors in South Vietnam rises to 12,000.

1963 The Viet Cong, the Communist guerrillas operating in South Vietnam, defeats units of the ARVN, the South Vietnamese Army. In the summer, Buddhist demonstrations spread. Several Buddhist monks publicly burn themselves to death as an act of protest. On November 1, President Ngo Dinh Diem is overthrown.

August 3, 1964 Two U.S. destroyers, U.S.S. *Maddox* and U.S.S. *C. Turner Joy,* begin a series of vigorous zigzags in the Gulf of Tonkin, sailing to within eight miles of North Vietnam's coast, while at the same time South Vietnamese commandos in speedboats harass North Vietnamese defenses along the coastline. By nightfall, thunderstorms roll in, affecting the accuracy of electronic instruments on the destroyers. Crew members reading their instruments believe they have come under torpedo attack from North Vietnamese patrol boats. Both destroyers open fire on numerous apparent targets, but there are no actual sightings of any attacking boats.

August 4, 1964 Two Navy jets are shot down during bombing raids, resulting in the first American prisoner of war, Lieutenant Everett Alvarez of San Jose, California. Alvarez is taken to an internment center in Hanoi that is later dubbed the Hanoi Hilton by the nearly six hundred American airmen who become POWs.

August 6, 1964 During a meeting in the Senate, Secretary of Defense Robert McNamara is confronted by Senator Wayne Morse of Oregon, who has been tipped off by someone in the Pentagon that the *Maddox* had been involved in the South Vietnamese commando raids against North Vietnam and thus was not the victim of an "unprovoked" attack. McNamara responds that the U.S. Navy "played absolutely no part in, was not associated with, was not aware of, any South Vietnamese actions, if there were any."

August 7, 1964 In response to the two incidents involving the *Maddox* and the *C. Turner Joy,* the U.S. Congress, at the behest of President Johnson, passes the Gulf of Tonkin Resolution, allowing the president "to take all necessary steps, including the use of armed force," to prevent further attacks against U.S. forces. The resolution, passed unanimously in the House and 98 to 2 in the Senate, grants enormous power to President Johnson to wage an undeclared war in Vietnam from the White House. The only senators voting against the resolution are Morse and Ernest Gruening of Alaska, who says that "all Vietnam is not worth the life of a single American boy."

March 2, 1965 Operation Rolling Thunder begins, as more than one hundred American fighter-bombers attack targets in North Vietnam and on the Ho Chi Minh Trail. Scheduled to last eight weeks, Rolling Thunder instead will go on for three years. During the entire war, the United States will fly three million sorties and drop nearly eight million tons of bombs, four times the tonnage dropped during all of World War II, in the largest display of firepower in the history of warfare.

March 8, 1965 The first U.S. combat troops arrive in Vietnam, as 3,500 Marines land at China Beach to defend the American air base at Da Nang. They join 23,000 American military advisors already in Vietnam.

May 3, 1965 The first U.S. Army combat troops arrive in Vietnam: 3,500 men of the 173d Airborne Brigade.

June 18, 1965 Nguyen Cao Ky takes power in South Vietnam as the new prime minister, with Nguyen Van Thieu functioning as official chief of state. They lead the tenth government in twenty months.

November 14–16, 1965 The Battle of Ia Drang Valley marks the first major battle between U.S. troops and North Vietnamese Army (NVA) regulars inside South

Vietnam. The 1st Cavalry Division (Airmobile) uses helicopters to fly directly into the battle zone; troops quickly disembark, then engage in fierce firefights, supported by heavy artillery and B-52 air strikes, marking the first use of B-52s to assist combat troops. The two-day battle ends with the NVA retreating into the jungle. Seventy-nine Americans are killed and 121 wounded, while NVA losses are estimated at 2,000.

November 17, 1965 The American success at Ia Drang is marred by a deadly ambush against 400 soldiers of the U.S. 7th Cavalry sent on foot to occupy nearby Landing Zone Albany. NVA troops that had been held in reserve during Ia Drang, along with troops that had retreated, kill 155 Americans and wound 124.

January 28– March 6, 1966 Operation Masher marks the beginning of large-scale U.S. search-and-destroy operations against Viet Cong and NVA troop encampments. (President Johnson orders the name changed to the less aggressive-sounding White Wing over concern for U.S. public opinion.) During the forty-two-day operation in South Vietnam's Bon Son Plain, near the coast, troopers of the 1st Cavalry Division (Airmobile) once again fly by helicopter directly into battle zones and engage in heavy fighting. 228 Americans are killed and 788 wounded. NVA losses are put at 1,342.

August 3, 1966 The U.S. Marines launch Operation Prairie and engage elements of the 324B North Vietnamese Division. Fierce fighting take place in October on hills 400 and 484. The operation ends in January 1967 with 209 Marines killed and 998 wounded. 1,313 NVA are killed.

December 27, 1966 The U.S. mounts a large-scale air assault against suspected Viet Cong positions in the Mekong Delta using napalm and hundreds of tons of bombs.

By year's end, U.S. troop levels reach 389,000, with 5,008 combat deaths and 30,093 wounded having been recorded. More than half of the American causalities are caused by snipers and small-arms fire during Viet Cong ambushes, along with handmade booby traps and mines planted everywhere in the countryside by the Viet Cong. American allies fighting in Vietnam include 45,000 South Koreans and 7,000 Australians. An estimated 89,000 soldiers from North Vietnam have infiltrated the South via the Ho Chi Minh trail during 1966.

February 22– May 14, 1967 The largest U.S. military offensive of the war occurs. Operation Junction City involves twenty-two U.S. and four South Vietnamese battalions in an attempt to destroy the NVA's Central Office headquarters in South Vietnam. The offensive includes the only U.S. parachute assault (by the 173d Airborne Brigade) during the entire war. Junction City ends with 2,728 Viet Cong killed and 34 captured. American losses are 282 killed

and 1,576 wounded. The NVA relocates its Central Office headquarters to Cambodia, thus avoiding capture.

April 24– May 11, 1967 The battle for Hill 881 rages near Khe Sanh, between U.S. 3rd Marines and the North Vietnamese Army. The battle results in 940 NVA killed; American losses are 155 killed and 425 wounded.

November 3– December 1, 1967 The Battle of Dak To occurs in the mountainous terrain along the border with Cambodia and Laos, as the U.S. 4th Infantry Division and 173rd Airborne Brigade head off a planned NVA attack against the Special Forces camp there. NVA losses are put at 1,644, while U.S. troops suffer 289 killed.

By year's end, U.S. troop levels reach 463,000, with 16,000 combat deaths to date. By this time, over a million American soldiers have rotated through Vietnam. An estimated 90,000 soldiers from North Vietnam infiltrated the South via the Ho Chi Minh trail in 1967. Overall Viet Cong and NVA troop strength throughout South Vietnam is now estimated at up to 300,000 men.

January 21, 1968 20,000 NVA troops under the command of General Giap attack the American air base at Khe Sanh. A seventy-seven-day siege begins as 5,000 Marines in the isolated outpost are encircled. "I don't want any damn Dinbinfoo," President Johnson tells Joint Chiefs Chairman General Earle Wheeler. At the peak of the battle, NVA soldiers are hit around the clock, every ninety minutes, by aerial bombardment from groups of B-52s. Over the course of the siege, U.S. B-52s drop 110,000 tons of bombs, the heaviest bombardment of a small area in the history of warfare.

January 31, 1968 The turning point of the war occurs, as 84,000 Viet Cong guerrillas, aided by NVA troops, launch the Tet Offensive, attacking a hundred cities and towns throughout South Vietnam.

January 31– March 2, 1968 In the Battle for Hue, 12,000 NVA and Viet Cong troops storm the lightly defended historic city and begin systematic executions of more than 3,000 "enemies of the people," including South Vietnamese government officials, captured South Vietnamese officers, and Catholic priests. South Vietnamese troops and three U.S. Marine battalions counterattack, in the heaviest fighting of the entire Tet Offensive, and retake the old imperial city, house by house and street by street, aided by American air and artillery strikes. On February 24, U.S. Marines occupy the Imperial Palace in the heart of the citadel, and the battle soon ends with a North Vietnamese defeat. American losses are 142 Marines killed and 857 wounded, 74 U.S. Army killed and 507 wounded. The South Vietnamese suffer 384 killed and 1830 wounded. NVA losses are put at more than 5,000.

April 1, 1968	The U.S. 1st Cavalry Division (Airmobile) begins Operation Pegasus to reopen Route 9, the relief route to the besieged Marines at Khe Sanh.
April 8, 1968	The siege of Khe Sanh ends with the withdrawal of NVA troops from the area as a result of intensive American bombing and the reopening of Route 9. NVA losses during the siege are estimated at up to 15,000. U.S. Marines suffered 205 killed and 830 wounded, while the 1st Cavalry suffered 92 killed and 629 wounded in reopening Route 9. The U.S. command secretly shuts down the Khe Sanh air base and withdraws the Marines. Commenting on the heroism of U.S. troops that defended Khe Sanh, President Johnson states that "they vividly demonstrated to the enemy the utter futility of his attempts to win a military victory in the South." A North Vietnamese official labels the closing of Khe Sanh air base as America's "gravest defeat" so far.
May 1968	The Viet Cong launches "Mini Tet," a series of rocket and mortar attacks against Saigon and 119 cities and military installations throughout South Vietnam. The U.S. responds with air strikes using napalm and high explosives.
September 30, 1968	The nine-hundredth U.S. aircraft is shot down over North Vietnam.

1969	Ho Chi Minh dies. President Nixon begins to reduce U.S. ground troops in Vietnam to 115,000. By the end of the year, 40,024 Americans have been killed in Vietnam. Domestic public opposition to the war grows.
1970	Nixon's national security advisor, Henry Kissinger, and Le Duc Tho, for the Hanoi government, start secret talks in Paris.
October 1972	Nixon and Kissinger announce that "peace is at hand."
January 23, 1973	Cease-fire agreement in Paris. U.S. troop pullout is completed by the end of March.
April 17, 1975	In Cambodia, Phnom Penh falls to Khmer Rouge.
April 30, 1975	Communist forces capture Saigon, as the last Americans leave in scenes of panic and confusion.

The United States lost 58,245 soldiers in Vietnam and suffered more than 300,000 wounded. Later estimates put Vietnamese deaths at up to 3 million. The war cost the United States nearly $150 billion.

——

Excerpted and adapted from the History Place (historyplace.com) Vietnam War timeline, authored by Philip Gavin. © The History Place

Acknowledgments

I am deeply grateful to Fred Ritchin, Zohar Nir-Amitin, and Aviva Michaelov of PixelPress for undertaking the design of our website, *Under Fire: Images From Vietnam* (www.pieceuniquegallery.com). A multimedia presentation, it has received many accolades and more than three hundred thousand visitors since going online. Designed as a tribute to the work of photojournalists, this website offers for the first time the opportunity to own some of the strongest photographs from the Vietnam War.

Mokie Porter and Marc Leepson of *The VVA Veteran*, a publication of the Vietnam Veterans of America, opened their columns to us and published several essays by some of the best writers of the Vietnam generation. Each essay accompanied a photo from one of the photographers involved in our website project. The idea for a book took shape soon thereafter.

The advice and friendship of Robert Pledge at Contact Press Images, as well as the help of his staff, Dominique Deschavanne, Tim Mapp, Greg Sauter, Frank Seguin, and Jeffrey Smith, proved invaluable. Brian Storm, Ken Johnston, and Wendy Rysanek at Corbis opened their archives. Jim Wood, Chuck Zoeller, and Ollie Jones from AP Wide World Photos and Ben Chapnick of the Black Star agency were equally supportive of the project from the earliest stage.

I am grateful to Natalie Riou at the ECPAD (archives of the French Defense Ministry) and Marc Brincourt at *Paris-Match* for supplying the Dien Bien Phu portfolio of Daniel Camus. My deepest gratitude to Pamela Peffer-Smith for making available the essay by Jack Smith at a time of personal grief following Jack's death.

I would like to thank Robert Loomis of Random House for undertaking the project, and Fred Ritchin for his decisive creative input as consulting editor. Random House designer Barbara Bachman was patient and diligent in support of our graphic vision.

And an enormous thanks to all the photographers and writers whose work is represented in this book.

ABOUT THE AUTHORS

CATHERINE LEROY went to Vietnam in 1966, at twenty-one, with a Leica. In 1967, she became the only journalist accredited to jump with the 173rd Airborne Brigade, and later was wounded while with the Marines. In 1968, she was captured by the North Vietnamese Army in Hue during the Tet Offensive. Later, as a contract photographer for *Time*, her camera took her to Lebanon, Afghanistan, Iran, Iraq, Vietnam, the Horn of Africa, China, Pakistan, and Libya. Her honors include the George Polk Award, the Robert Capa Award, and Picture of the Year. In 1997, she received an Honor Award for Distinguished Service in Journalism from the University of Missouri. A retrospective of her work was exhibited at Visa Pour l'Image, the prestigious photojournalism festival in Perpignan, France, in 1996. She collaborated with Tony Clifton on the book *God Cried*, about the siege of West Beirut by the Israeli army in 1982. She has produced *Under Fire: Images from Vietnam* (www.pieceuniquegallerycom), the first multimedia project on the Vietnam War.

As a naval aviator, JOHN McCAIN was shot down over Hanoi in 1967. He was tortured, held in solitary confinement, and imprisoned for the next five and a half years. He served two terms in Congress (1982–1986) before being elected to the United States Senate in 1986. He was reelected in 1992, 1998, and 2004. His books include *Faith of My Fathers*, *Worth the Fighting For*, and *Why Courage Matters*. He and his wife, Cynthia, reside in Phoenix.

FRED RITCHIN is director of PixelPress (www.pixelpress.org), associate professsor of photography and imaging at New York University, former picture editor of *The New York Times Magazine*, and author of many books and essays on media, including *In Our Own Image: The Coming Revolution in Photography* and the forthcoming *Reinventing Photography*.